GALLERY 1988's CRAZY4CULT CULT MOVIE ART 2

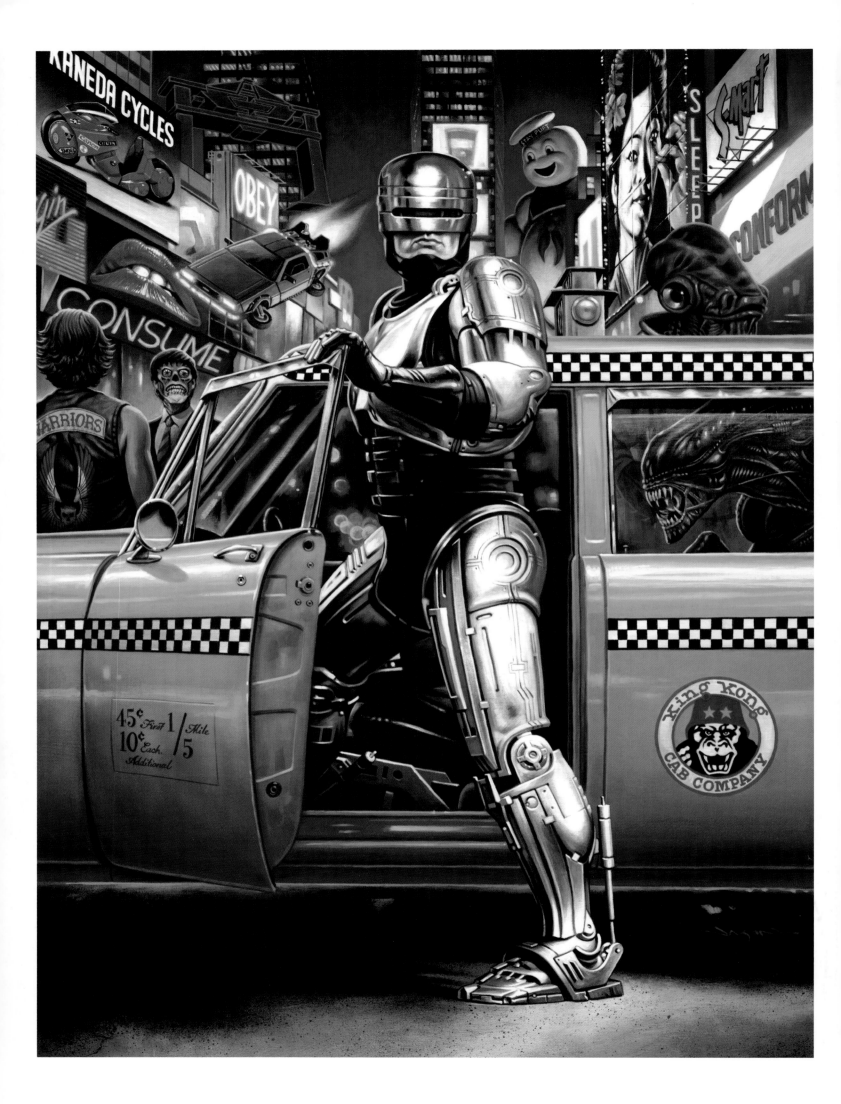

GALLERY 1988's CRAZY4CULT
CULT MOVIE ART 2

INTRODUCTION BY

SETH ROGEN

TITAN BOOKS

SETH ROGEN

Art is usually pretty boring. Ok, maybe it's not boring. Alienating might be more accurate. Don't get me wrong. It usually looks good. I mean, *Starry Night* is nice. I once saw that painting of the farmer and his wife with the pitchfork that has a totally different name than you would assume it has (I think it's *American Gothic*, but to maintain the integrity of this blurb, I won't check). The billion paintings of Jesus and Mary in the Louvre are pretty badass. The way the candles glow, the way the nails really look like they're going through the hands and into the cross. But the truth is, most of the art that is in galleries is super old and the subject matter is just plain hard to relate to. I don't live in Paris, and the nights I've been there you can't see stars because of the rain and Vespa pollution. I don't know any farmers that don't grow illegal narcotics, and ever since I was a kid, paintings of Jesus scared the shit out of me.

In general, art galleries were not really for me.

I remember the first time I saw a painting from Gallery 1988. It was of Sloth from the Goonies… or was it of Chunk? Or that opera singing gangster? Ok, fuck that. I do NOT remember the first time I saw a painting from Gallery 1988, but I can imagine that when I did, I had my mind blown. I hypothesize that, for the first time in a long time, I was excited about art because it was about shit that I really cared about. And I can conclude that I was almost certainly thrilled by the idea that so many talented artists seemed to like the same shit that I like. *Ghostbusters, The Big Lebowski, Indiana Jones, The Princess Bride, Back to the Future, Army of Darkness*. This is the stuff I want art about. These are the stories that entertained and inspired me growing up, and this is the stuff I want paintings of. Hill Valley is my Paris at night. Wesley and Buttercup are my farmer couple. And The Dude is my Jesus. I'd also take a Picasso or Dali, but I probably can't afford that due to some poor career decisions. Anyway, I don't really know how to end this. Do I like, introduce the book now? Ok, that sounds like a good way to wrap it up. So:

And now, enjoy… *CRAZY FOR CULT 2*!!!!! YAY!!!!

SETH ROGEN
3/13/13

Above:
Mike Mitchell
'Indica and Sativa'
Giclee print
8 x 10 inches
Pineapple Express

Katie used to work for an asshole. I say that without any real anger. It's just what he was. He was the type of art gallery owner who only paid attention to customers who were either recognizable celebrities or possessed the ability to purchase six figure paintings at the drop of a hat. God forbid you walked into his space hoping to just enjoy the artwork, hoping that one day you'd have the funds to hang one on your wall. We used to joke that whenever I walked into the gallery he just saw me as a homeless man the same way Annie Hall's Grammy saw a Hasidic Jew when Woody was sitting at the dinner table. Katie wasn't very happy with her job. It was painstaking.

In college I found myself as the all-time champion of an odd radio contest where I rap battled against three to four people a day, hoping to be crowned victorious and come back the next day to do it all over again. What had started as a joke entry, turned into over forty days on-air, an almost million dollar record deal at Interscope Records, and album featuring Kanye West and Fabolous and one day where I opened for Snoop Dogg. But my time as the poorly named MC "Hot Karl" always felt like a gag I did in between college courses, and I just kept questioning if that was what I meant to do for a living. I wasn't very happy with my job. It was painstaking.

Between Katie's Art History degree and my hopes to ditch the music industry, we knew we wanted a plan to avoid choosing another job or profession we didn't like. While this "plan" was in its early stages, I was adamant about finding artwork that actually spoke to my age demographic and interests for my walls. I had some money from accidentally becoming a rapper, and didn't want to frame the same Scarface poster that everyone on *Cribs* had. Katie and I went on a mission and found a handful of artists, who were not only in our age group, but were also working in themes and subjects that spoke to us. But each time we bought something, we'd have to meet the artist in a Rite-Aid parking lot, like we were buying crystal meth or a baby on the black market. We would ask them why traditional galleries weren't showing them, and they'd complain they weren't taken seriously, weren't expensive enough and were too young. And

hence, we began to formulate our plan.

With Katie's knowledge of the art universe, and my absolute lack of knowledge regarding anything related to art, we knew she'd make up for my ignorance. But we both knew we wanted to exhibit affordable artwork, display artists who focused on pop culture similar to the feelings Katie and I had, and, above all else, never be an asshole.

We opened Gallery1988 in Los Angeles, on the corner of Melrose & La Brea, in 2004 to what they call in the art industry, "absolutely zero fucking fanfare." We focused on prints and affordable originals, with moments of vintage video games, cartoon references and as much pop culture as we could get into one space. We didn't sell a ton those first two years, but we promised each other to stay the course and not give up. We hoped, as time went on, that people would tell friends and being the only pop culture art gallery in the universe would pay off. We hoped buyers that felt ignored by gallery owners like Katie's old boss would find refuge in G1988 and notice we spoke their language.

Word did get out. Only a few years after our (not so) grand opening, we started seeing buyers and art lovers literally line up around the block just to see pop culture themed art shows. We forged relationships with The Walt Disney Company and Mattel, paid tribute to Stan Lee and the Beastie Boys, and created a marketing division that has since worked on *Lost*, *Breaking Bad*, numerous projects with Paramount Pictures (including their official 100th Anniversary poster), a collaboration with The Oscars, and our own marketing strategy for opening weekend of *The Avengers*. We once were the only pop culture gallery in the universe, praying that customers would one day walk in, and now we're one of dozens who've copied our business plan, strategy and artist line-ups, praying they'd all just go away.

This book is the second anthology for our most popular display, an annual show that we conceived with Scott Mosier and Kevin Smith, another duo we were lucky to work with as the gallery became more popular. We always had the idea to create an art show based on our favorite cult movies, and once Scott

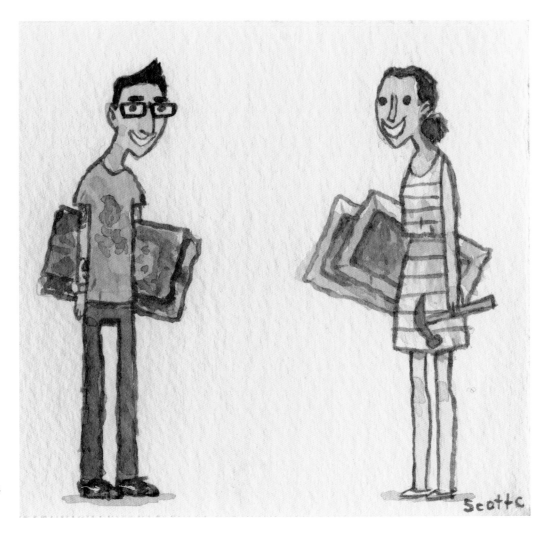

Right:
Scott Campbell
'Jensen & Katie'
Watercolor on paper,
3 1/2 x 3 1/2 inches

& Kevin wanted to be involved, we knew it would become one of our most popular events. We've had hour-long lines for Crazy 4 Cult, a brand that's almost surpassed the gallery, especially when we traveled to New York in 2012 to have our first exhibit outside of California. We've sold artwork from the show to many of the filmmakers and cast members that actually produce the movies we're honoring, from JJ Abrams to Frank Darabont. Crazy 4 Cult has been covered in magazines, newspapers, TV shows and blogs we never imagined would publish the word "G1988", and it's helped the exhibit become the template for most of our competitors. We've been privileged to collaborate with some of the most talented artists in the world during

these past five Crazy 4 Cults, and the majority of them are now chronicled in these pages.

It's been a pretty crazy ride for Katie and me over the past decade. G1988 was an idea built from frustration and the fact that asshole gallery owners wouldn't pay attention to a potential art buyer because they cited Tarantino or Apatow as an influence over Picasso or Rothko. We sweat and bled all over this place, hoping that it would one day become a space where people just like us can find the artistic merit in our favorite TV shows, movies, video games and music, and turn that love into brand new artistic creations. We hope this book can be that space for you. If not, no worries, we only sell to celebrities now anyway.

JENSEN KARP
Co-owner & Co-curator
3/14/13

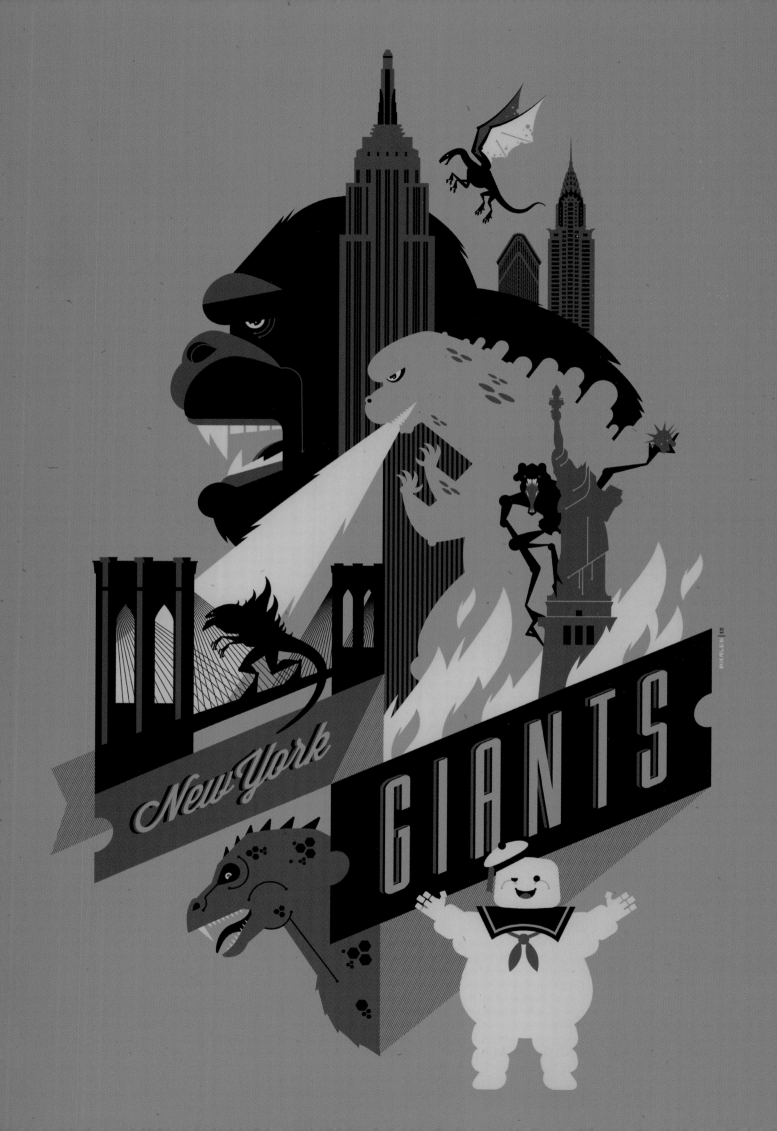

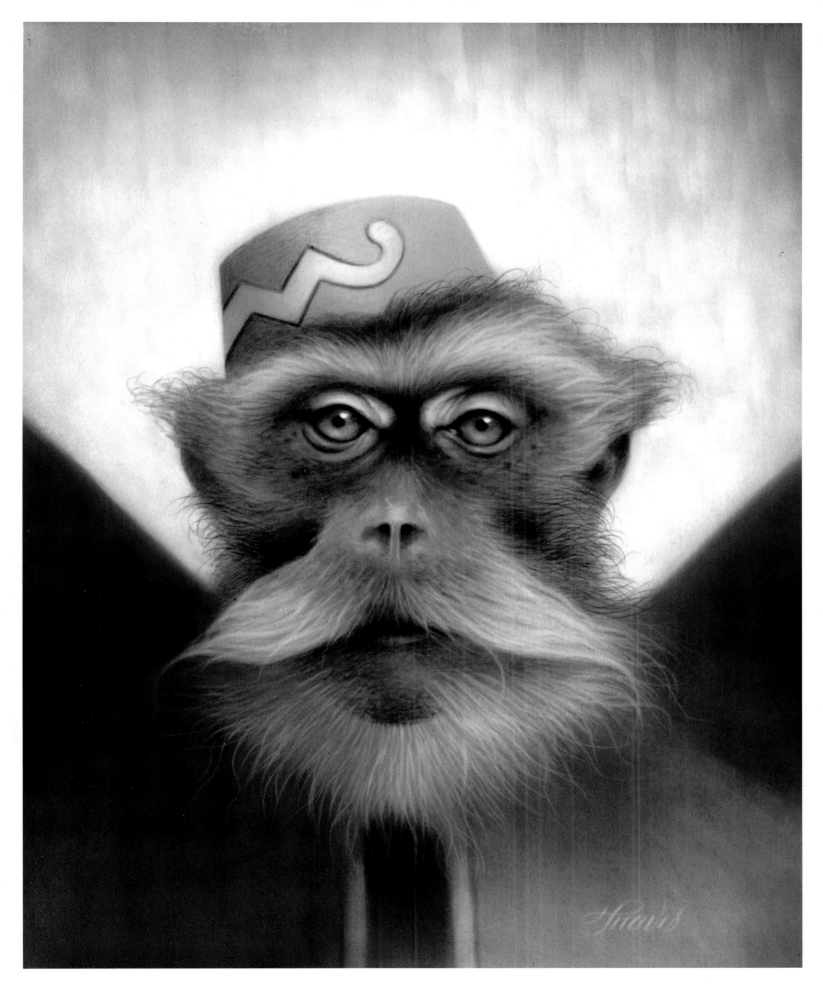

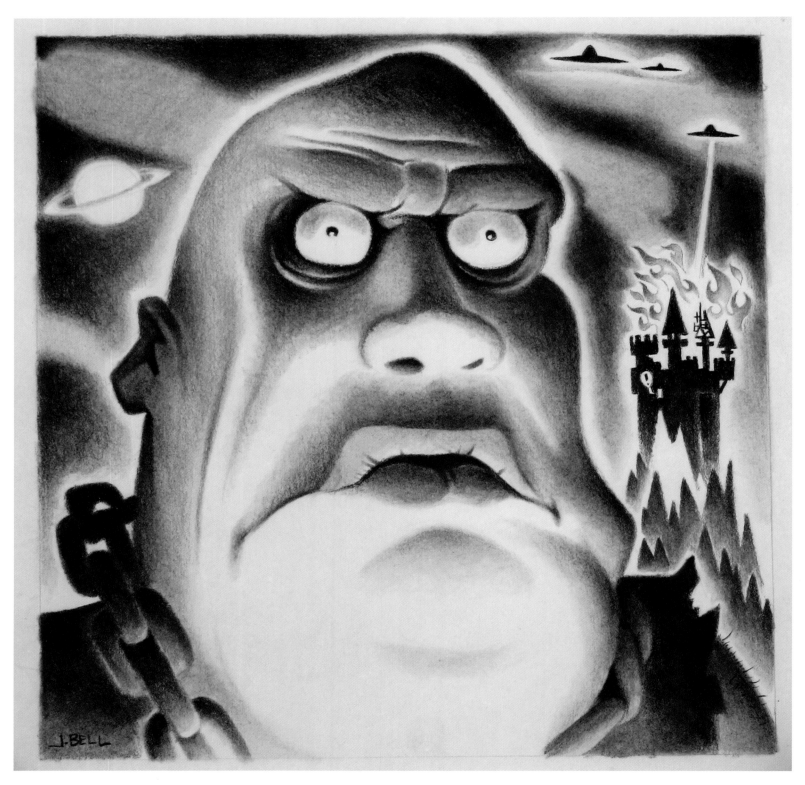

Left:
John Bell
'Mr. Saturday Night'
Charcoal on Paper
12 x 12 inches
Plan 9 From Outer Space/Ed Wood

Right:
Matt Taylor
'We Blew It'
2 color screenprintl
11 3/4 x 16 1/2 inches
Easy Rider

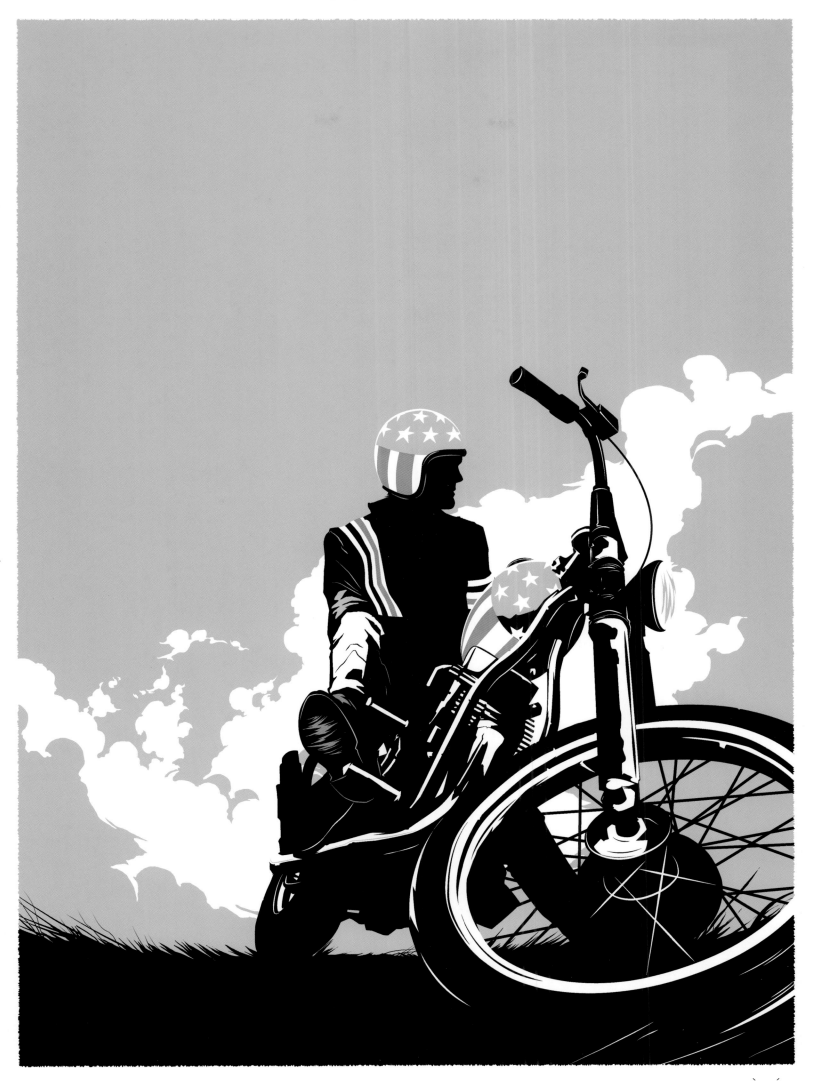

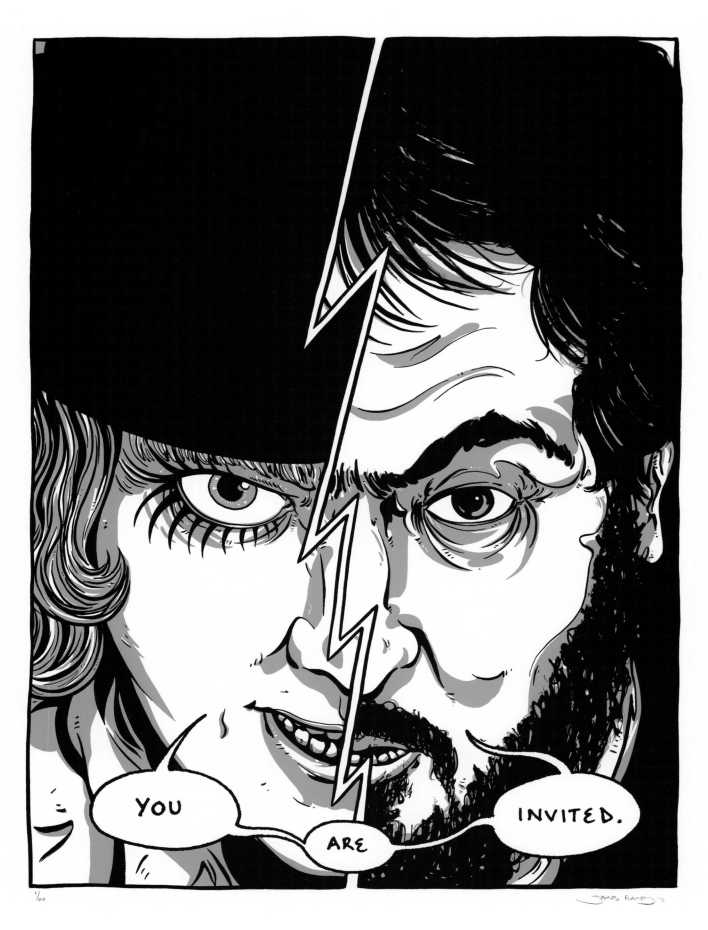

Above:
James Flames
'You Are Invited'
Screenprint
18 x 24 inches
A Clockwork Orange

Right:
Scott Derby
'Ode To Alex'
Screenprint
12 x 18 inches
A Clockwork Orange

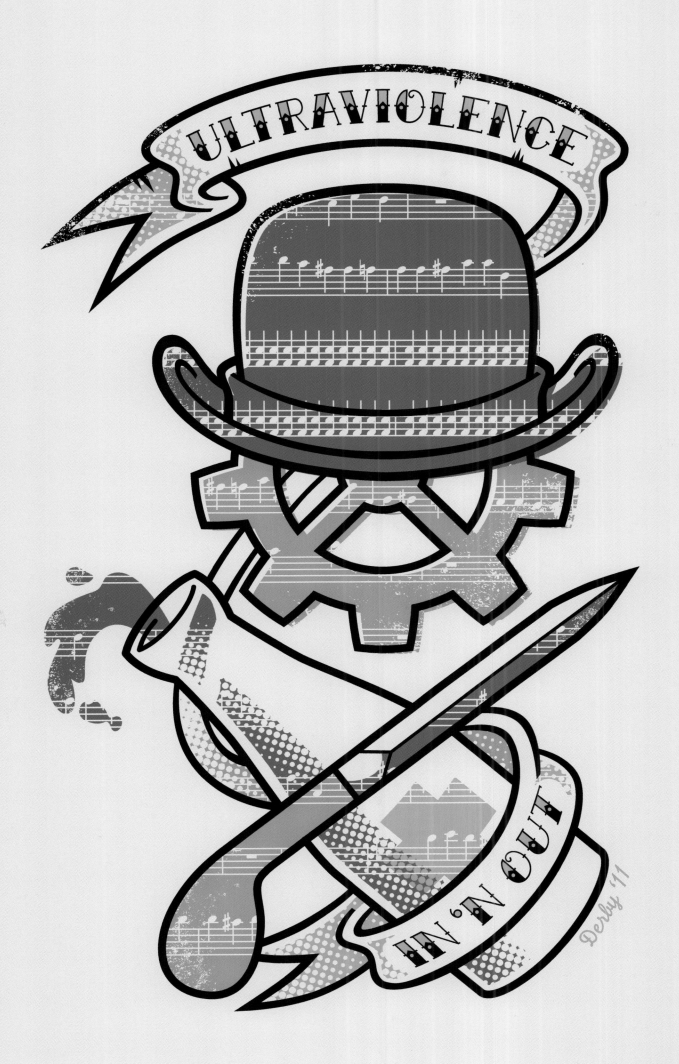

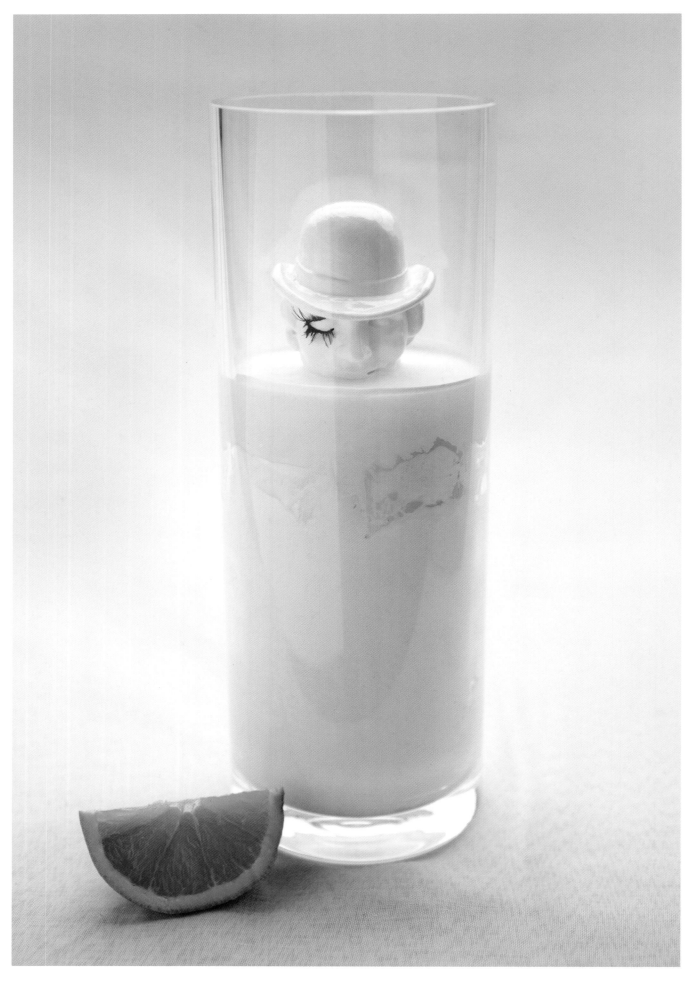

Above:
Danielle Buerli
'Milk Plus'
Mixed Media
10 inches tall
A Clockwork Orange

Right:
Eric Price
'Is The Grizzly Reaper Mowing?'
Ceramics and Acrylic
8 x 13 1/2 inches
Willy Wonka And The Chocolate Factory

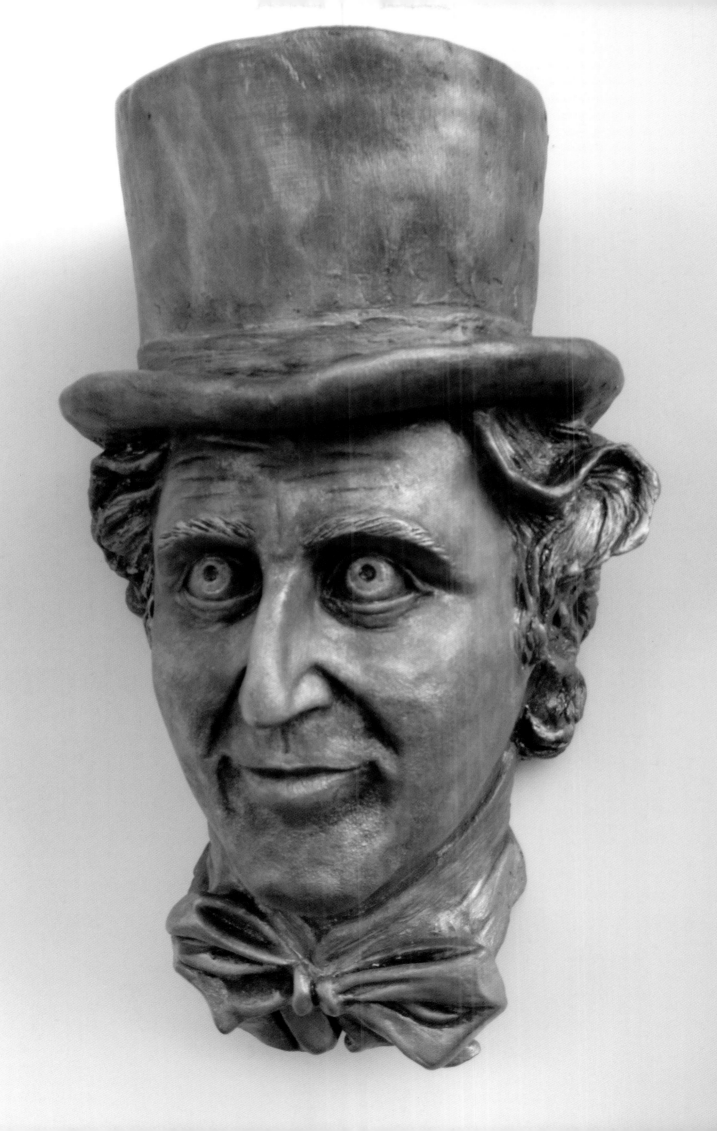

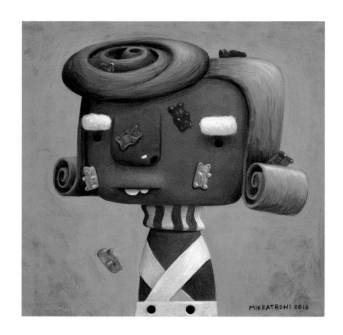

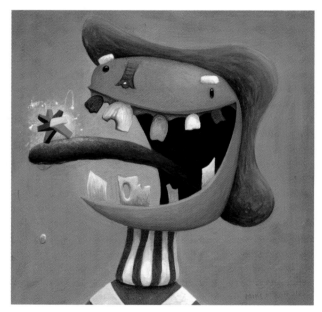

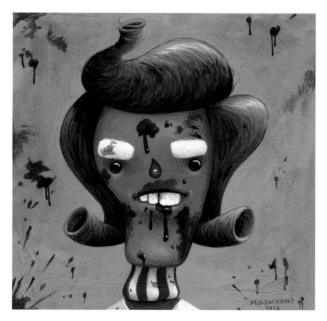

Right:
Mike Mitchell
'Good Day Sir'
Giclee print on archival museum quality paper
16 x 20 inches
Willy Wonka And The Chocolate Factory

Left, from top to bottom:
Mikeatron
'Gerald, the Gummiest'
'Stimpson, Eater of the Everlasting'
'Ferdinand, The Chocolate Worker'
Acrylic
6 x 6 inches
Willy Wonka And The Chocolate Factory

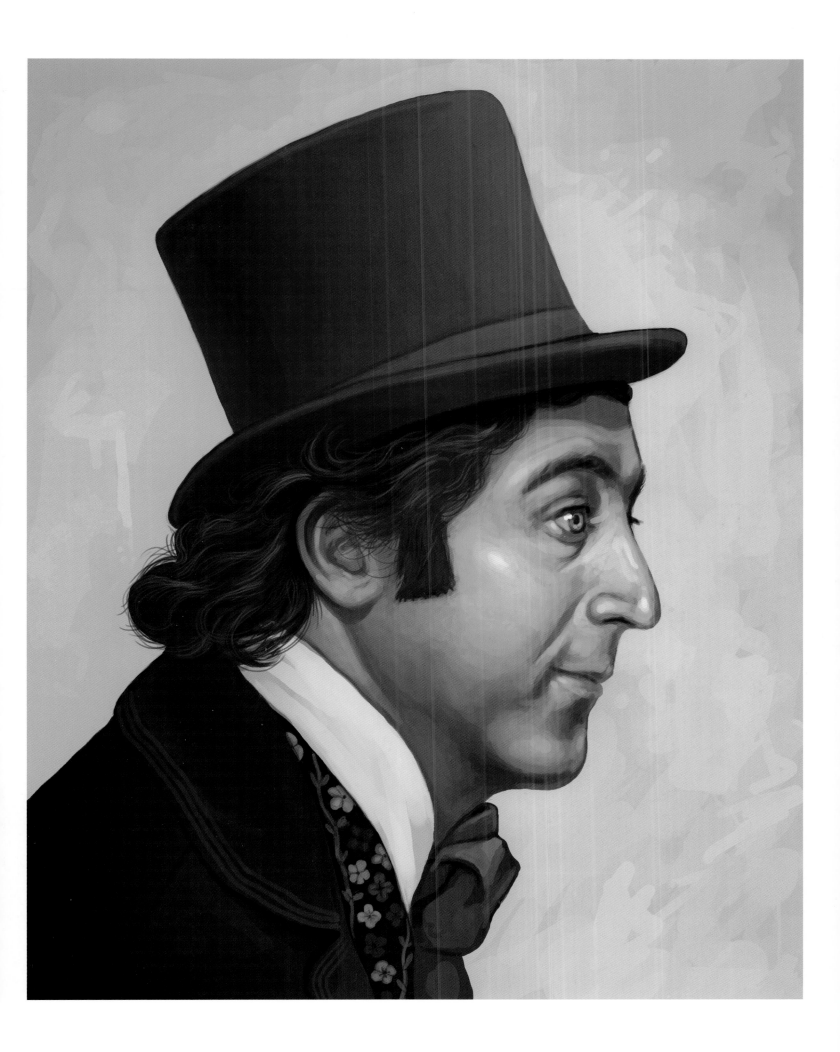

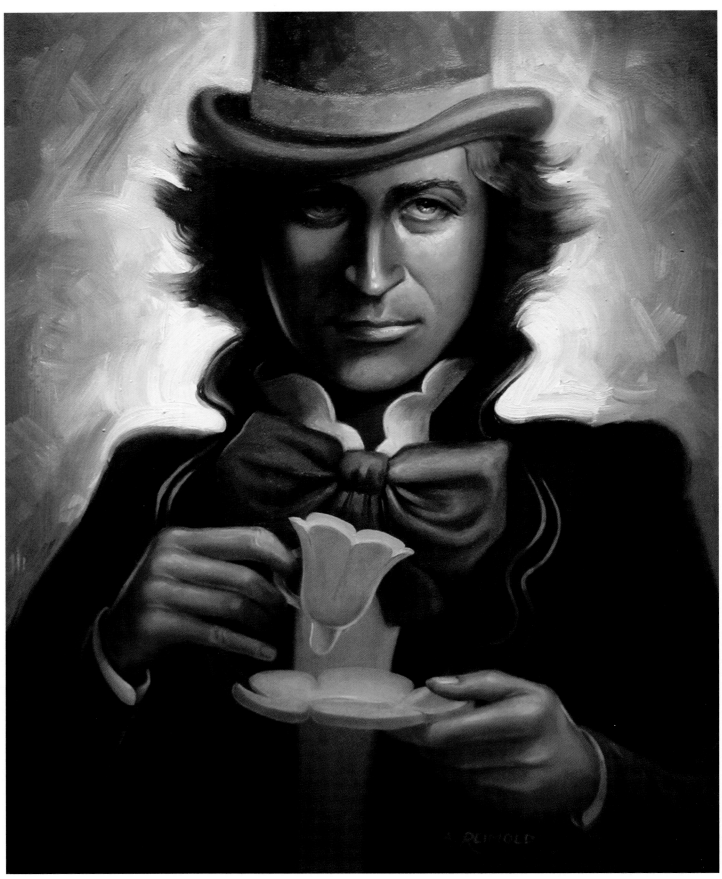

Above:

Allison Reimold

'The Candy Man Can'

Oil on panel

11 x 14 inches

Willy Wonka And The Chocolate Factory

Right:

Matt Chase

'Willy Wonka and the Chocolate Factory'

Screenprint

18 x 24 inches

Willy Wonka And The Chocolate Factory

GENE WILDER · 1971

WILLY WONKA
— AND THE —
CHOCOLATE FACTORY

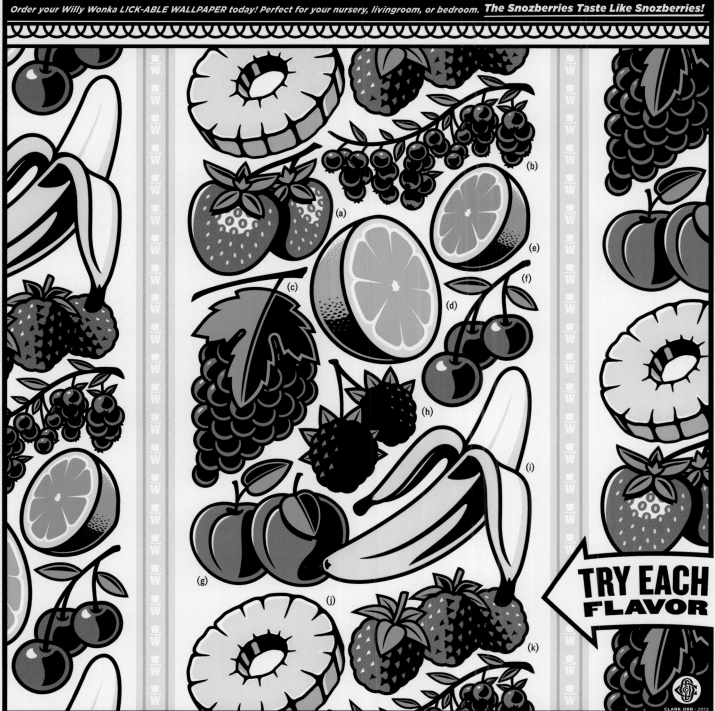

WILLY WONKA Candy Co. ™

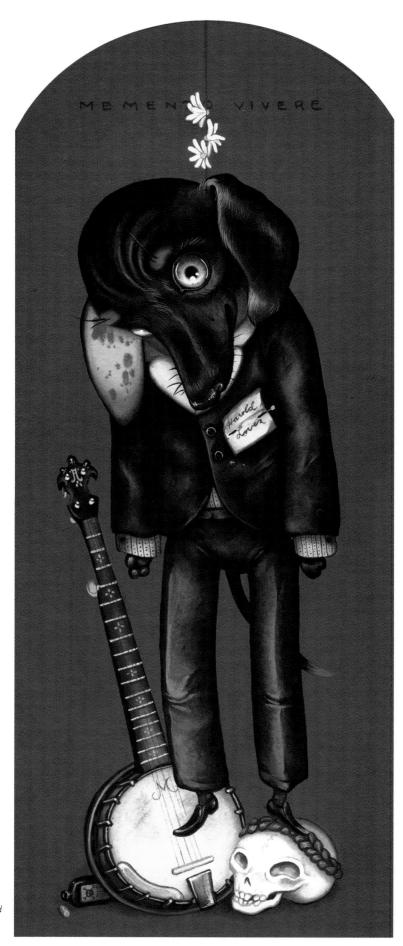

Right:
Allison Sommers
'Memento Mori'
Gouache on illustration board
3 x 4 1/2 inches
Harold And Maude

Above:
Ben Walker
'Go and Love Some More'
Watercolor and Ink on Clayboard
5 x 7 inches
Harold And Maude

Graham Erwin

'Leatherface'

Screenprint, 18 x 24 inches

The Texas Chainsaw Massacre

Mikeatron

'Invincible!'

Acrylic on Canvas, 6 x 12 inches

Monty Python And The Holy Grail

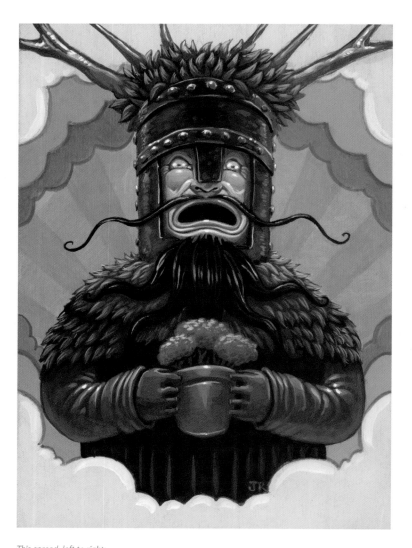
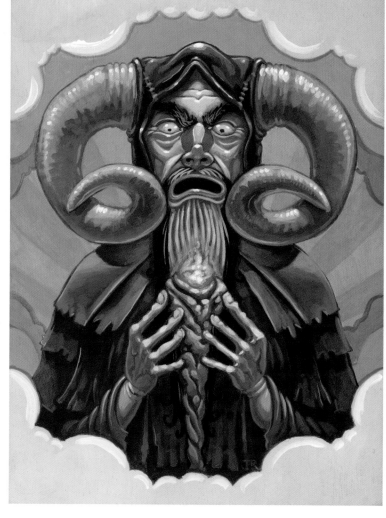

This spread, left to right:
Jesse Riggle
'It Is A Good Shrubbery'
'There Are Some Who Call Me...Tim?'
'Uh, He's Already Got One, You See?'
Acrylic on Maple Panel
5 x 7 inches
Monty Python And The Holy Grail

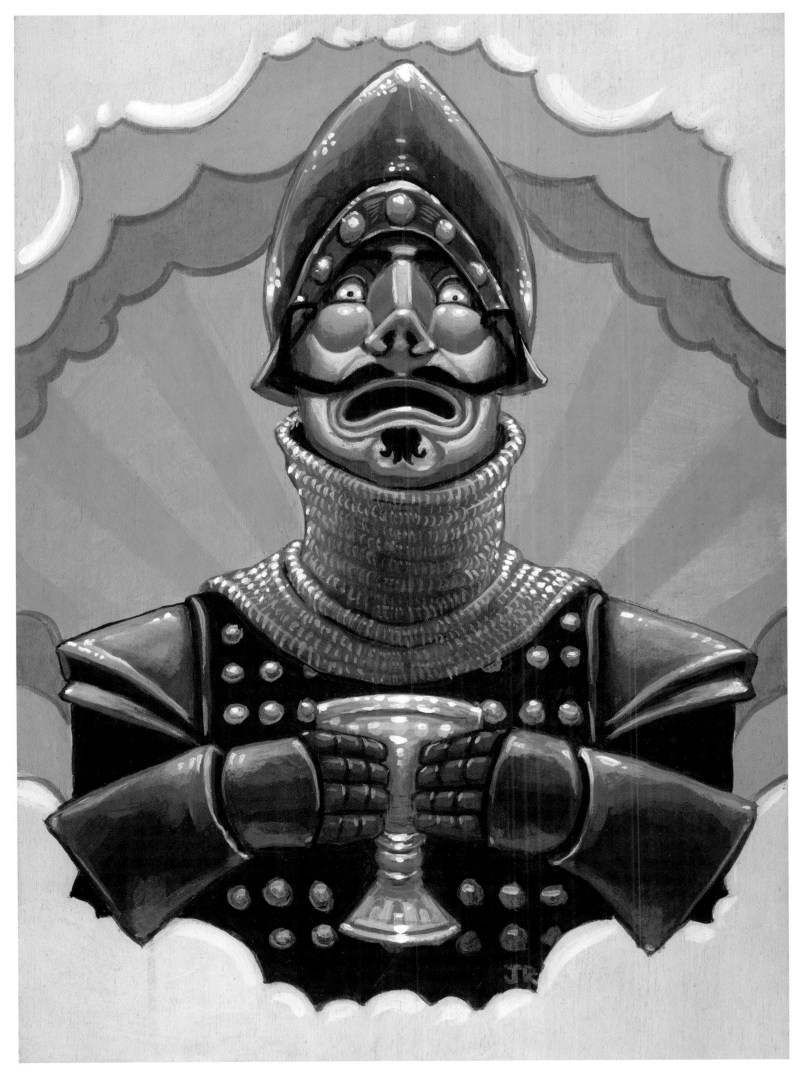

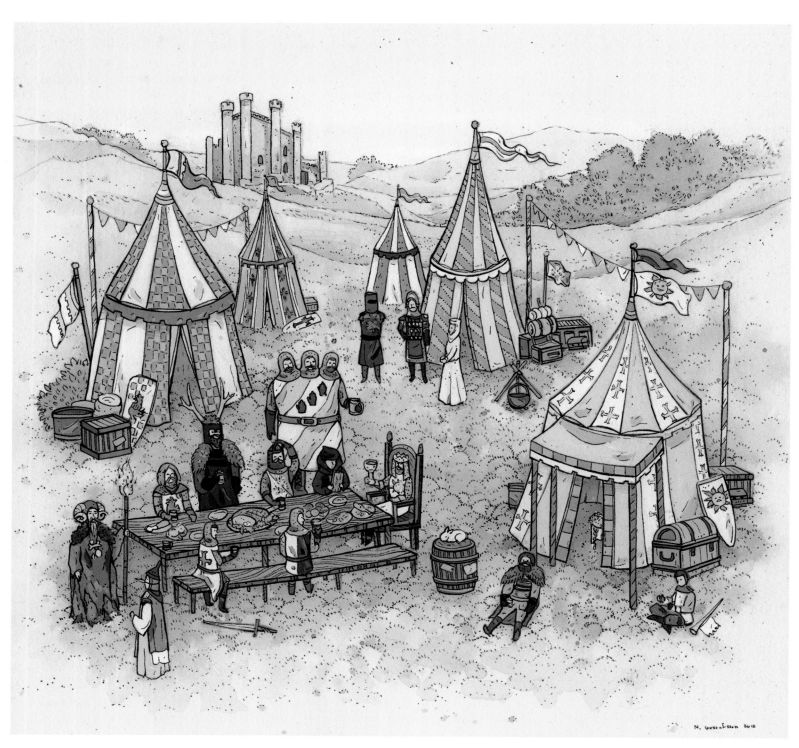

Above :
Nicole Gustafsson
'Quest Complete'
Gouache and Ink on Paper
10 x 9 1/2 inches
Monty Python And The Holy Grail

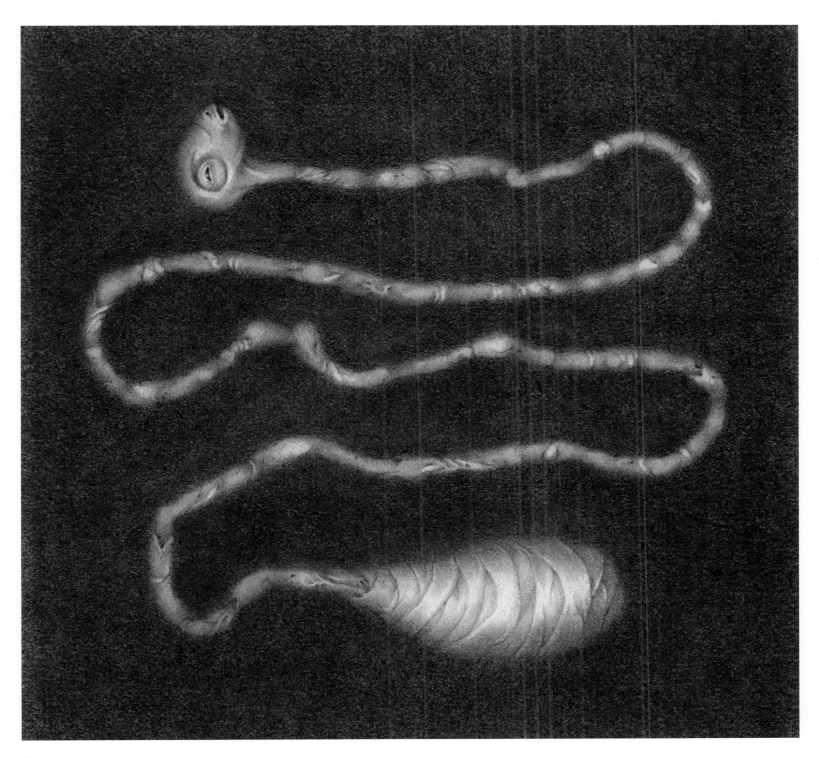

Above :
Allison Sommers
'Offspring'
Graphite on paper
5 x 5 inches
Eraserhead

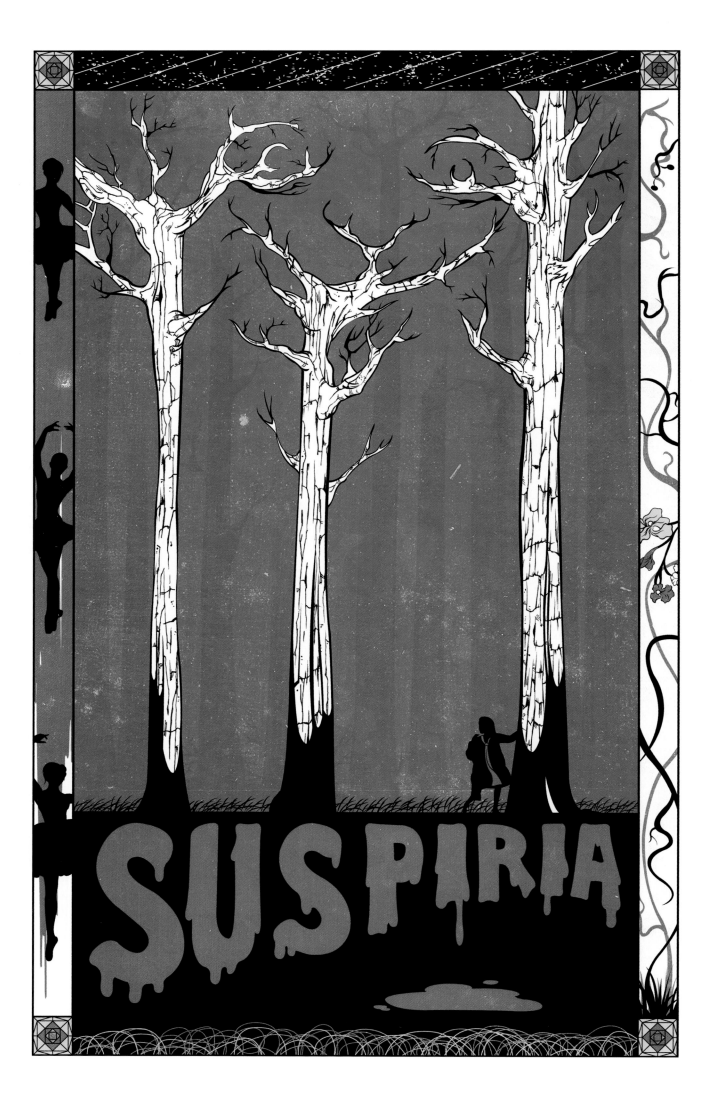

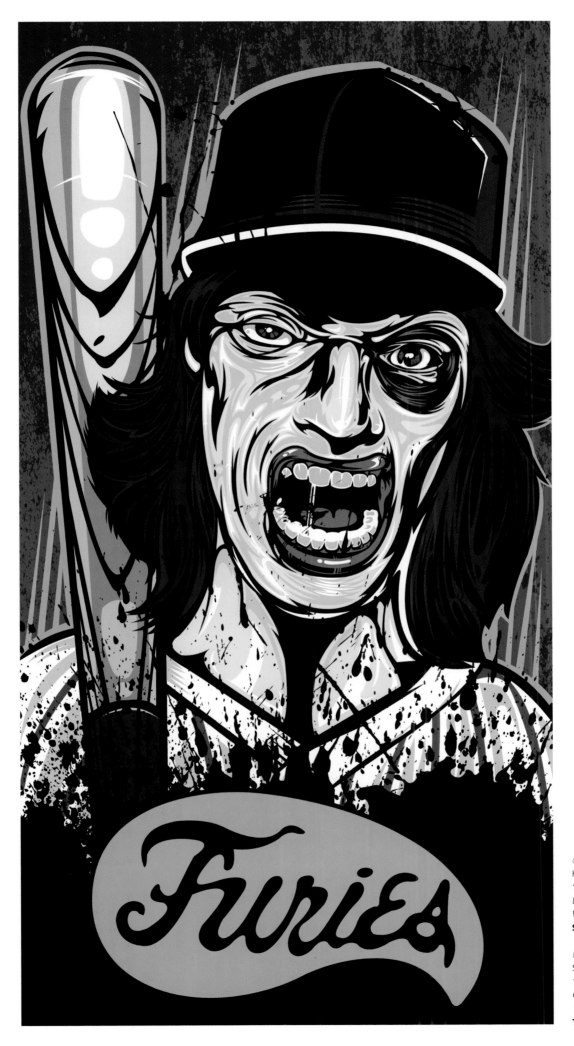

Opposite :
Keith Noordzy
'Suspiria'
Digital Print on
Watercolor Paper
Suspiria

Left :
Samuel 'Sho' Ho
'Furies'
Giclee Print
10 x 20 inches
The Warriors

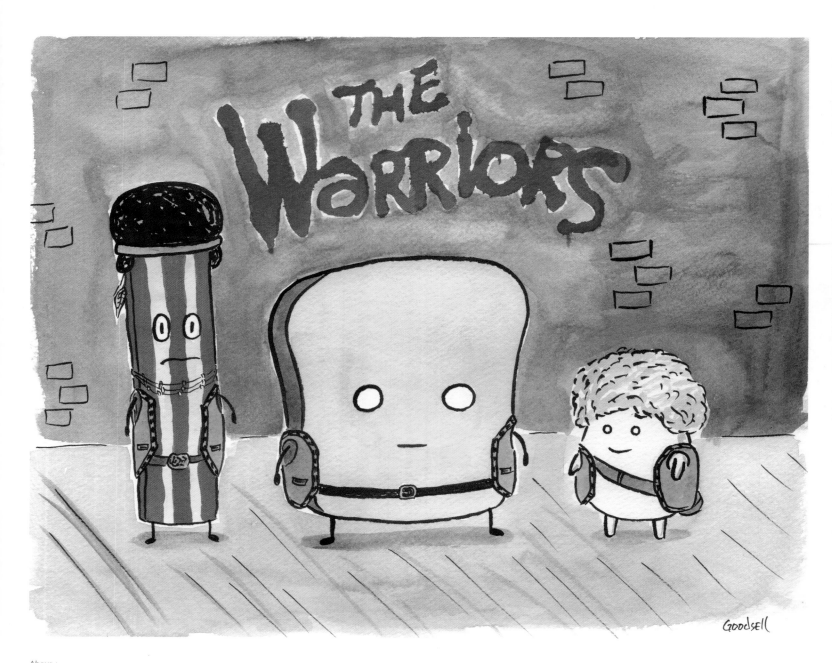

Above :
Dan Goodsell
'Warriors'
Ink and watercolor on paper
11 x 14 inches
The Warriors

Right :
Dave Perillo
'Come Out & Play!'
Screenprint
18 x 24 inches
The Warriors

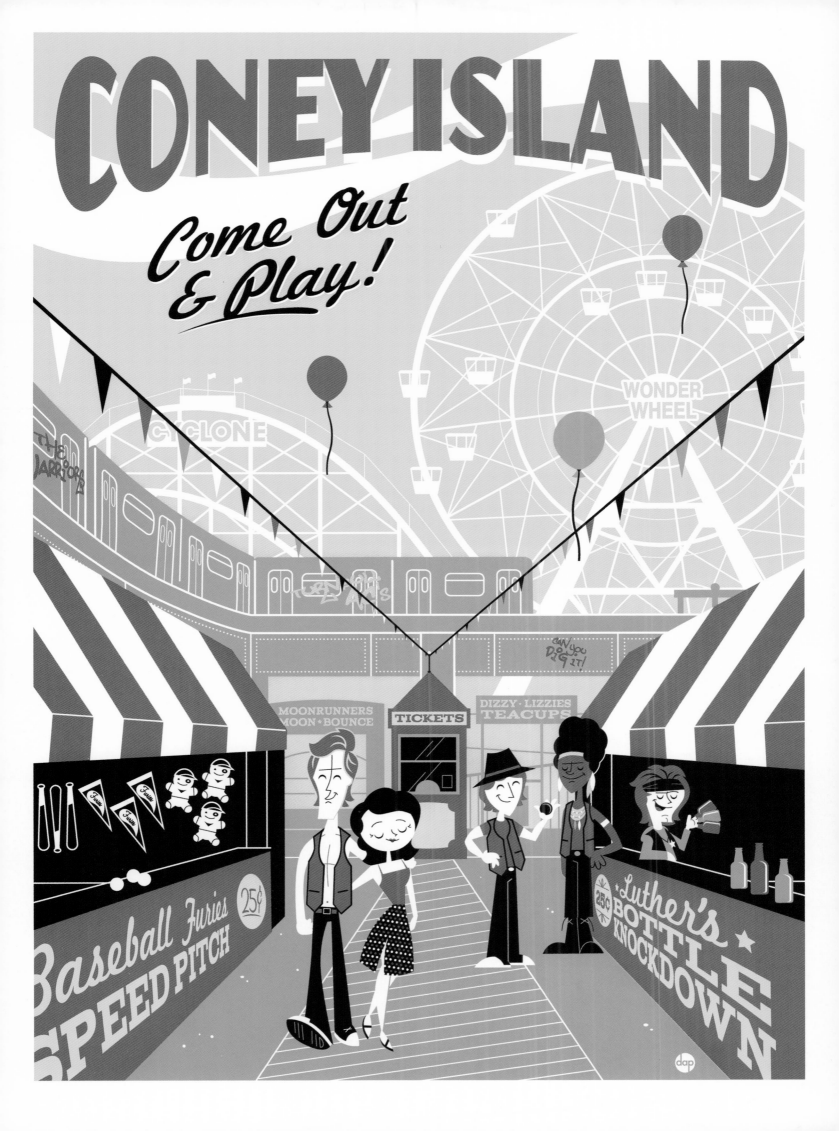

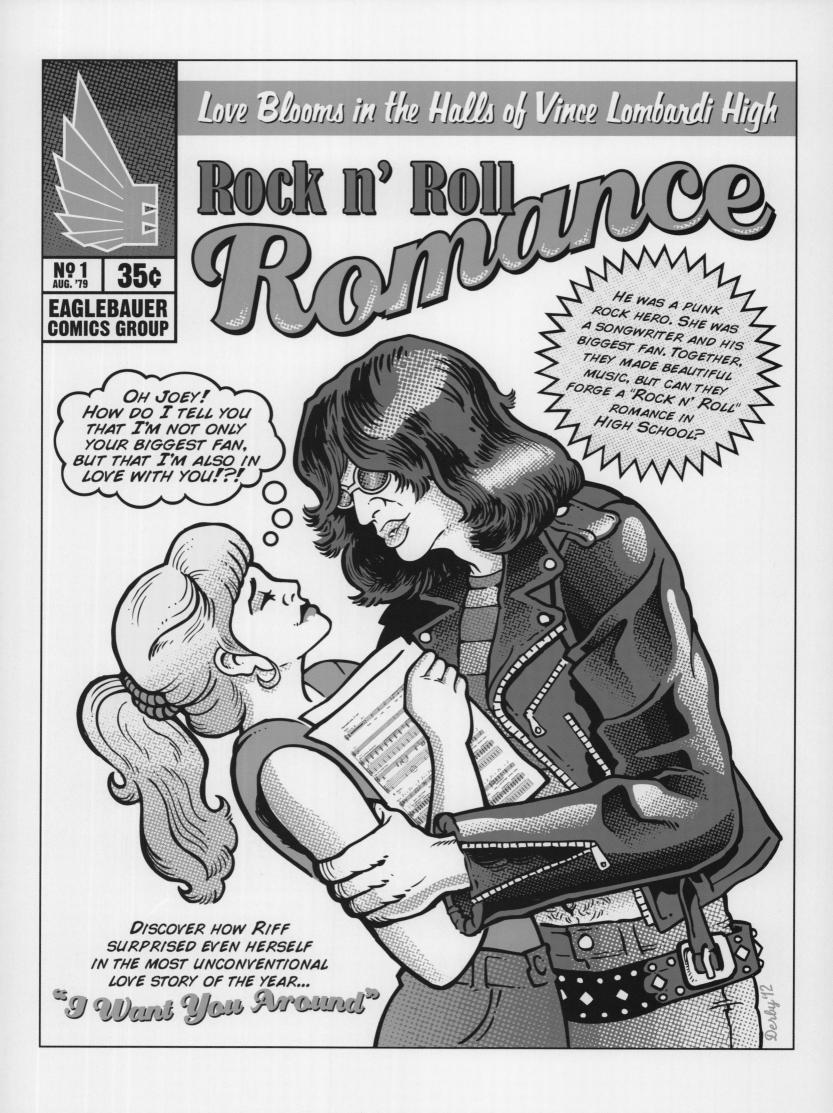

Left :
Scott Derby
'Rock n' Roll Romance'
Screenprint, 18 x 24 inches
Rock 'n' Roll High School

Above:
Keith Noordzy
'Shark vs. Zombie'
Giclee Print, 9 1/2 x 13 inches
Shark Vs. Zombie

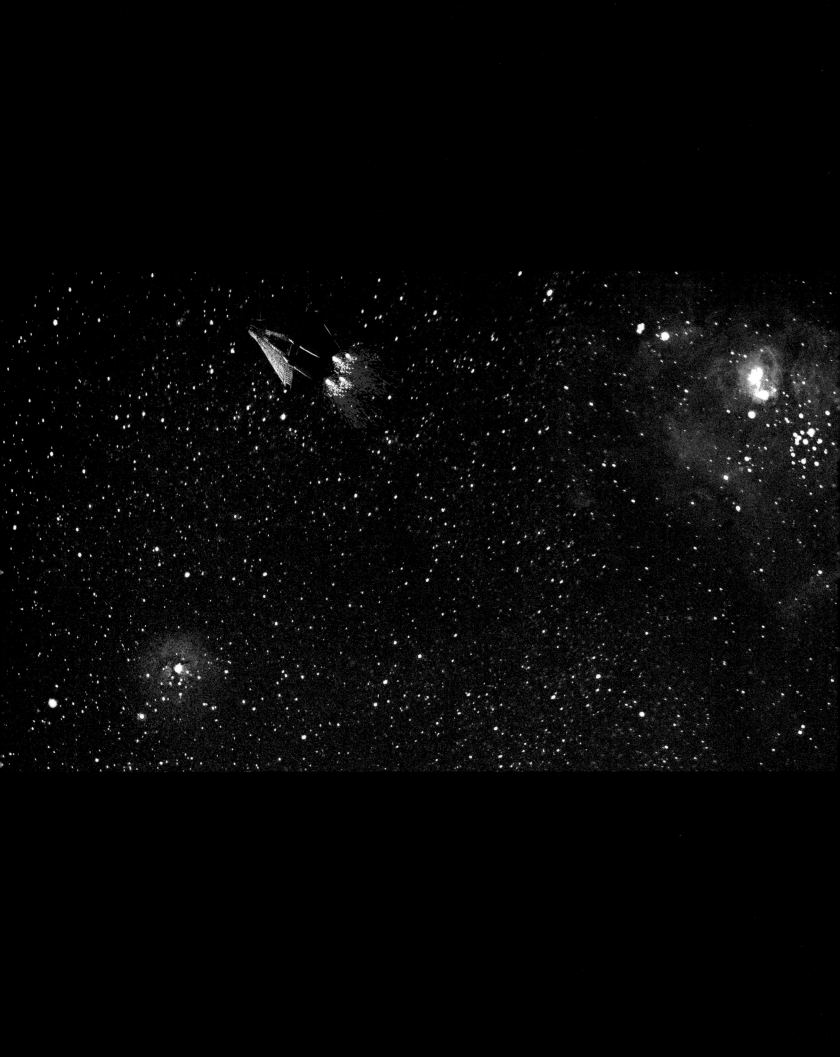

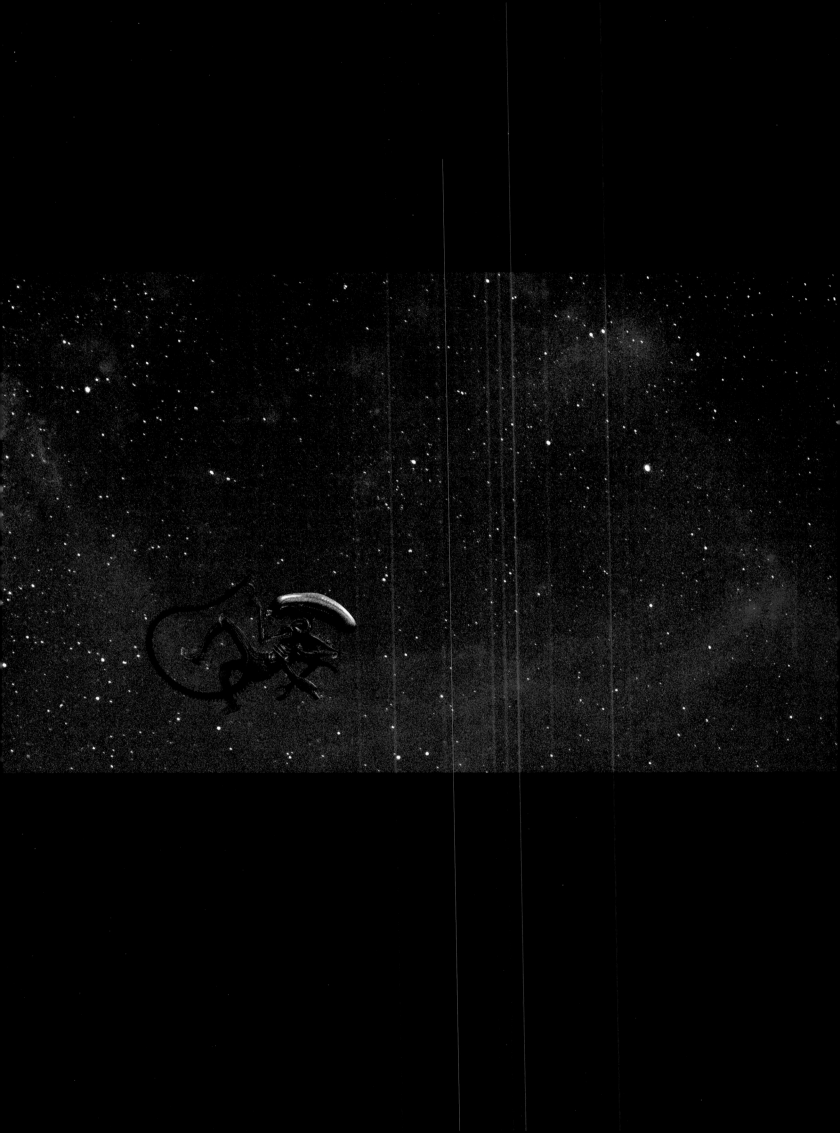

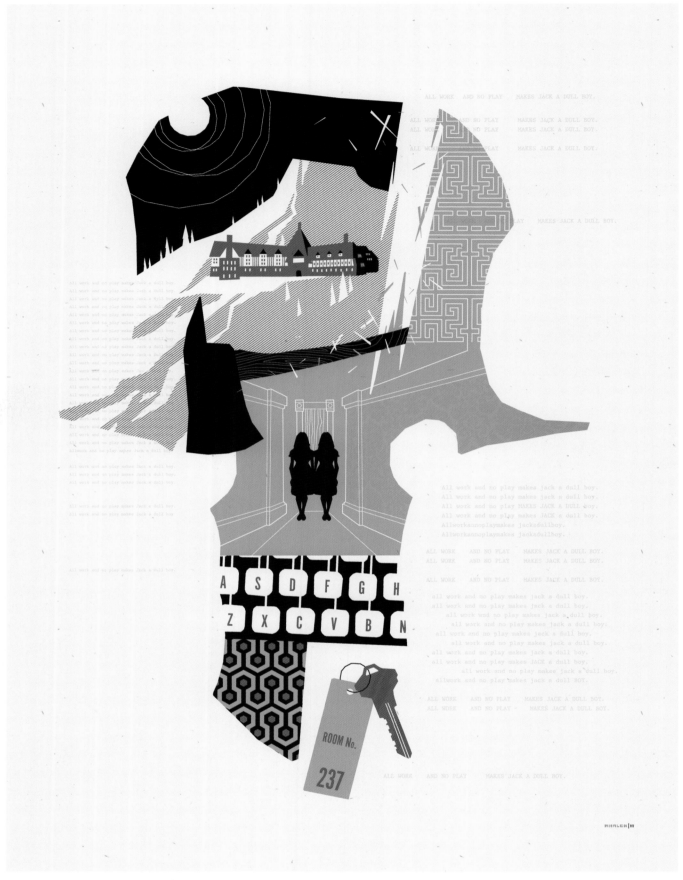

Previous spread :
Mark Englert
'You Are My Lucky Star'
Screenprint, 36 x 12 inches
Alien

Above :
Tom Whalen
'Room 237'
Screenprint, 17 x 22 1/2 inches
The Shining

Right:
N.C. Winters
'Descent Into Madness'
acrylic ink on paper, mounted to
wood panel, resined
13 1/4 x 14 1/4 inches
The Shining

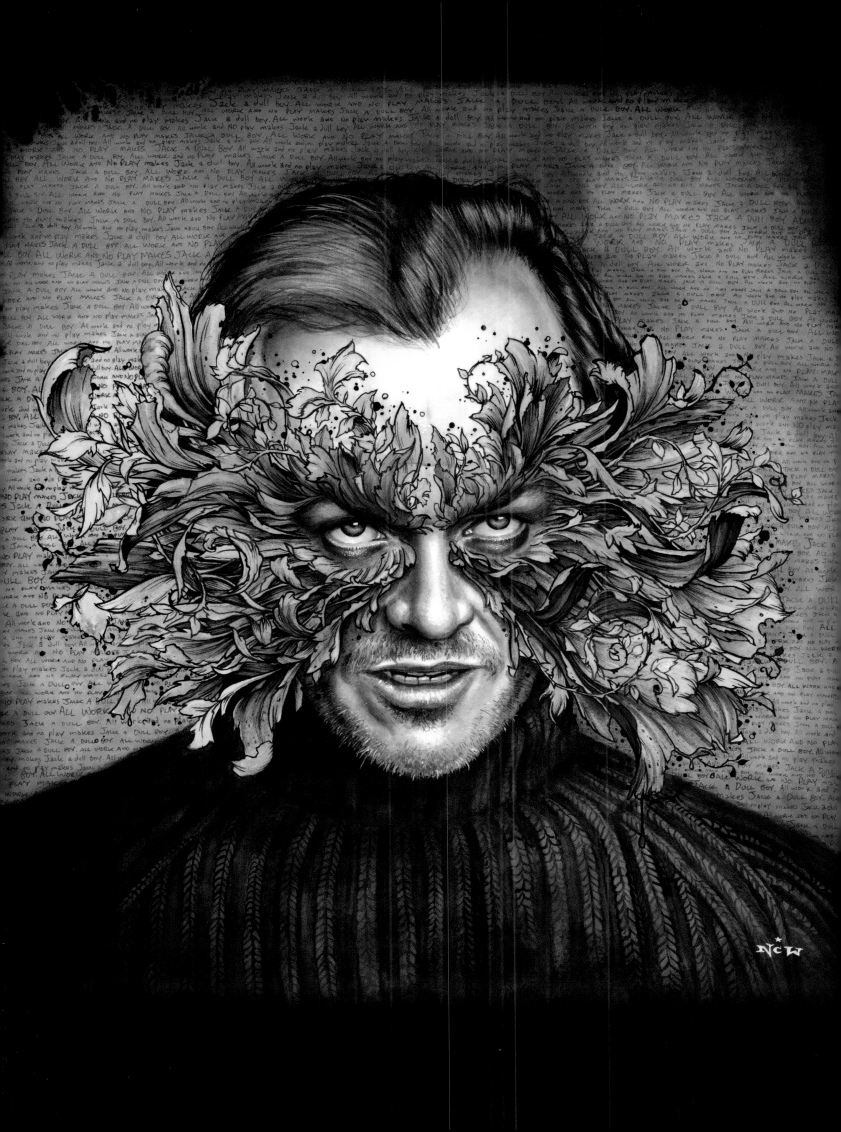

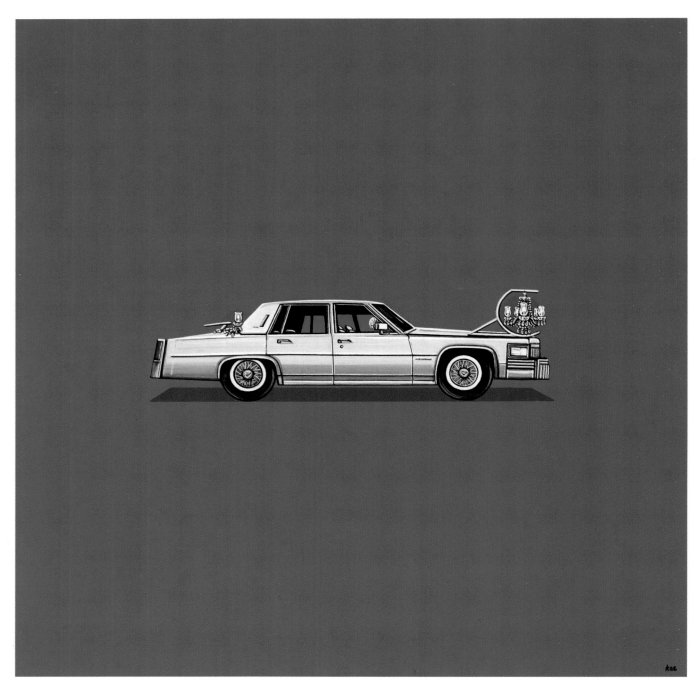

Above:
Kiersten Essenpreis
'The Duke Arrives'
Flashe Paint on Wood,
Sealed in Resin
18 x 18 inches
Escape From New York

Right:
Adam Limbert
'I Escaped NY'
Giclee print on archival
watercolor paper
11 x 17 inches
Escape From New York

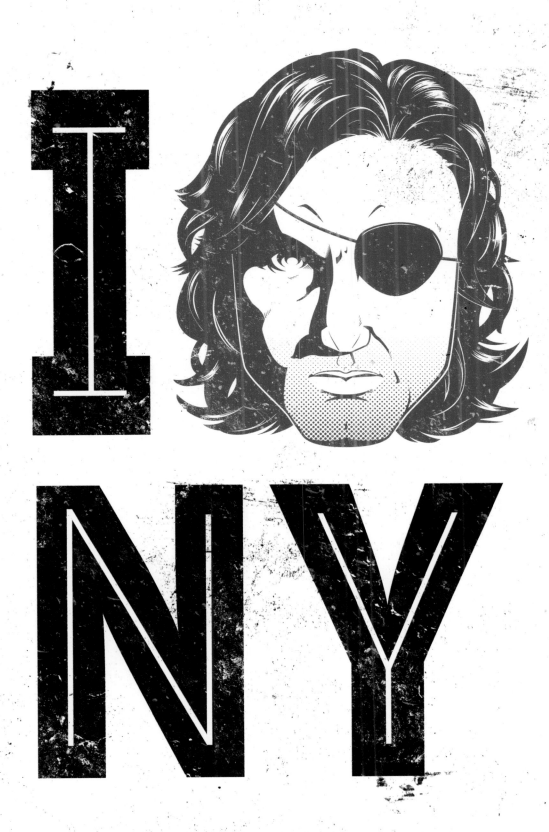

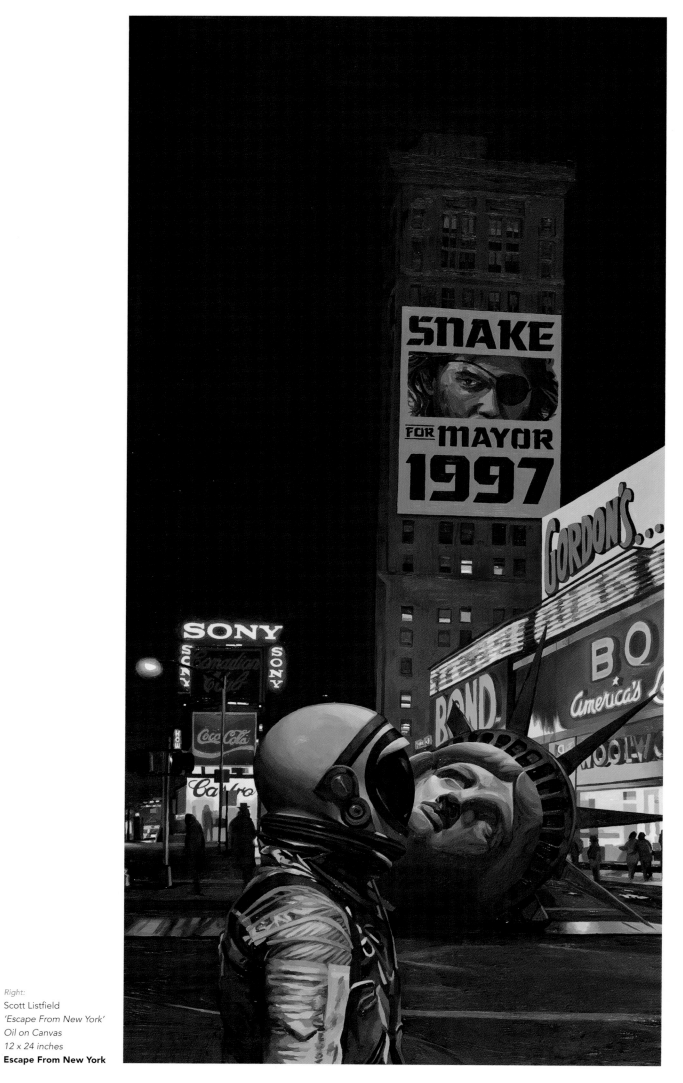

Left
Patrick Awa
'Dolls Fall'
Watercolor, Acrylic on
Watercolor Paper
12 x 22 inches
Blade Runner

Above and right:
Chris Sanchez
'Necronomicon Ex-Mortis (diptych)'
Mixed Media, 23 x 16 inches
The Evil Dead

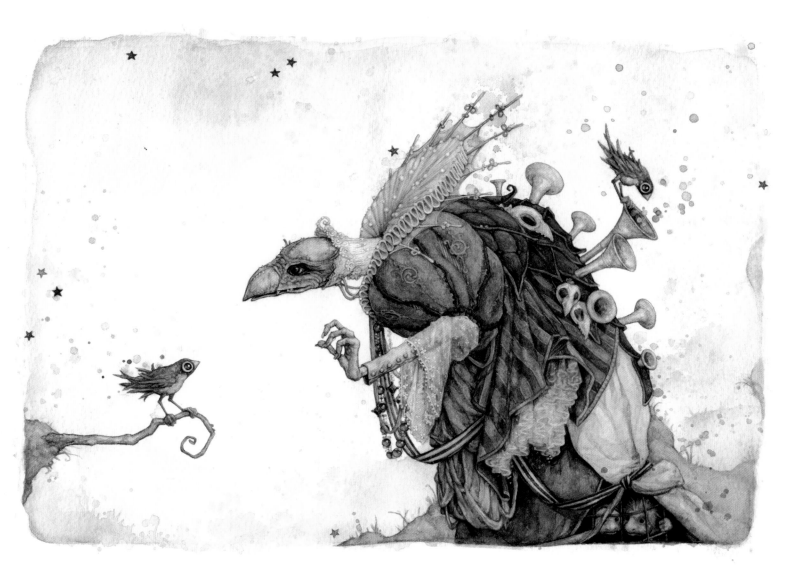

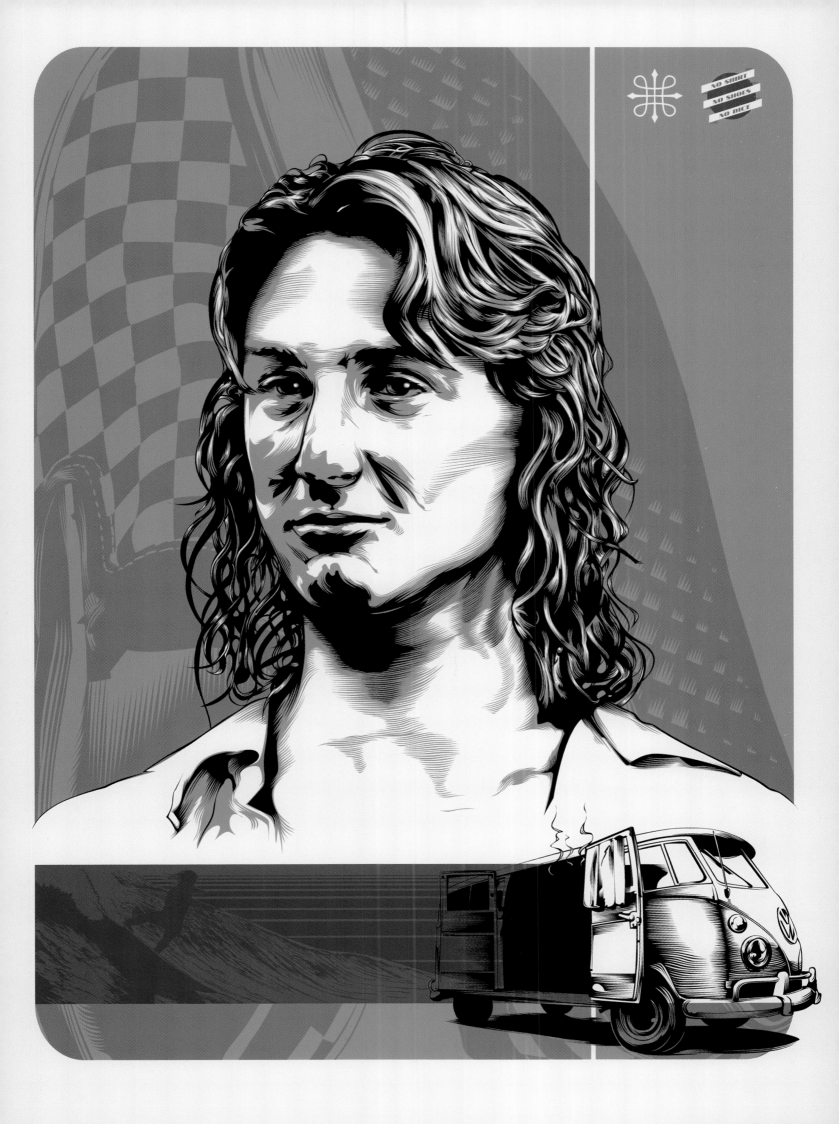

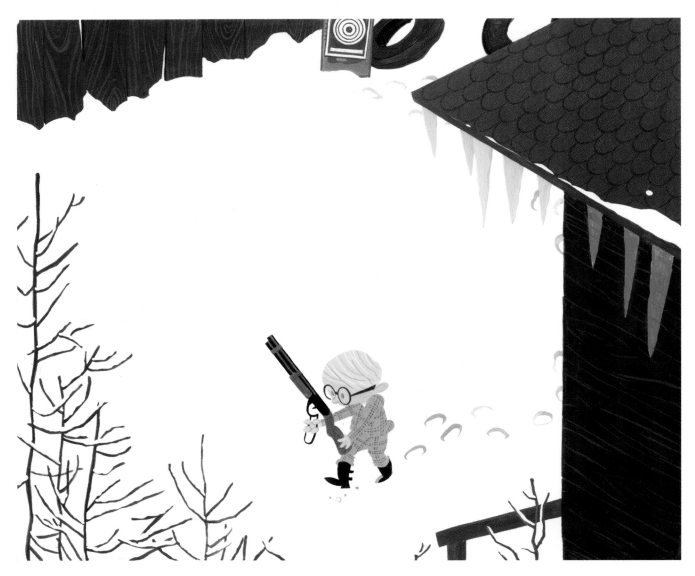

Above:
Israel Sanchez
'Christmas Morning'
Gouache On Watercolor Paper, 10 x 8 inches
A Christmas Story

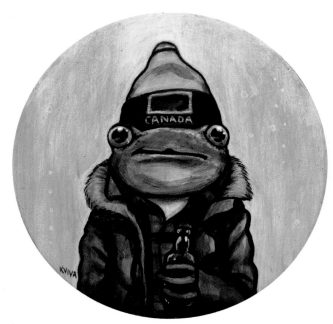
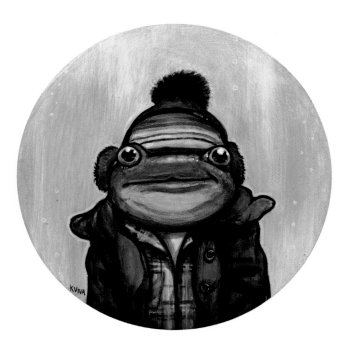

Above:
Kelly Vivanco
'Bob and Doug'
Acrylic on panel, 6 inch diameter
Strange Brew

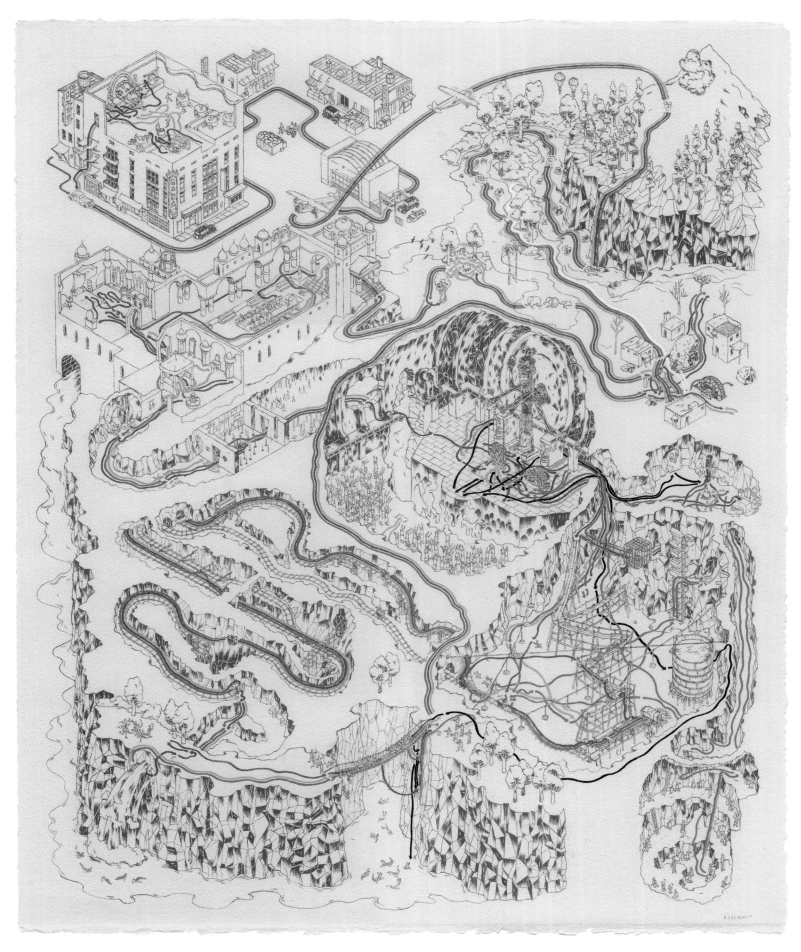

Above:
Andrew DeGraff
'Paths of Doom'
Gouache on paper, 18 1/2 x 22 inches
**Indiana Jones And
The Temple Of Doom**

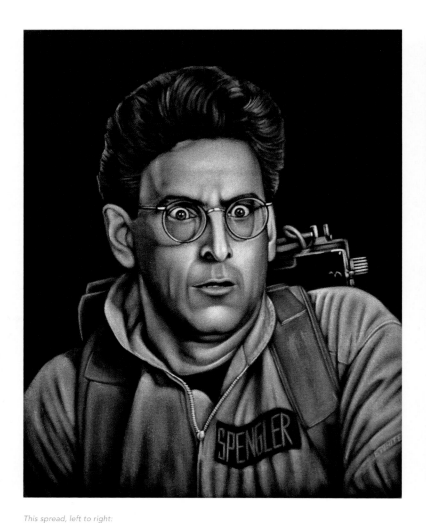
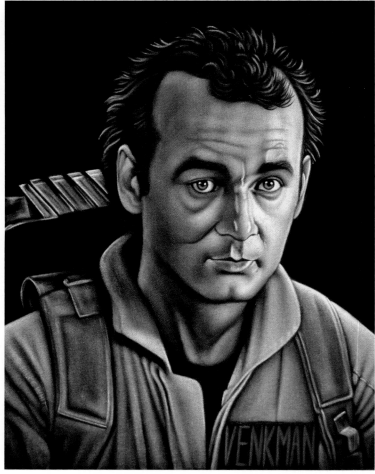

This spread, left to right:
Bruce White
'Egon'
'Venkman'
'Ray'
Acrylic on Velvet, 14 x 18 inches
Ghostbusters

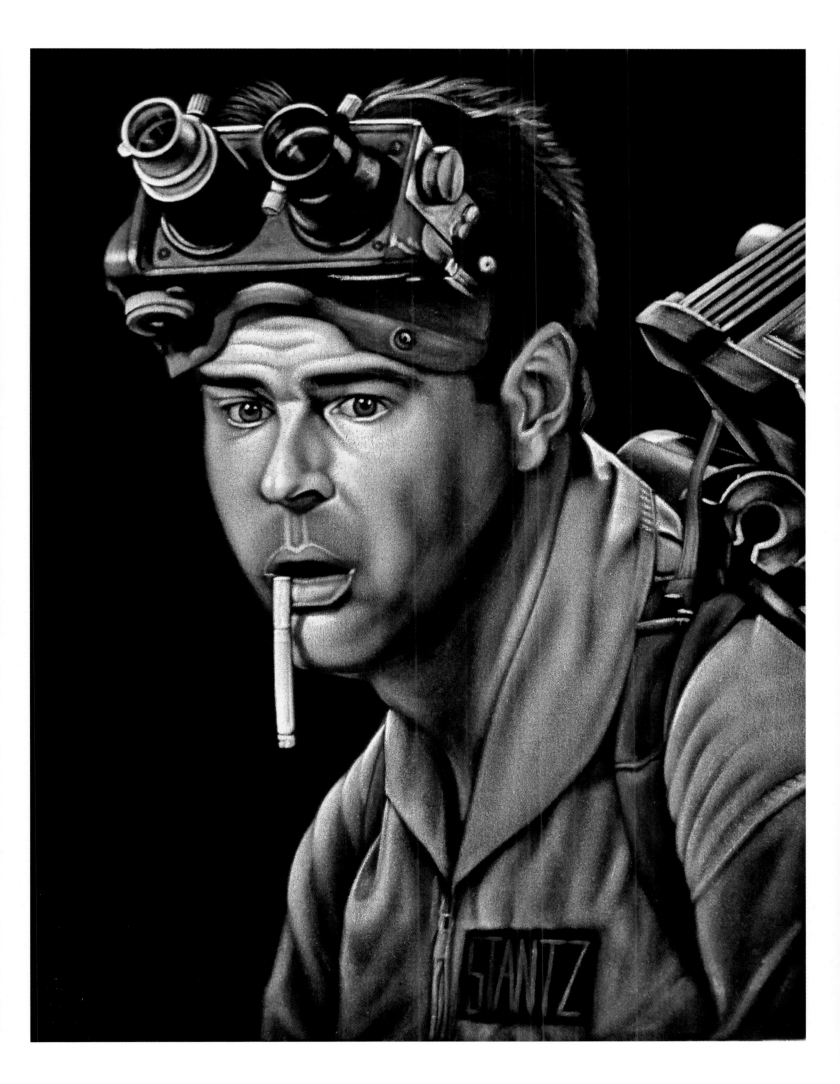

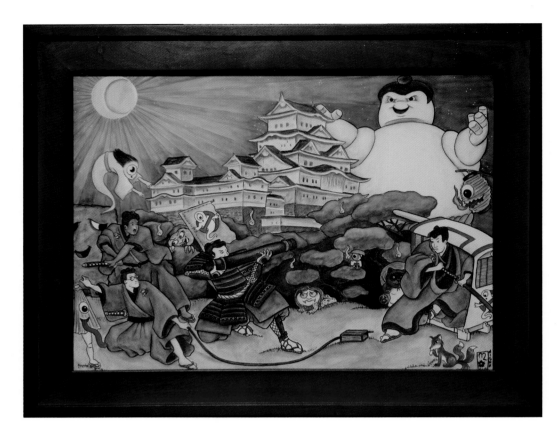

Right:
Misha
'Yokai Busters'
Mixed Media on
Watercolor Board
24 x 18 inches
Ghostbusters

Right:
Chogrin
'No Ghost Drip'
Print on wood
12 x 12 inches
Ghostbusters

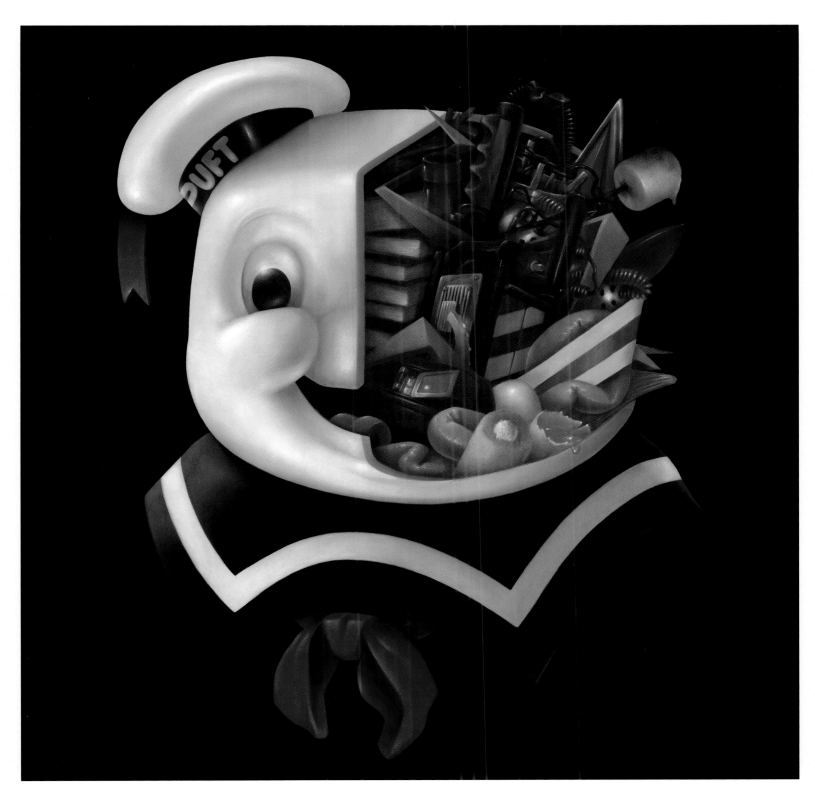

Above:
Bennett Slater
'Terrified Beyond The Capacity For Rational Thought'
Oil on wood
20 x 20 inches
Ghostbusters

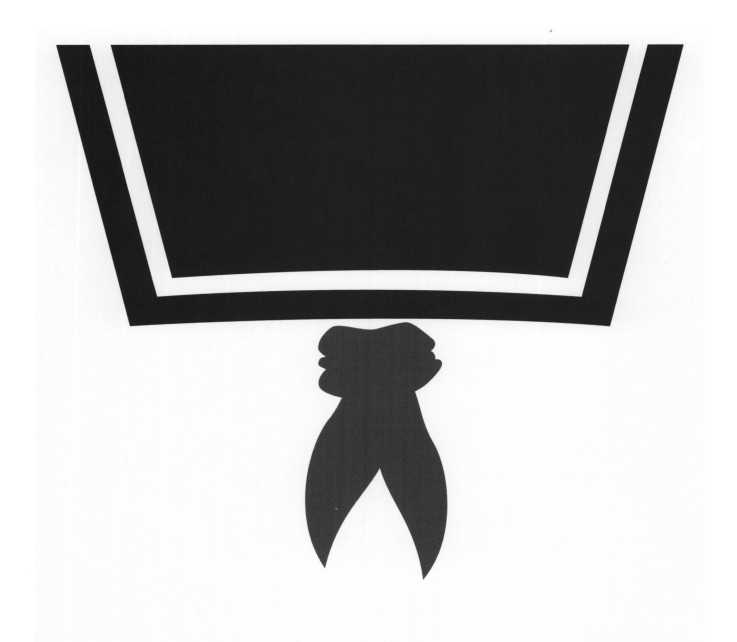

I tried to think of the most harmless thing.

Above:
Matt Owen
'The Destructor'
Screenprint
18 x 24 inches
Ghostbusters

Right:
Stanley Chow
'Derek, Nigel & David'
Giclee Print
11 3/4 x 16 3/4 inches
This Is Spinal Tap

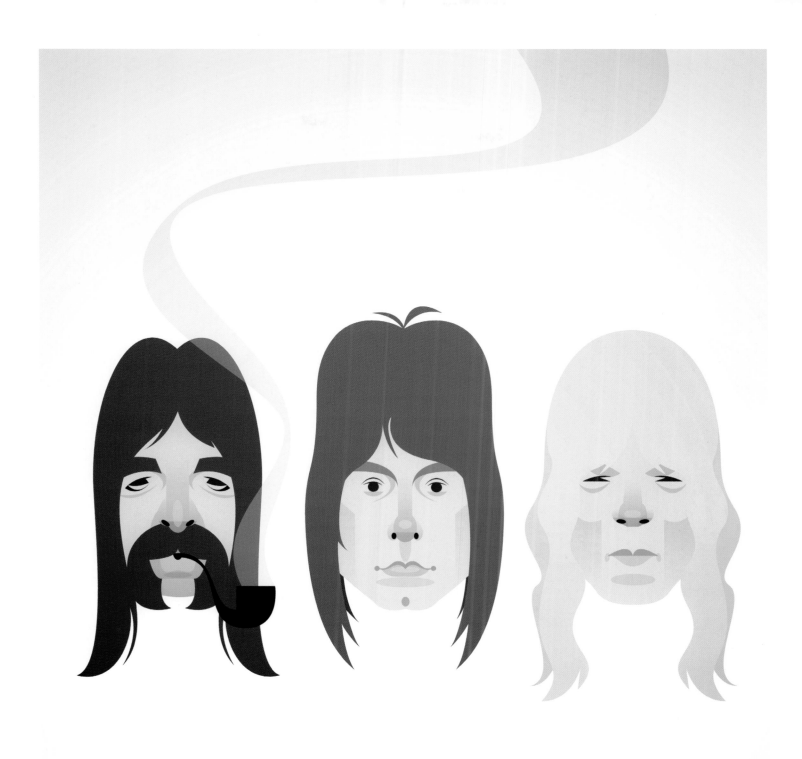

Derek, Nigel & David

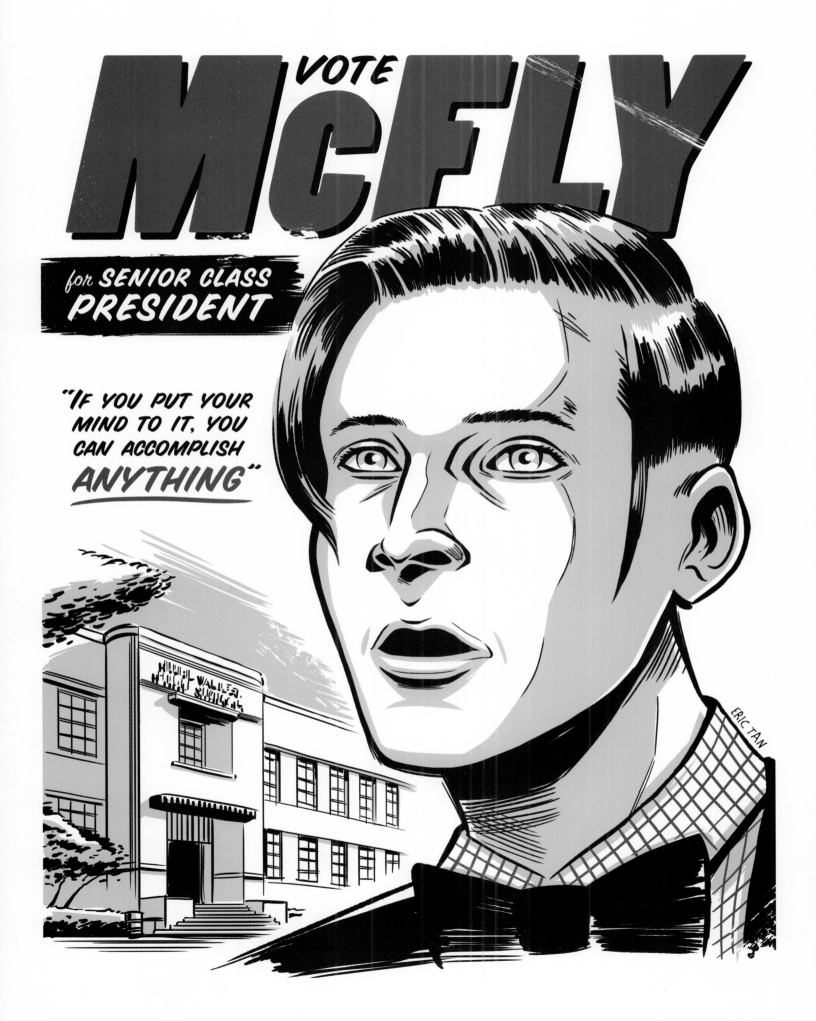

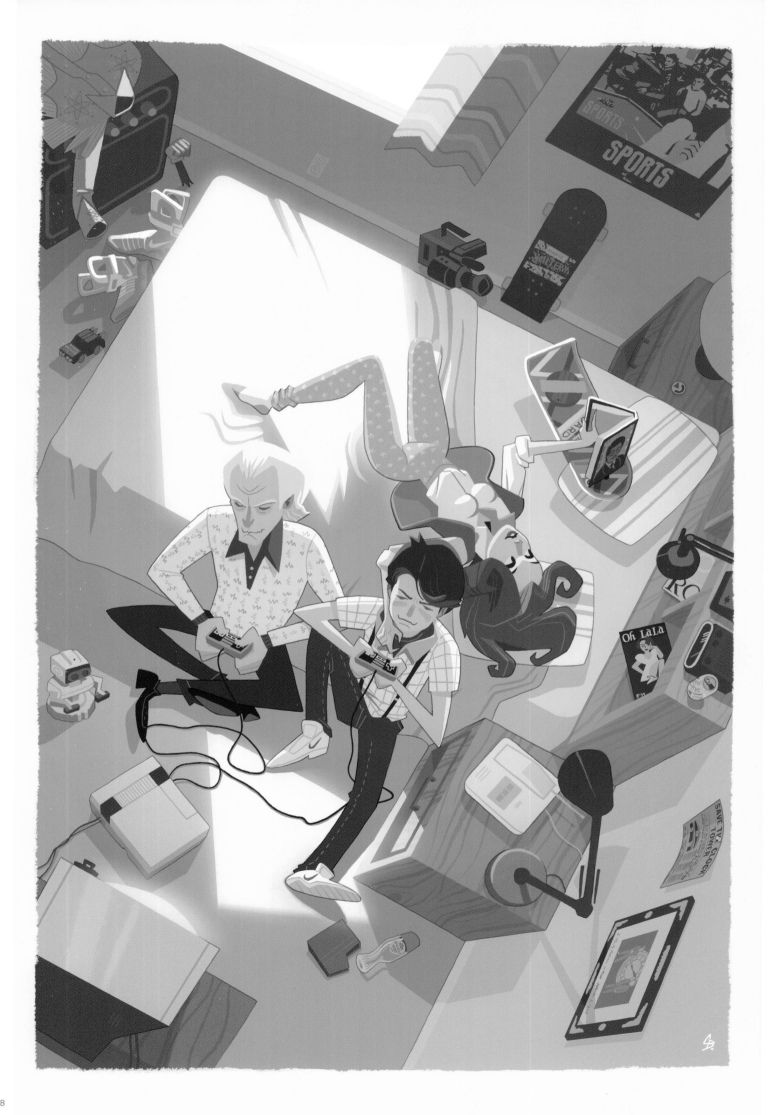

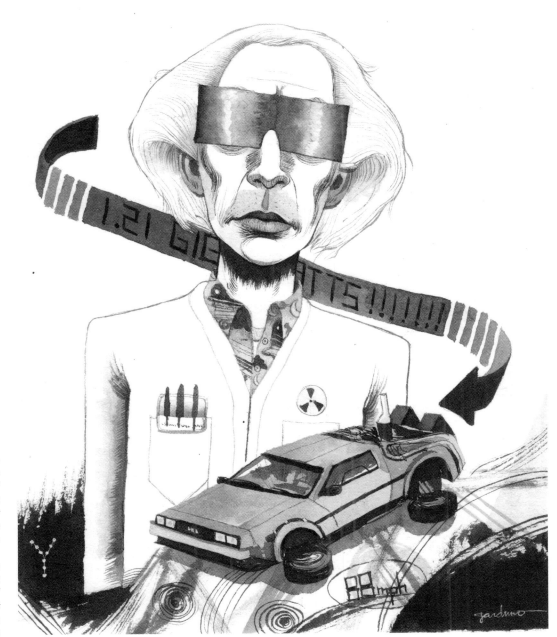

Right:
Ken Garduno
'Doc Brown'
Acrylic, ink and wash on
watercolor paper
8 x 10 inches
Back To The Future

Left:
Glen Brogan
'Marty's Room'
Digital Print
11 x 17 inches
Back To The Future

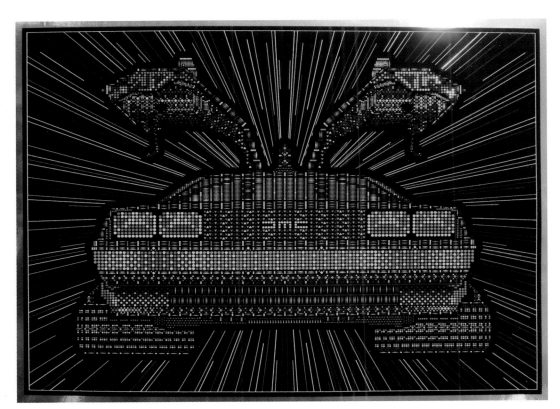

Right:
Todd Slater
'No Roads'
Screenprint on Foil
Hologram Paper
24 x 18 inches
Back To The Future

Following spread:
Fernando Reza
'Time Trials'
Giclee print on canvas
23 x 36 inches
Various

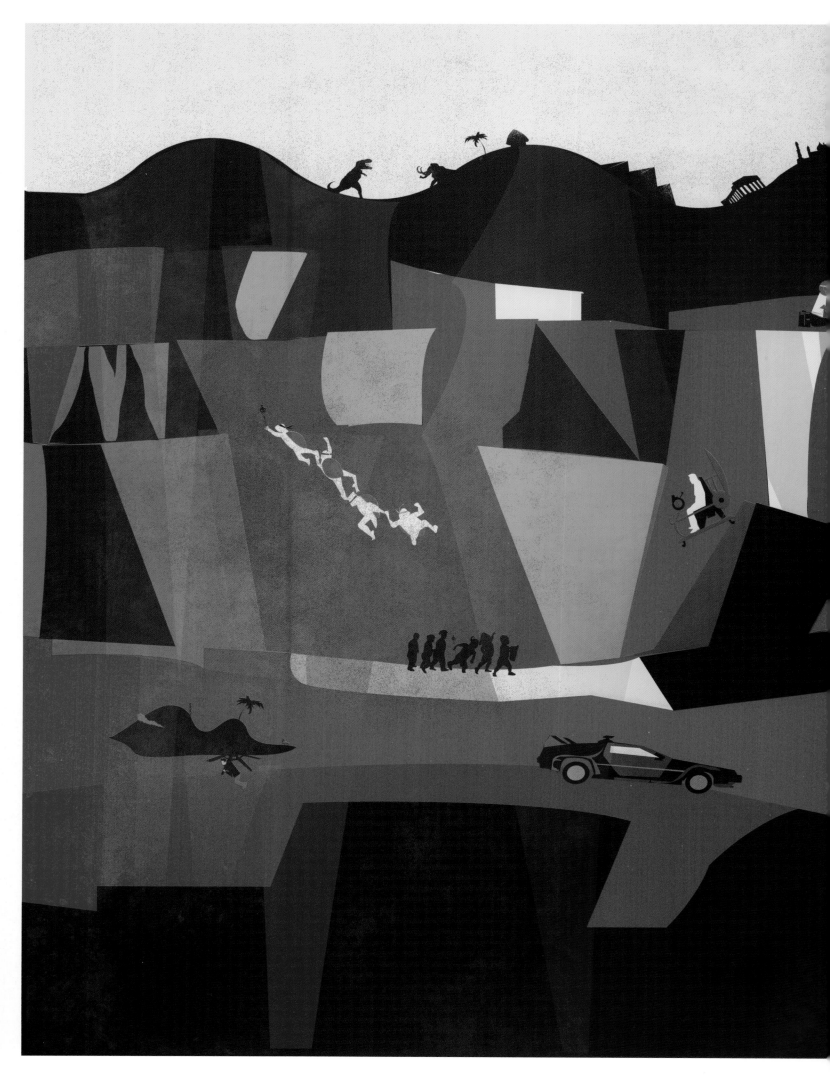

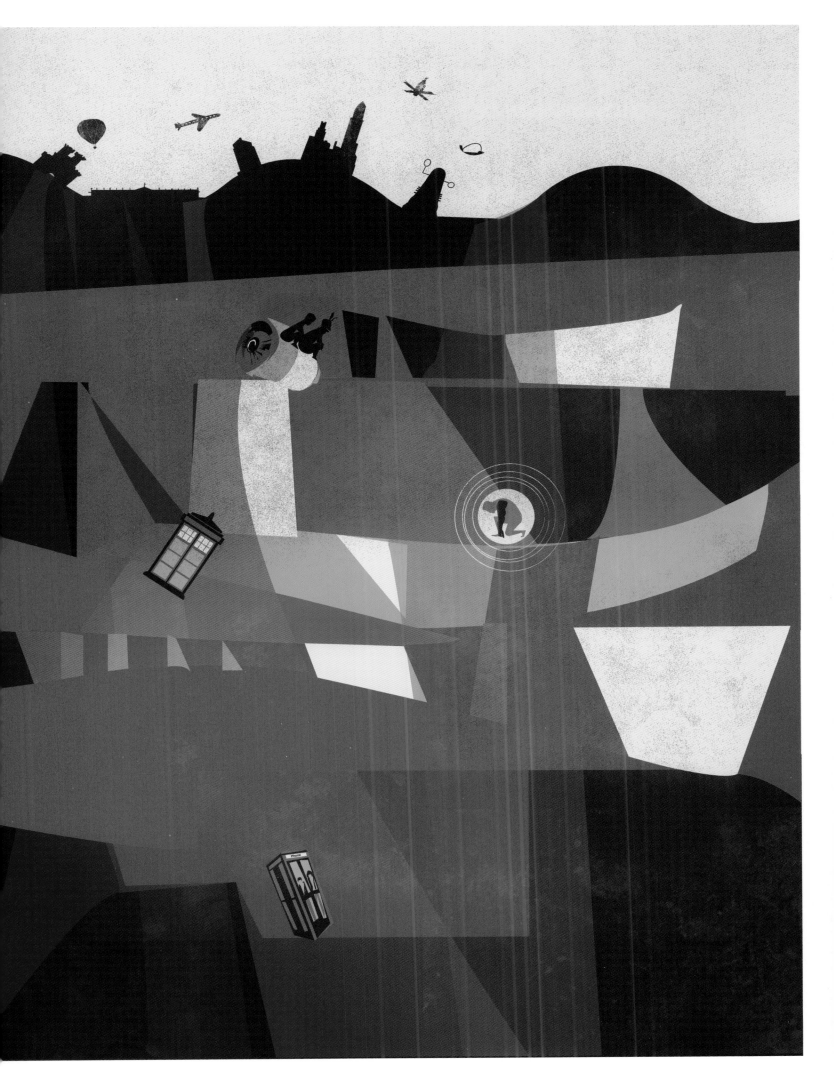

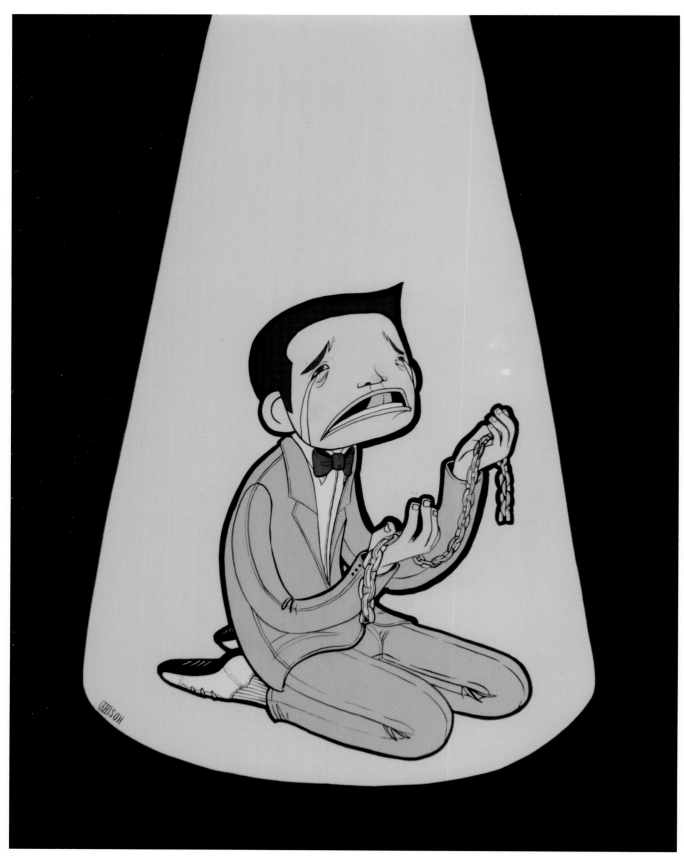

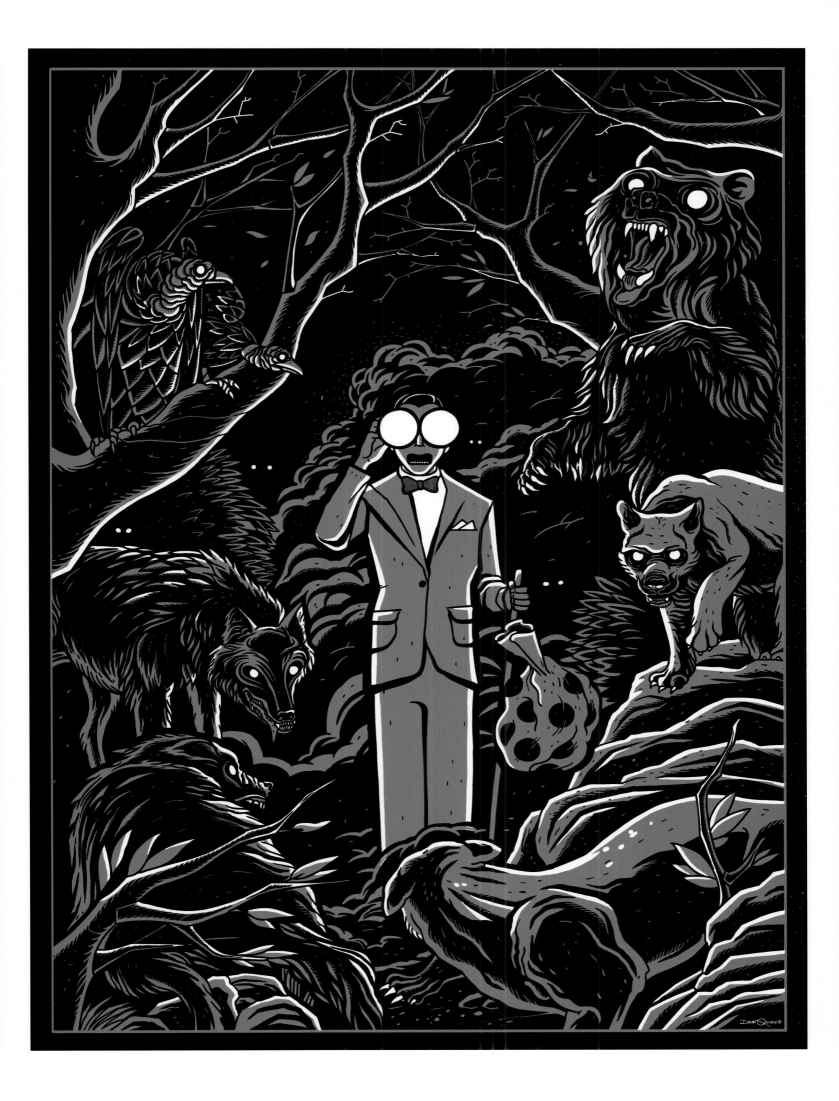

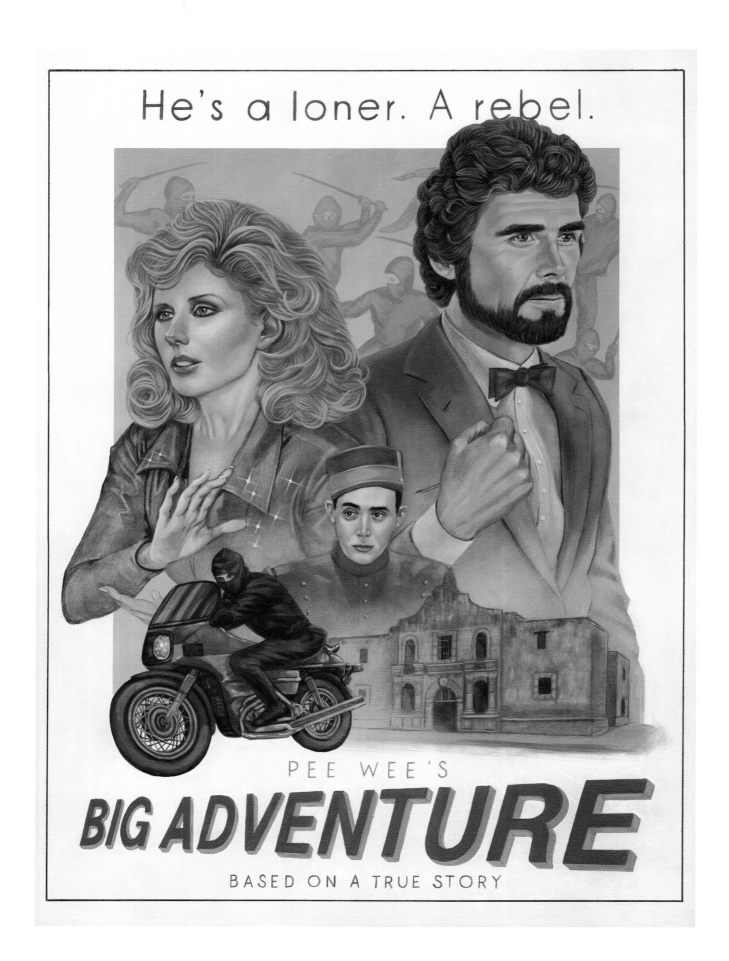

Above:
Casey Weldon
'PW Herman'
Acrylic on Wood, 18 x 24 inches
Pee-wee's Big Adventure

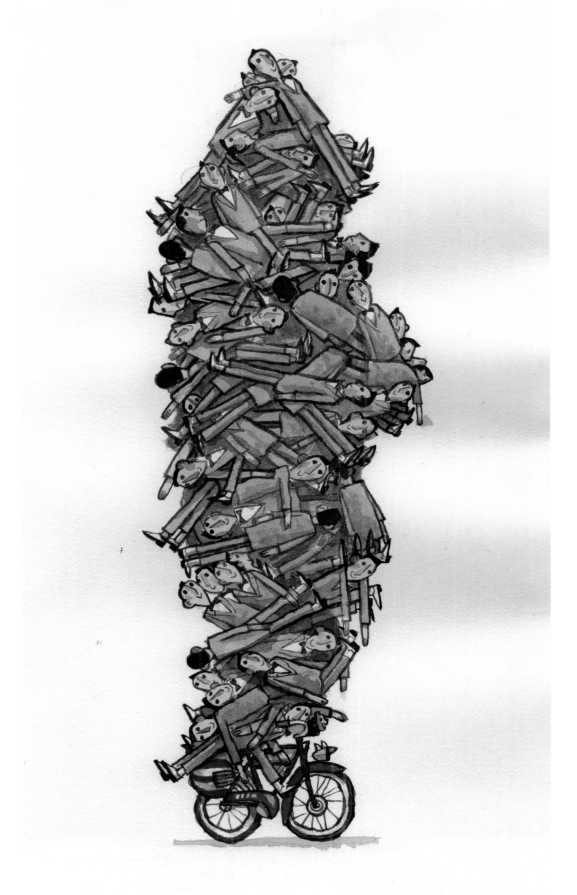

Scottc.

Right:
Scott Campbell
'PileOfPeeWees'
Watercolor on paper
10 x 20 inches
Pee-wee's Big Adventure

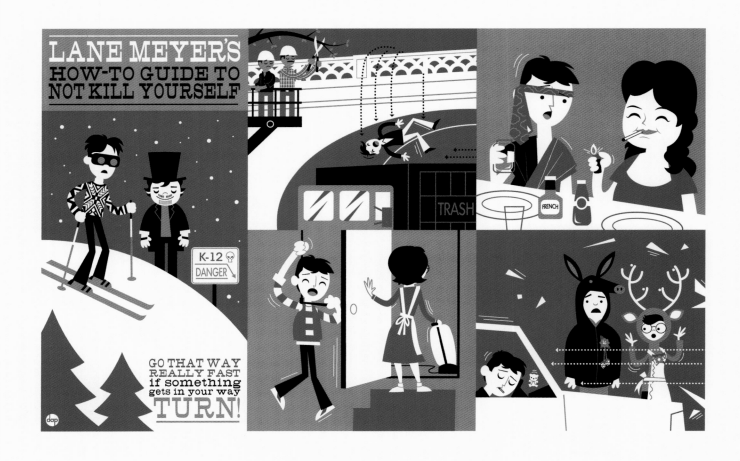

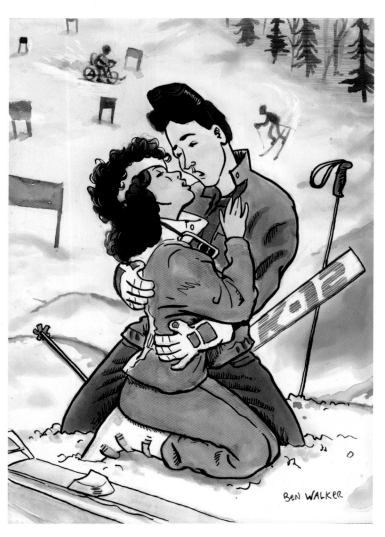

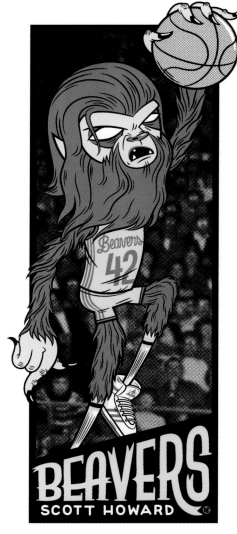

Above:
Dave Perillo
'Go That Way Really Fast...'
Screenprint
18 x 12 inches
Better Off Dead

Left:
Ben Walker
'Language Lessons'
Watercolor and Ink on Clayboard
5 x 7 inches
Better Off Dead

Right:
Nic Cowan
Scott Howard #42
4 color screenprint
8 x 18 inches
Teen Wolf

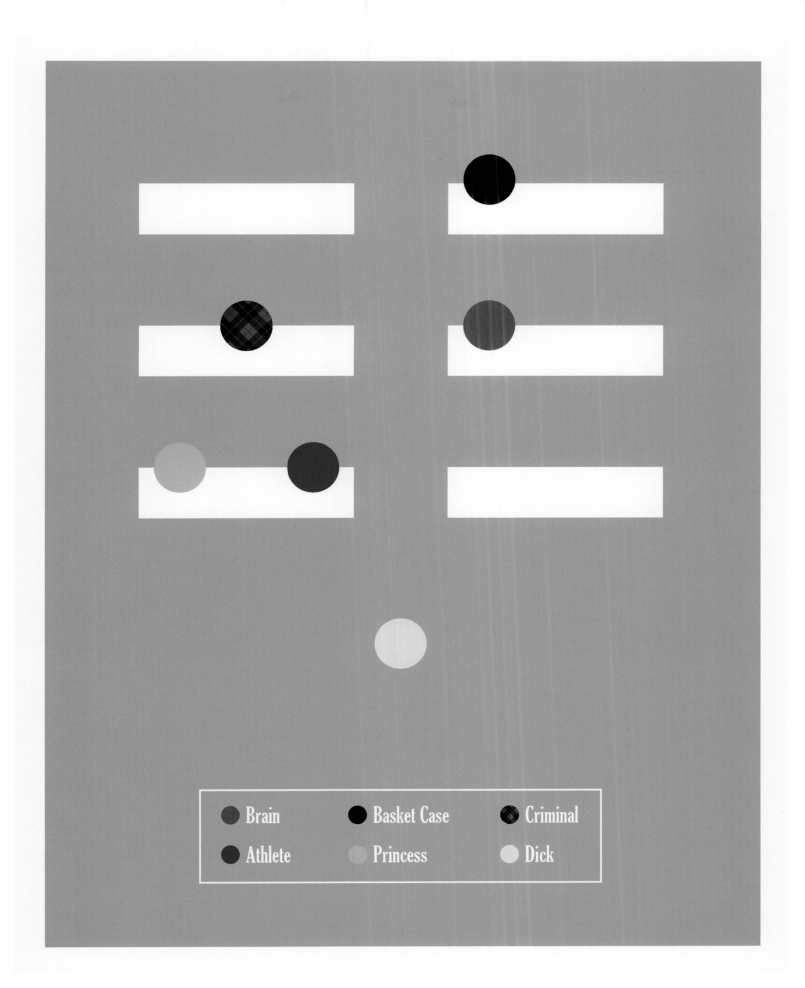

Above:
Matt Owen
'Detention'
Screenprint, 18 x 24 inches
The Breakfast Club

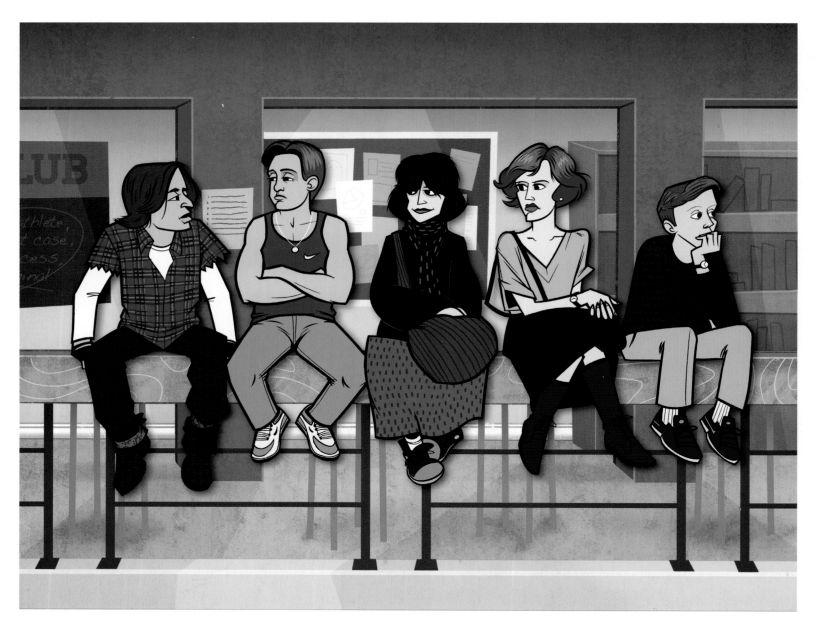

Above:
Justin White
'Saturday Morning'
Mixed media animation cell
20 x 16 inches
The Breakfast Club

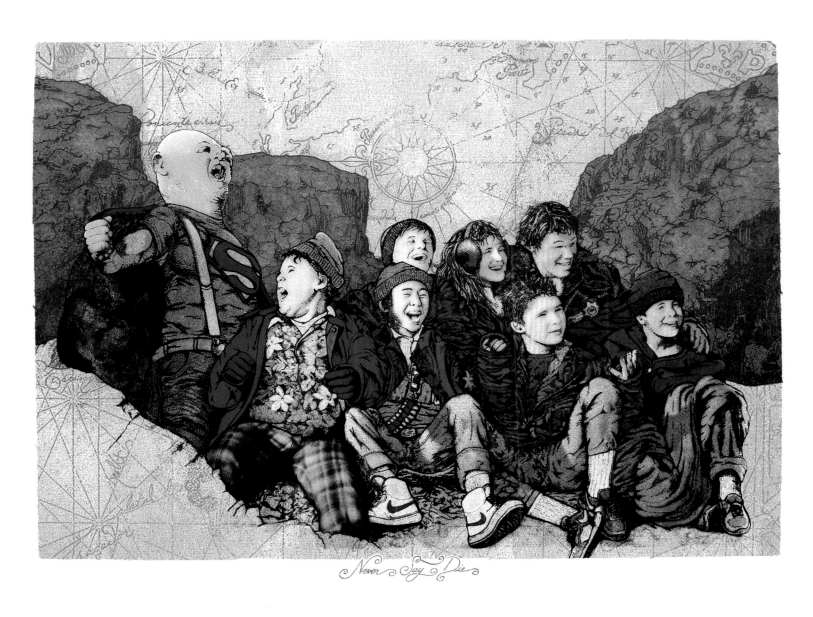

Above:
Monkey Ink Design
'Never Say Die'
Screenprint
24 x 18 inches
The Goonies

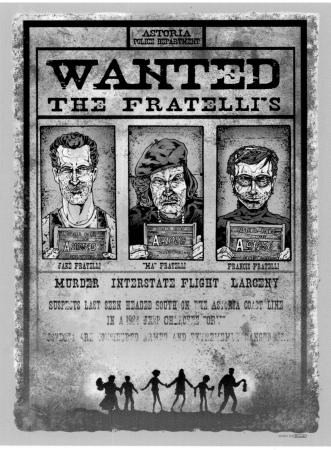

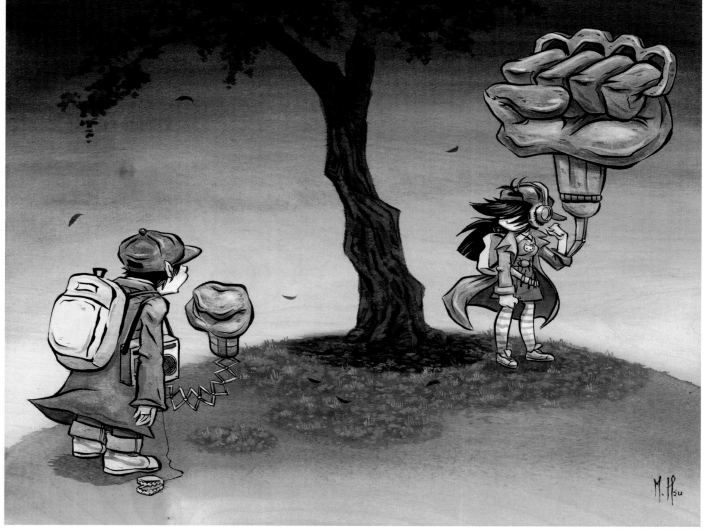

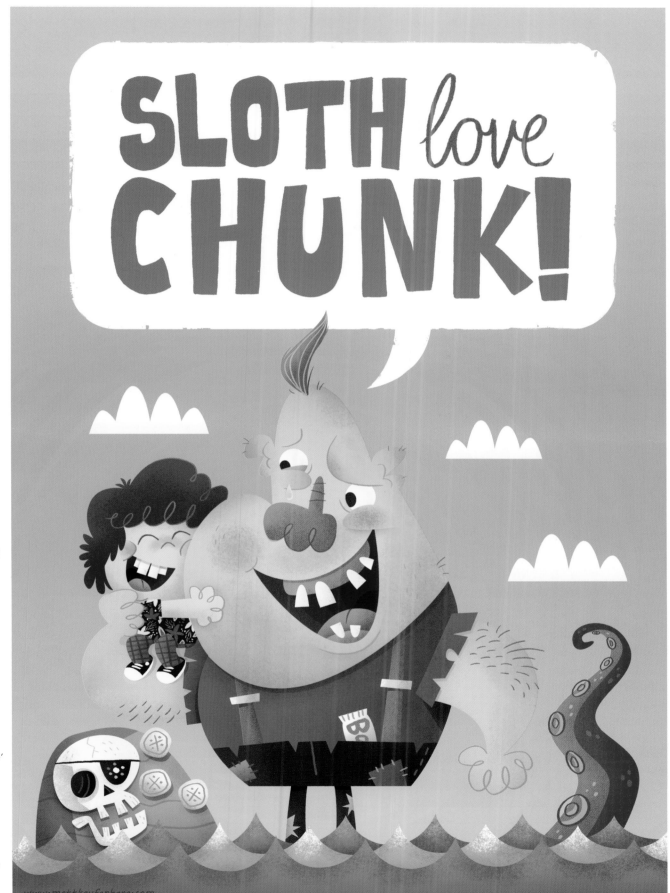

Opposite, top left:
Eric Braddock
'The First Goonie'
Pencil, white charcoal
and pastel on paper
18 x 24 inches
The Goonies

Opposite, top right:
Charles Moran
'Suspects At Large'
4 color silkscreen
19 x 25 inches
The Goonies

Left:
Martin Hsu
'When Data Met Byte'
Cel vinyl on wood
19 x 16 inches
The Goonies

Right:
Matt Kaufenberg
'Sloth Love Chunk'
Giclee print on Moab
Entrada 300gsm
9 1/2 x 13 inches
The Goonies

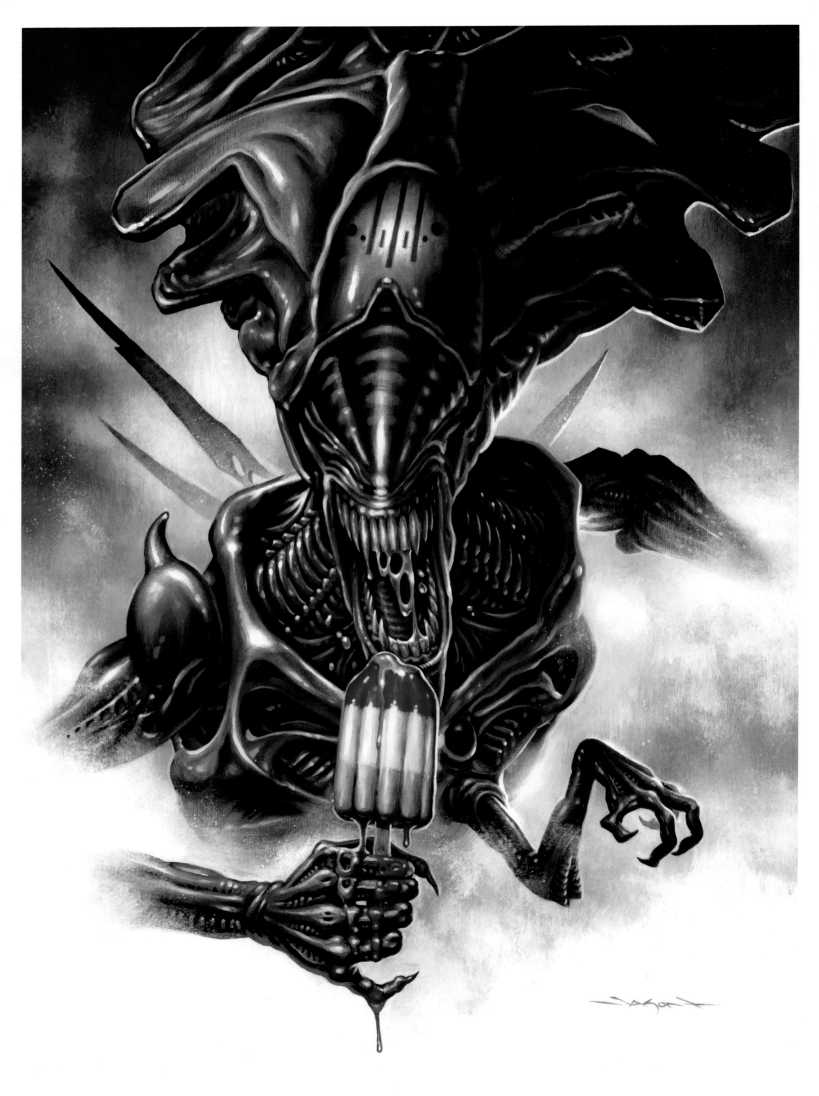

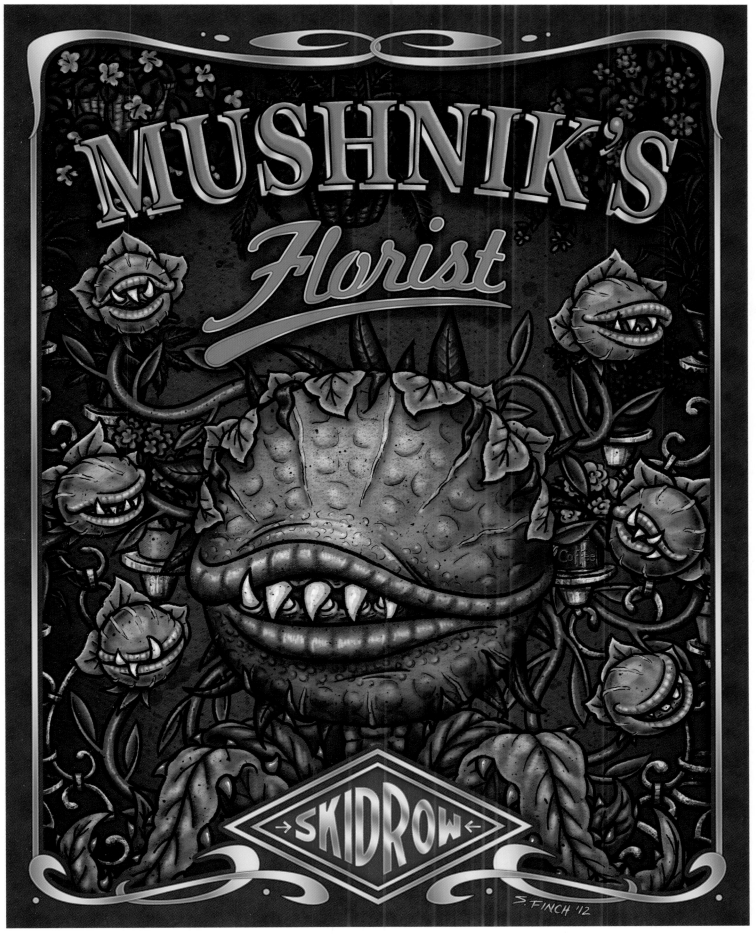

Left:
Jason Edmiston
'Rocket Queen'
Acrylic on wood pane, 16 x 20 inches
Aliens

Above:
Shannon Finch
'Mushnik's Florist'
Giclee Print, 11 x 14 inches
Little Shop Of Horrors

73

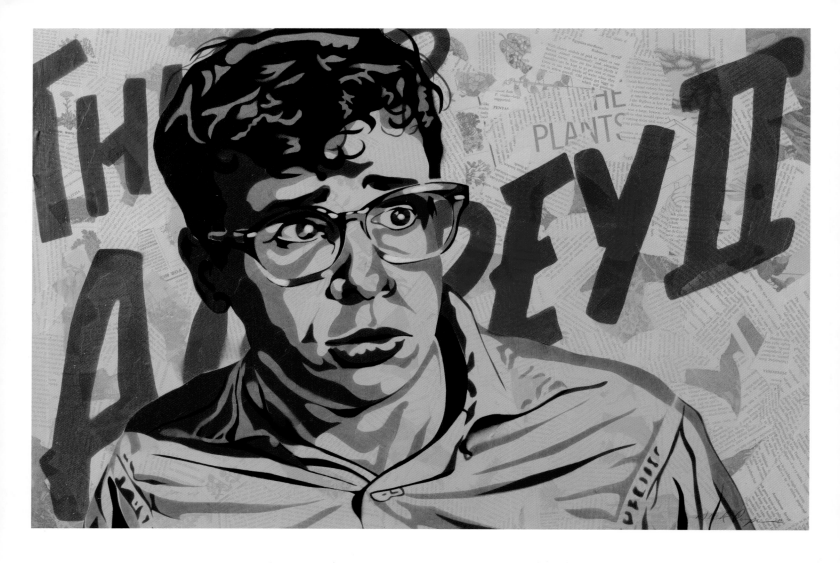

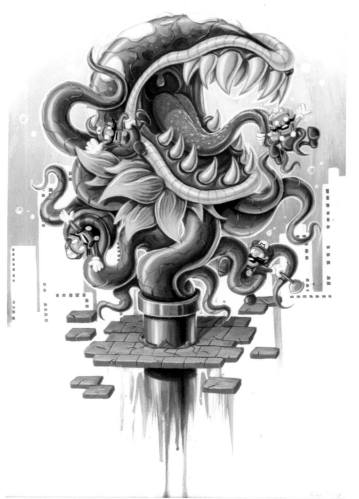

Above:
Nick Comparone
'I Call It An Audrey II'
Spray Paint and Collage on Canvas
20 x 30 inches
Little Shop Of Horrors

Left:
Brandon Sopinsky
'Attack Of Audrey 2'
Acrylic on Canvas
13 x 19 inches
Little Shop Of Horrors

Right:
Scott Scheidly
'Da Doo Dionaea'
Acrylic on wood
9.5 x 15.5 inches
Little Shop Of Horrors

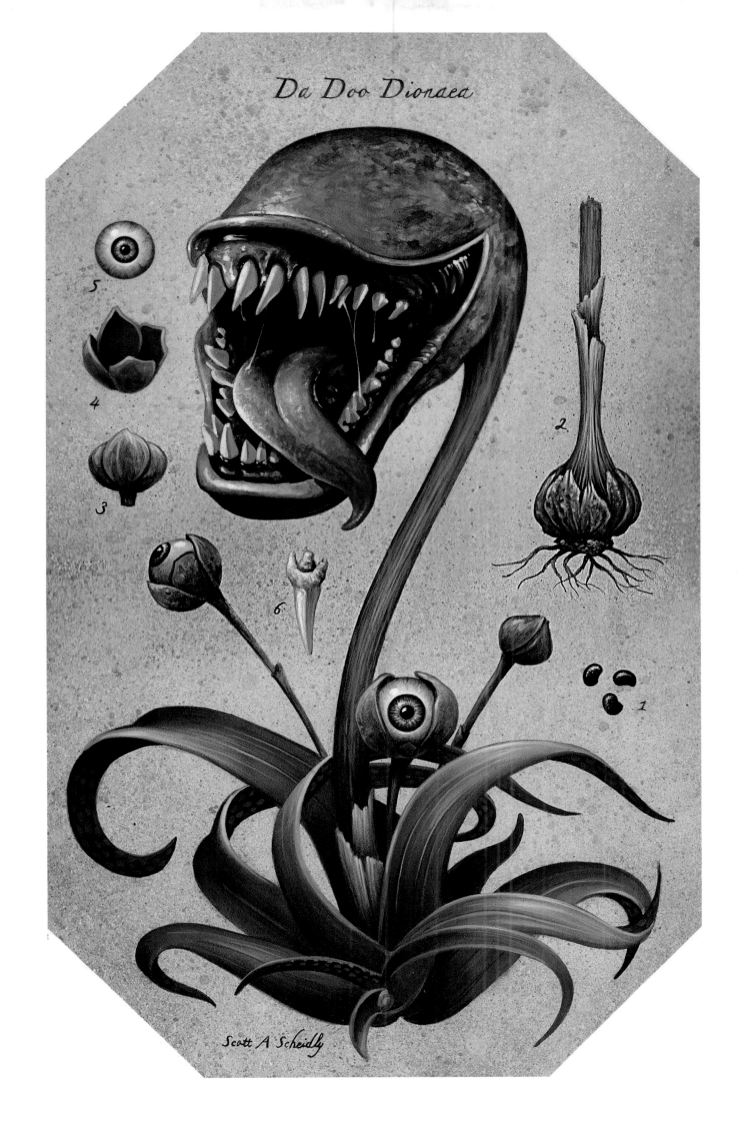

Da Doo Dionaea

Scott A Scheidly

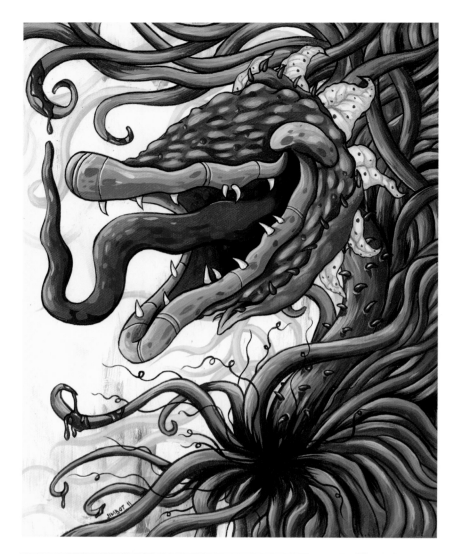

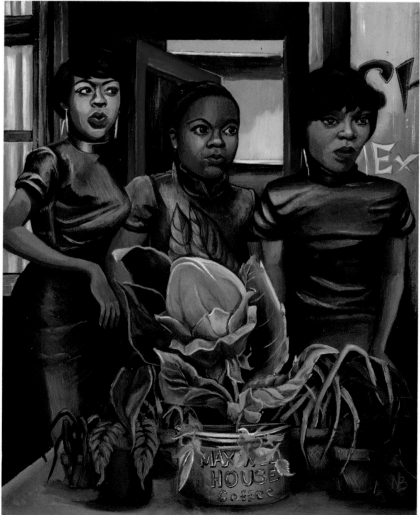

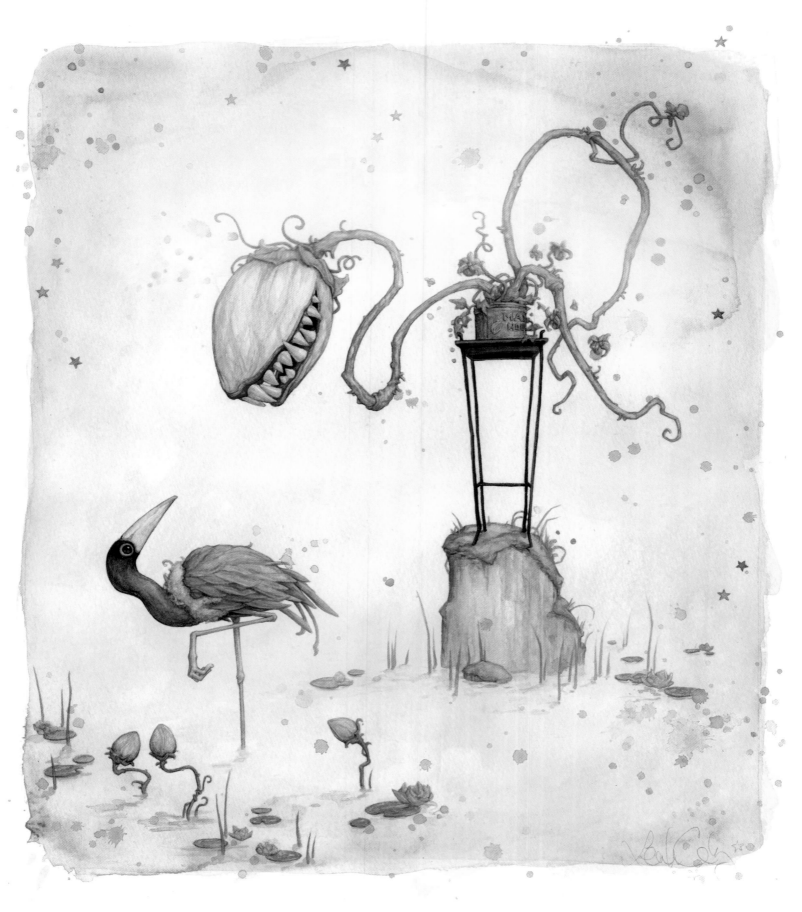

MUSHNIK'S

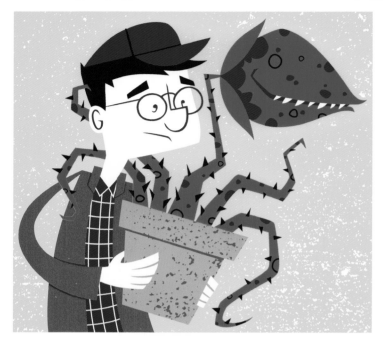

HOME OF THE
AUDREY II

Left:
Doug LaRocca
'Home Of The Audrey II'
Screenprint
11 x 14 inches
Little Shop Of Horrors

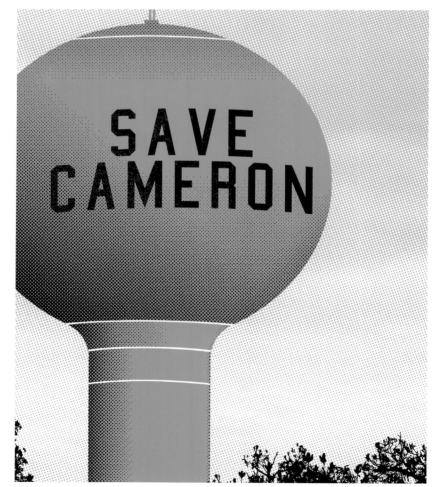

SAVE CAMERON

Left:
Joe Van Wetering
'Save Cameron'
Screenprint
8 x 10 inches
Ferris Bueller's Day Off

Right:
Ian Glaubinger
'Faking Out Parents PSA'
Giclee Print
11 x 14 inches
Ferris Bueller's Day Off

3 KEY STEPS TO
FAKING OUT PARENTS

A lot of people will tell you that a good phony fever is a dead lock, but if you get a nervous mother, you could wind up in a doctor's office. That's worse than school.

1 CLAMMY HANDS

It's a good non-specific symptom.

2 FAKE A STOMACH CRAMP

When you're bent over, don't forget moaning and wailing.

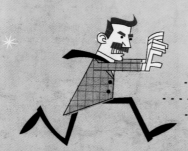
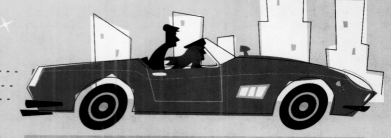

3 LICK YOUR PALMS

It's a little childish and stupid, but then, so is high school.

"3 Key Steps to Faking Out Parents" is brought to you in part by the Save Ferris Commission of Chicago, IL

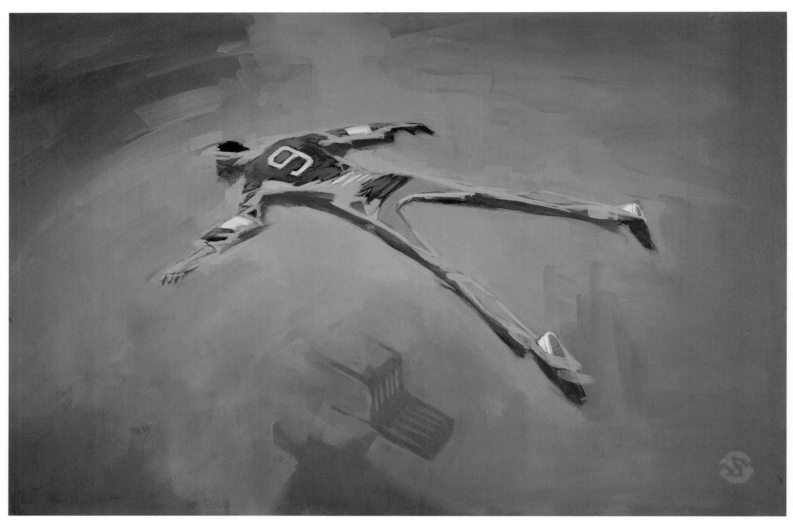

Above:
Sean Clarity
'When Ferris Was Banging Sloan'
Acrylic on Board
18 x 12 inches
Ferris Bueller's Day Off

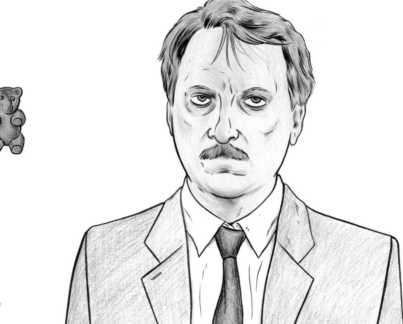

Right:
Paul Hornschemeir
'The Spoils of War'
India Ink and Colored Pencil
on Bristol board
20 3/4 x 16 3/4 inches
Ferris Bueller's Day Off

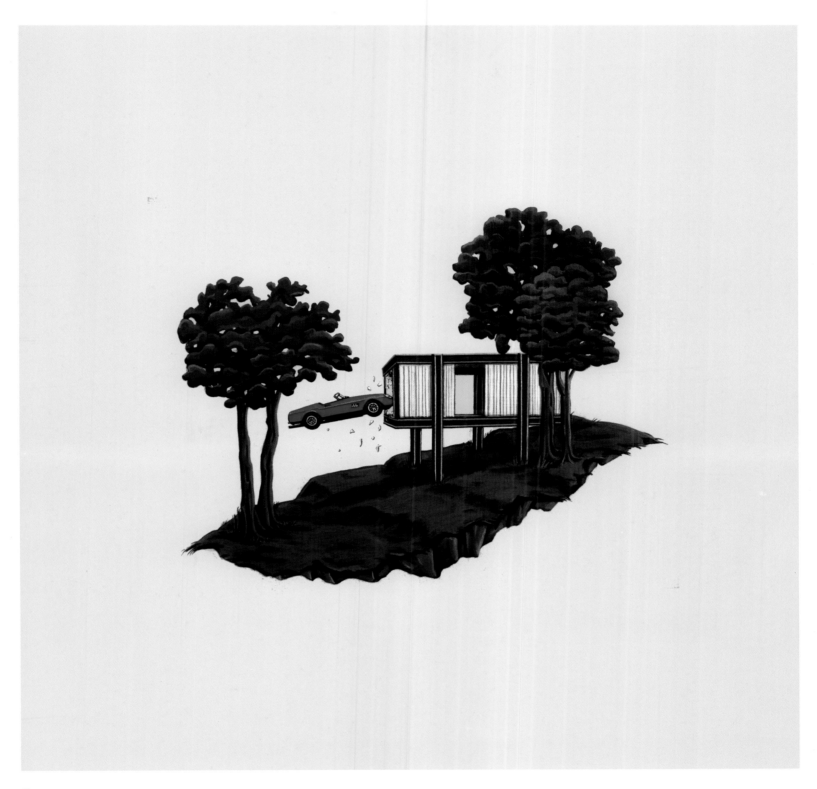

Above:
Kiersten Essenpreis
'I Gotta Take a Stand'
Flashe Paint on Wood, Sealed in Resin
13 x 13 inches
Ferris Bueller's Day Off

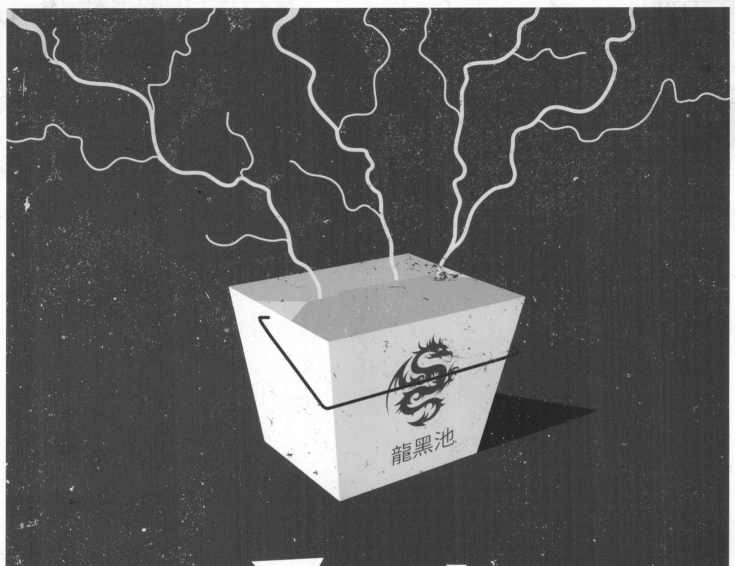

Above:
Adam Limbert
'I Was Born Ready'
Digital print on archival paper, 16 x 20 inches
Big Trouble In Little China

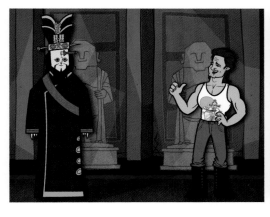 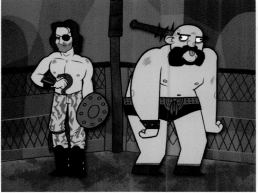 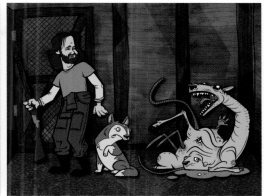

Above, left to right:
Justin White
'Its All in the Reflexes'
'When I Get Back I'm Going to Kill You'
'It's Weird and Pissed Off'
Mixed media animation cels, 16 x 20 inches
Big Trouble In Little China / Escape From New York / The Thing

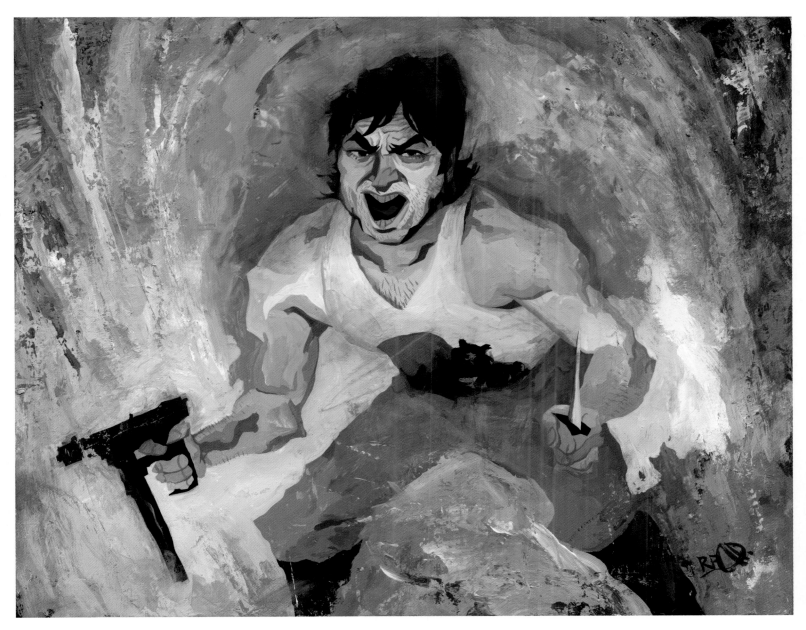

Above:
Rich Pellegrino
'Gimme Your Best Shot, Pal'
Acrylic on panel, 14 x 11 inches
Big Trouble In Little China

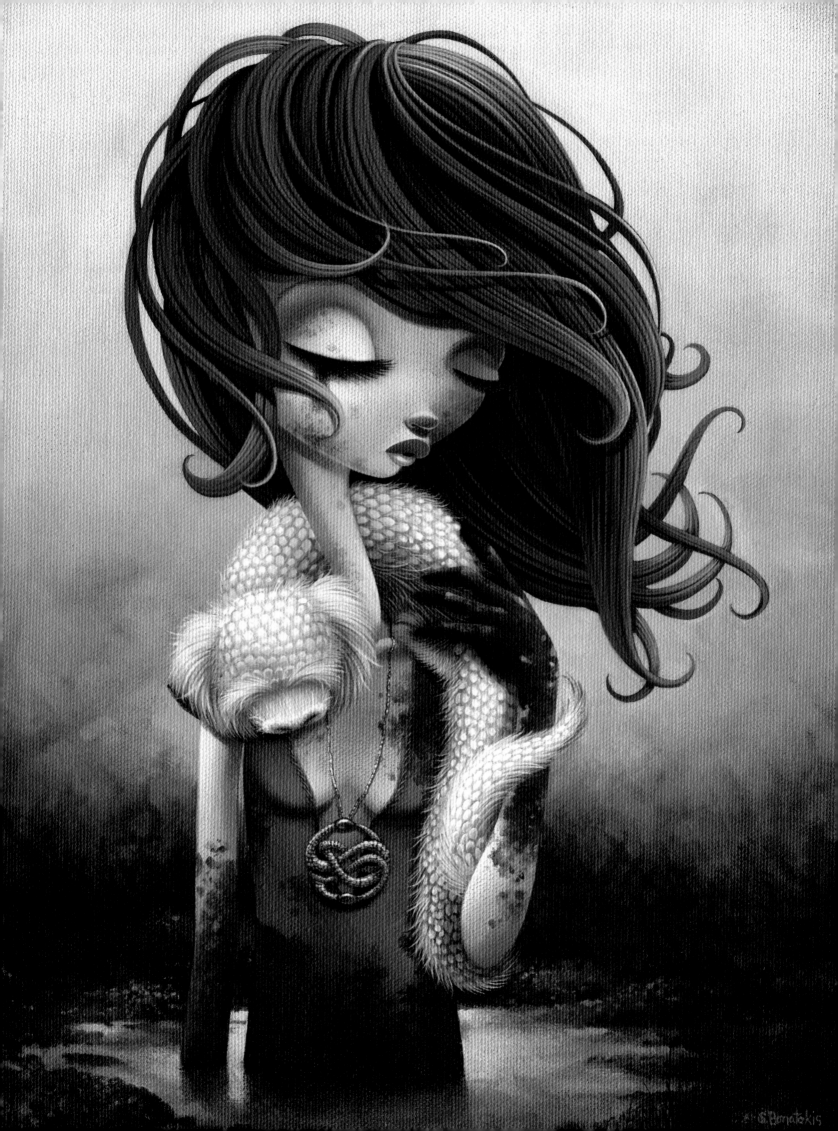

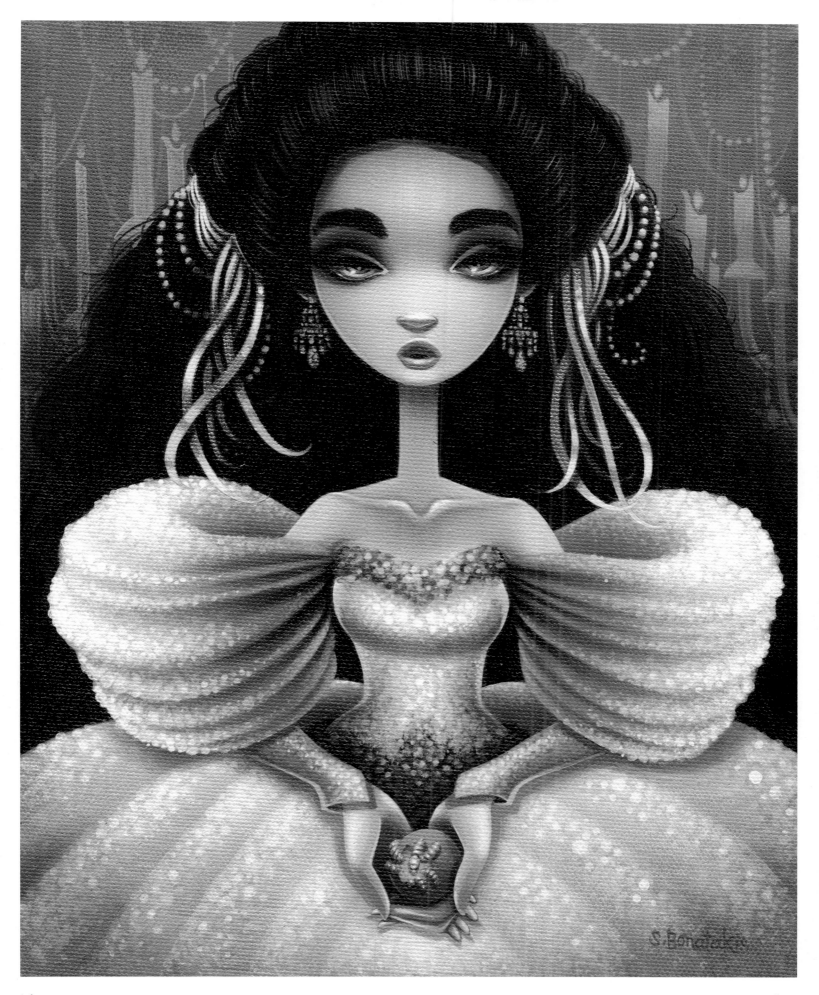

Shannon Bonatakis
'Luck is Never Enough'
Acrylic on Canvas, 11 x 14 inches
The NeverEnding Story

Shannon Bonatakis
'As the World Falls Down'
Acrylic on Canvas, 8 x 10 inches
Labyrinth

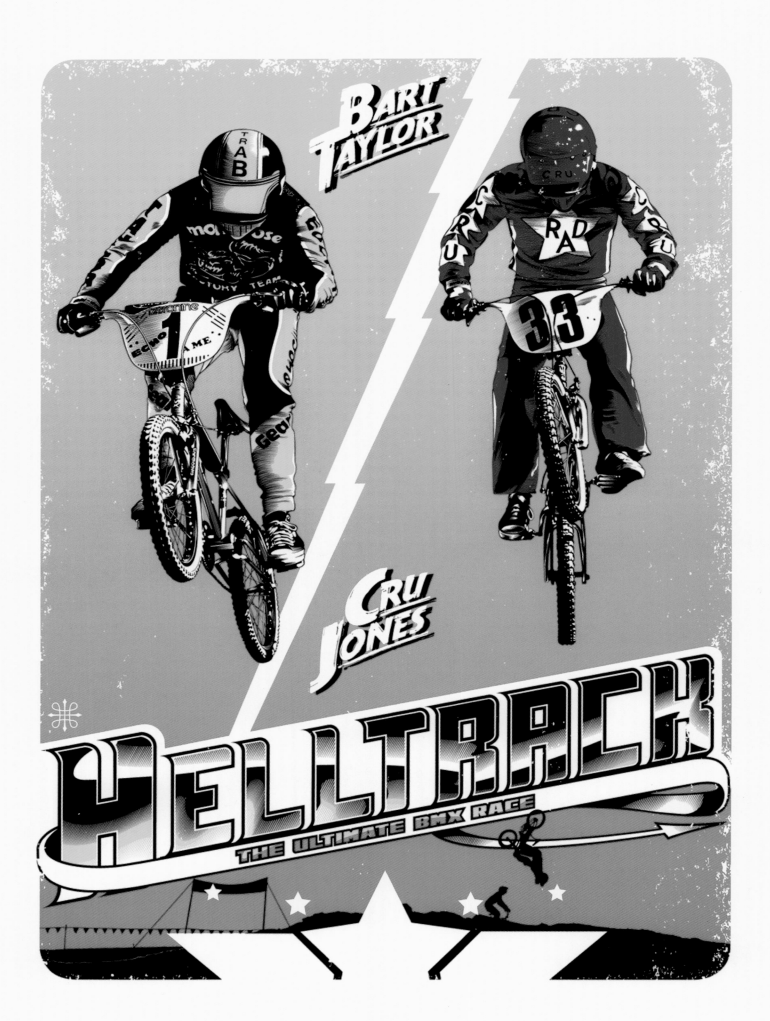

Right:
Jason D'Aquino
'Pocket Cenobite'
Graphite Miniature
on Matchbook
1 1/2 x 3 3/4 inches
Hellraiser

Below:
Jason D'Aquino
'Texas Chainsaw Breakfast'
Graphite Miniature with
Chalk on Found Surface
8 x 14 inches
The Breakfast Club /
The Texas Chain Saw
Massacre

Left:
Jeff Boyes
'Helltrack'
Screenprint
18 x 24 inches
Rad

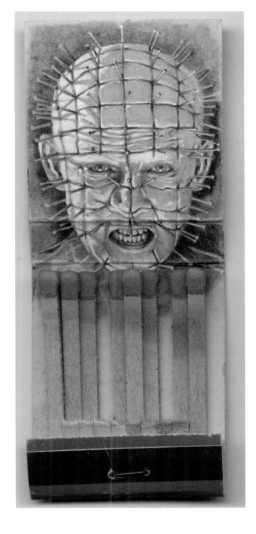

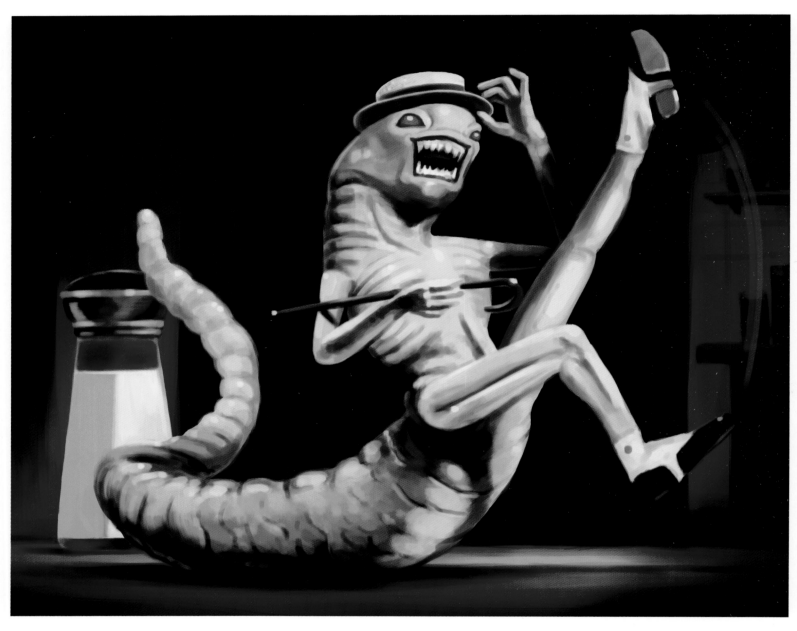

Above:
Derek Deal
'Check Please'
U/V digital print on FSC certified wood
8 x 10 inches
Spaceballs

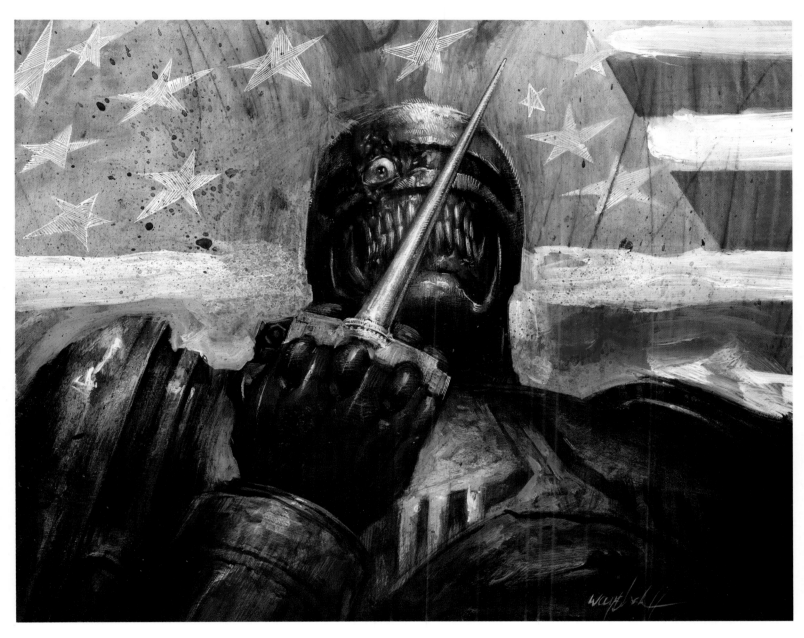

Above:
Jonathan Wayshak
'Way to Go Robo'
Acrylic, gouache and ink
11 x 8 1/2 inches
Robocop

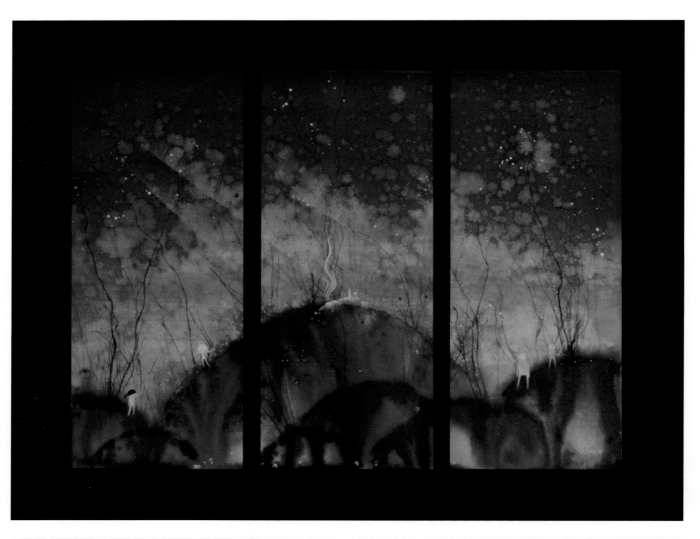

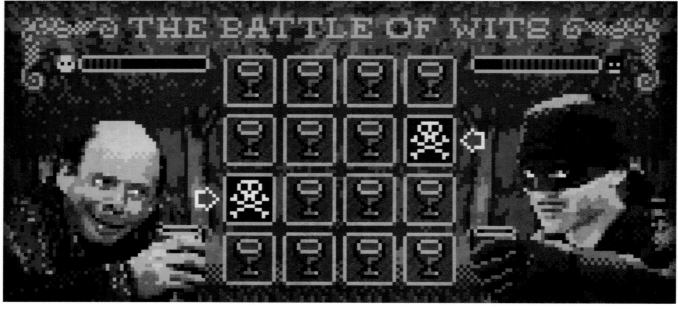

Top:
Lawrence Yang
'The Parting of the Ways'
Ink, Watercolor, and Gouace on Paper, 16 x 12 inches
The Princess Bride

Above:
Jude Buffum
'The Battle of Wits'
Giclee print on canvas, 19 3/4 x 9 inches
The Princess Bride

Right:
Aaron Jasinski
'The Mystery of True Love'
Acrylic on panel
16 x 24 inches
The Princess Bride

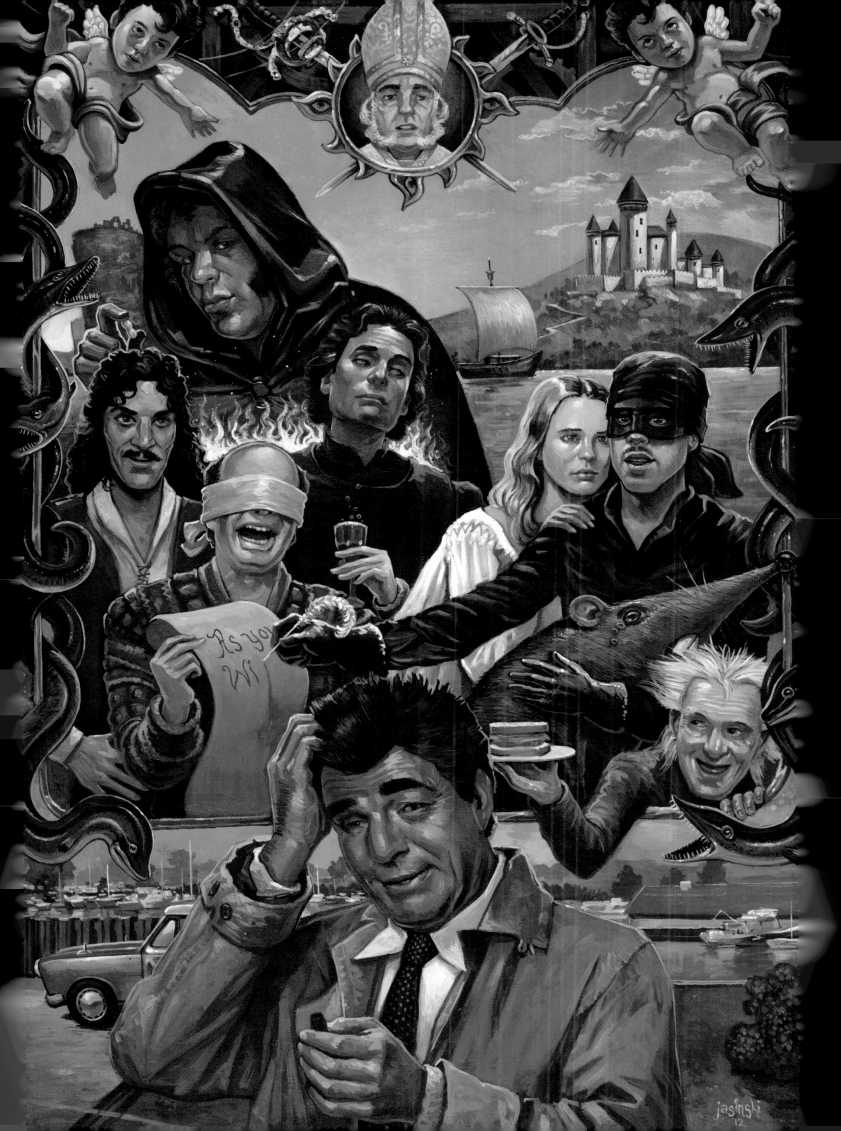

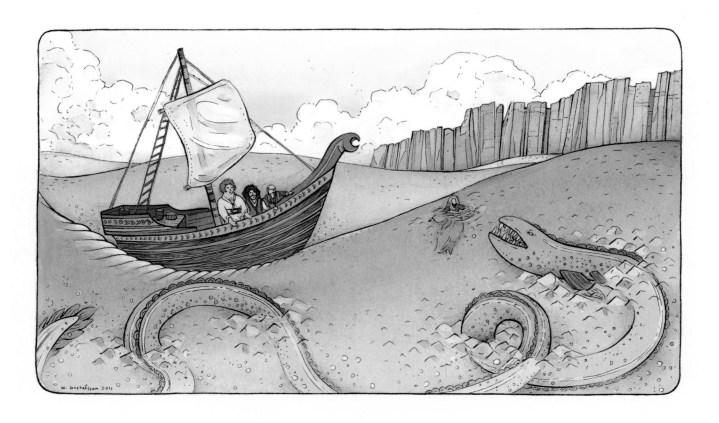

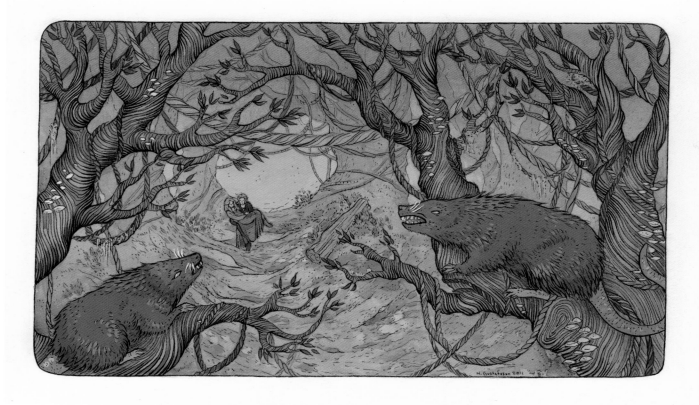

Above:
Nicole Gustafsson
'Beware The Shrieking Eels!'
'Rodents Of Unusual Size? I Don't Think They Exist'
Gouache and Ink on Paper, 5 1/4 x 9 inches
The Princess Bride

Right:
Andrew Wilson
'1984-1987 at 1988'
Giclee print
18 x 24 inches
Various

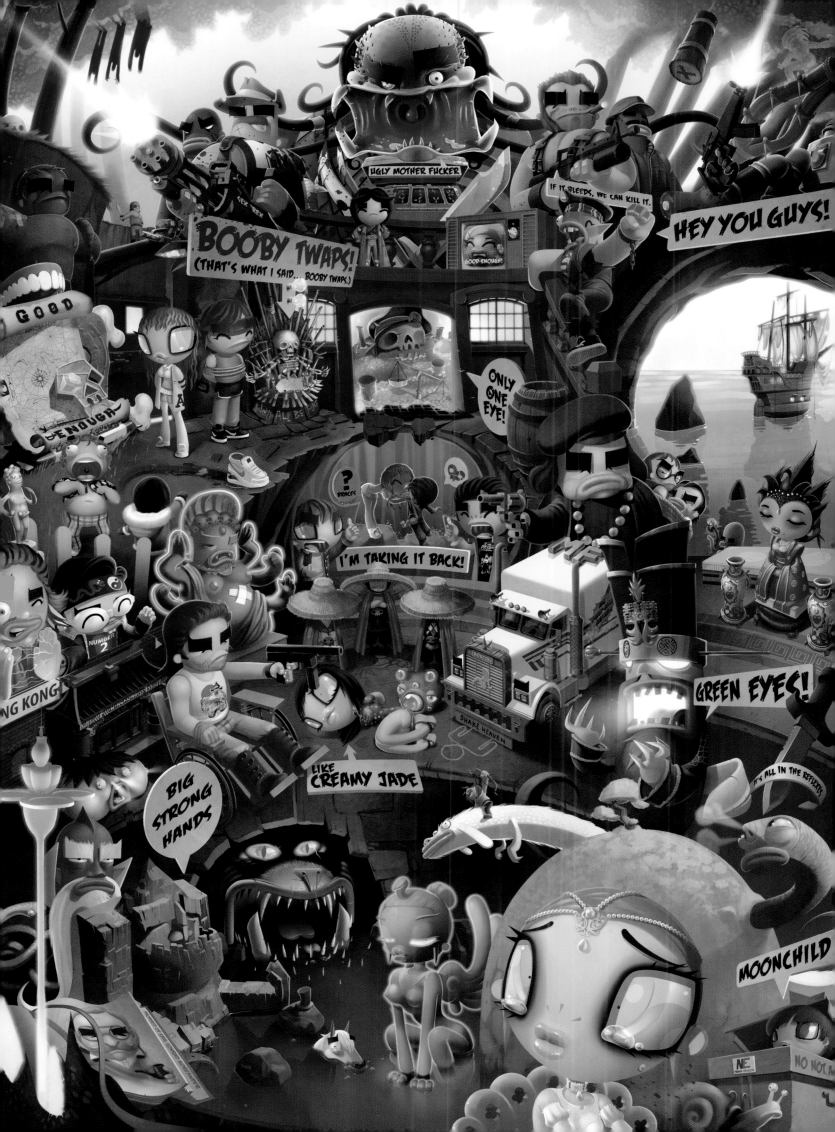

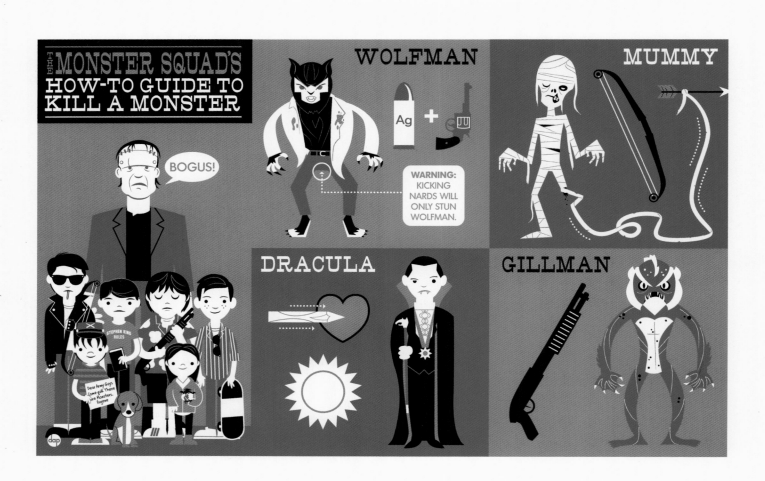

Above:
Dave Perillo
'Wolfman's Got Nards!'
Screenprint
18 x 12 inches
The Monster Squad

Right:
Anthony Petrie
'The One That Got Away'
Screenprint
18 x 24 inches
Predator

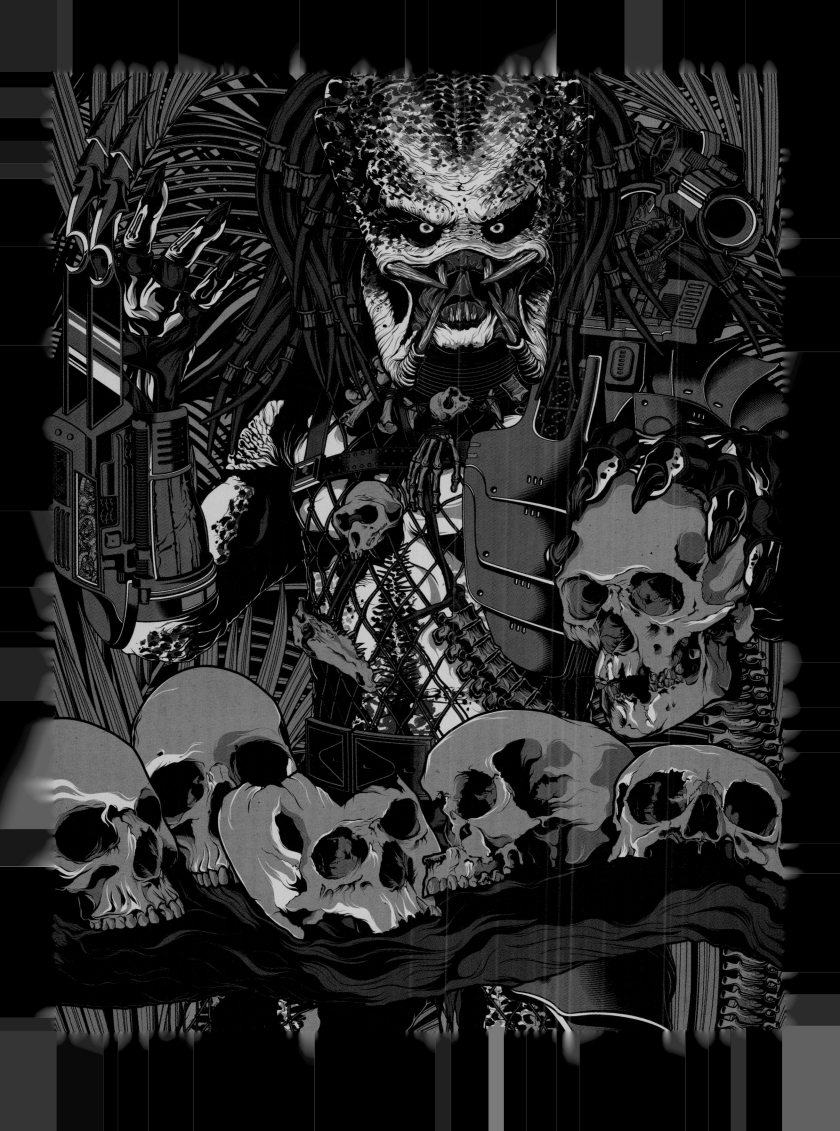

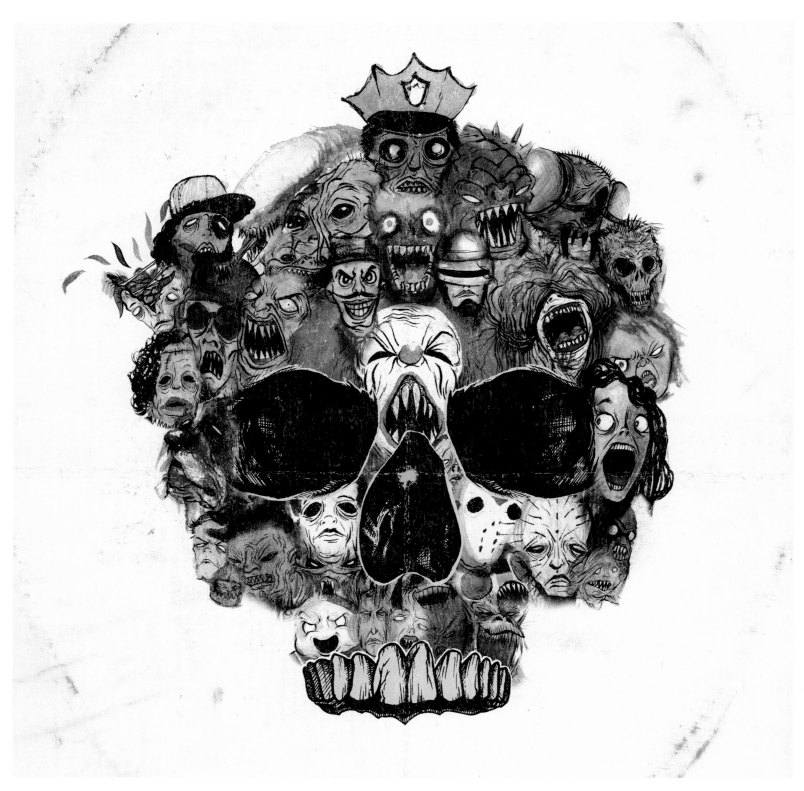

Above:
Alex Pardee
'Cult Skull'
Giclee print on archival paper
12 x 12 inches
Various

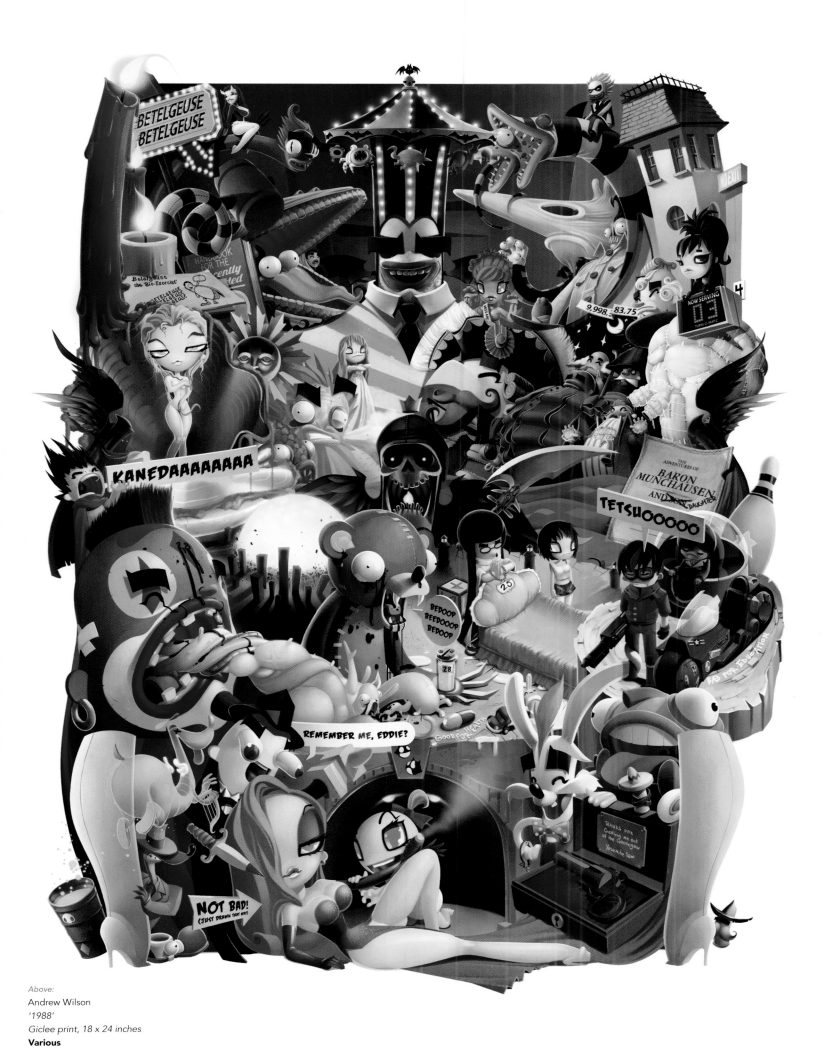

Above:
Andrew Wilson
'1988'
Giclee print, 18 x 24 inches
Various

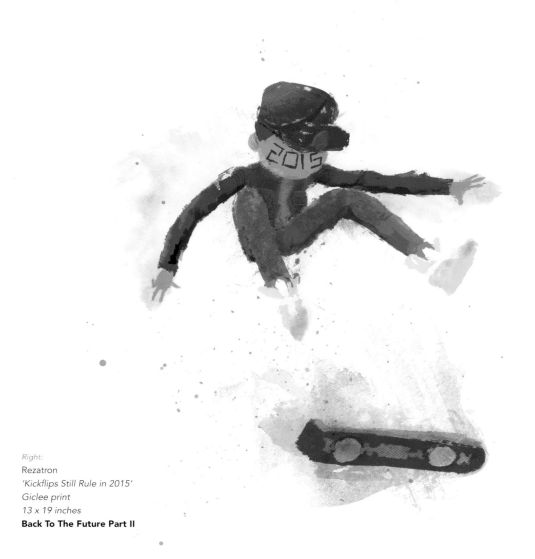

Right:
Rezatron
'Kickflips Still Rule in 2015'
Giclee print
13 x 19 inches
Back To The Future Part II

Above and left:
DKNG
'Your Wish Is Granted'
Screenprint Diptych
24 x 9 inches
Big

Above:
Steff Bomb
'I Believe I Can McFly'
Mixed media
16 x 6 x 3 inches
Back To The Future Part II

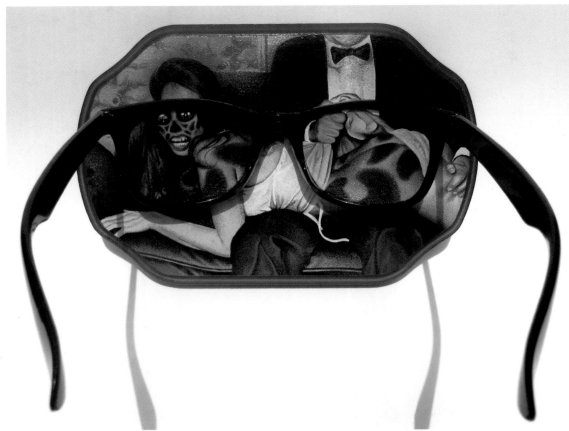

Right:
JoKa
'They Live to Reproduce'
Acrylic on Wood and
Plastic, Painted with
Toothpicks
5 x 7 x 7 inches
They Live

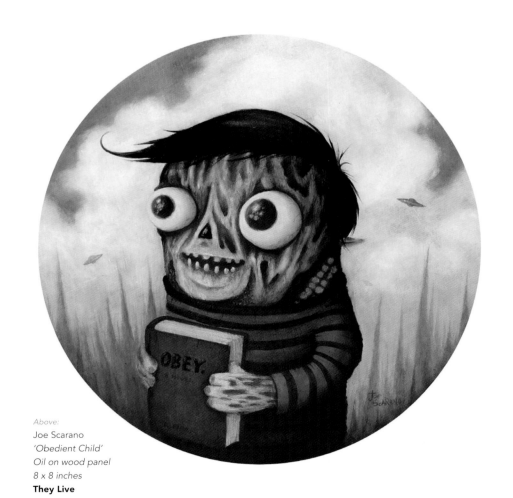

Above:
Joe Scarano
'Obedient Child'
Oil on wood panel
8 x 8 inches
They Live

Right:
Nathan Stapley
'King Jaffe Joffer'
Acrylic on Canvas
16 x 20 inches
Coming To America

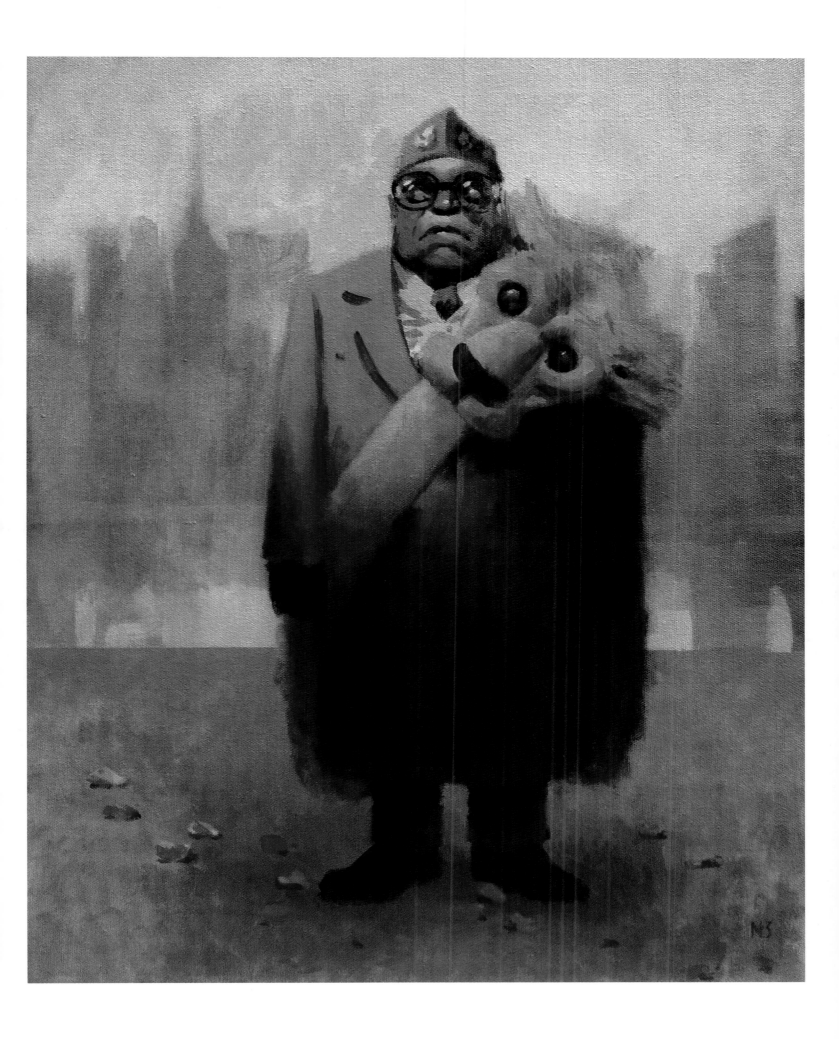

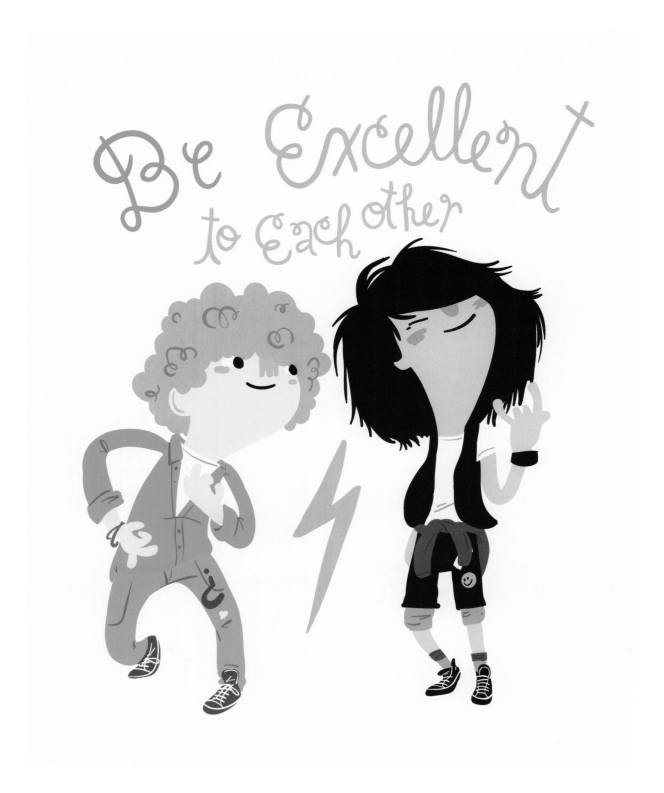

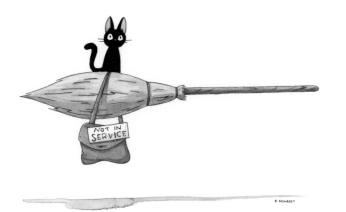

Above:
Lauren Gregg
'Be Excellent To Each Other'
Multimedia Print on Glass, 15 3/4 x 19 3/4 inches
Bill And Ted's Excellent Adventure

Left:
Keith Noordzy
'Jiji Waits'
Pen and Ink with Watercolor, 13 x 10 inches
Kiki's Delivery Service

Right:
Shana Bilbrey
'It Came With The Frame'
Digital Print, 8 1/2 x 14 inches
The 'Burbs

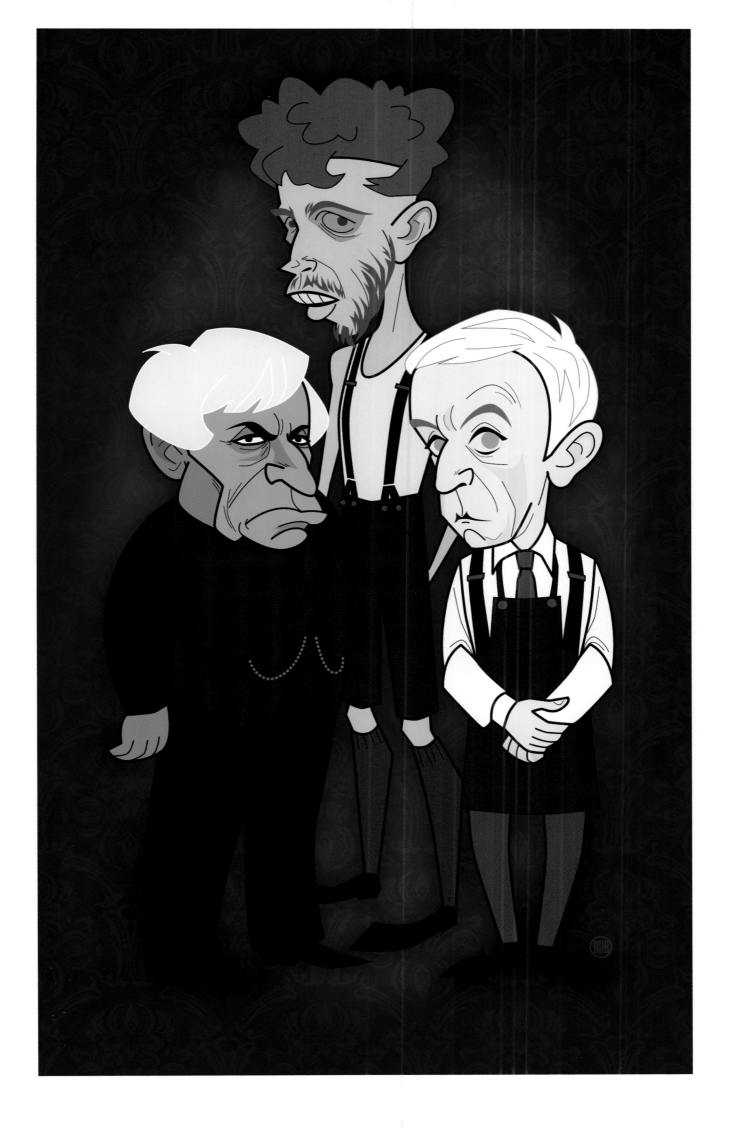

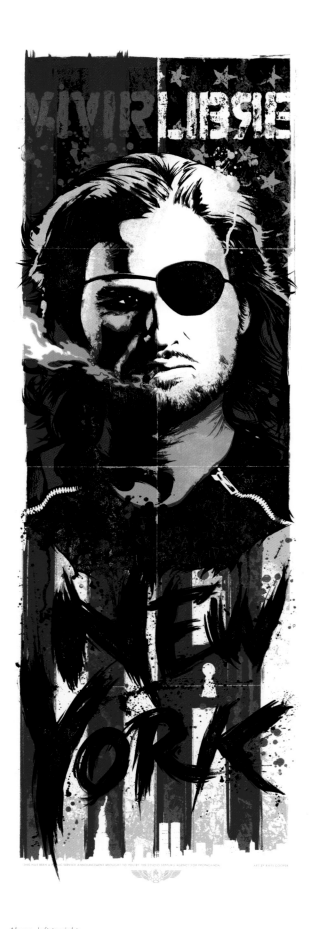
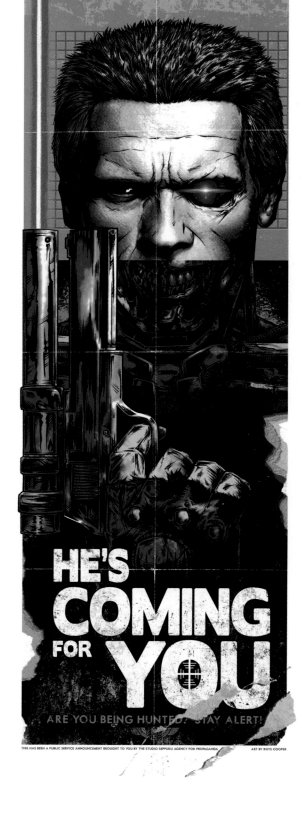

Above, left to right:
Rhys Cooper
'Vivir Libre New York!'
'He's Coming For You'
'Your Move'
'Free Mars'
Screenprint, 12 x 36 inches
Escape From New York / Terminator / Robocop / Total Recall

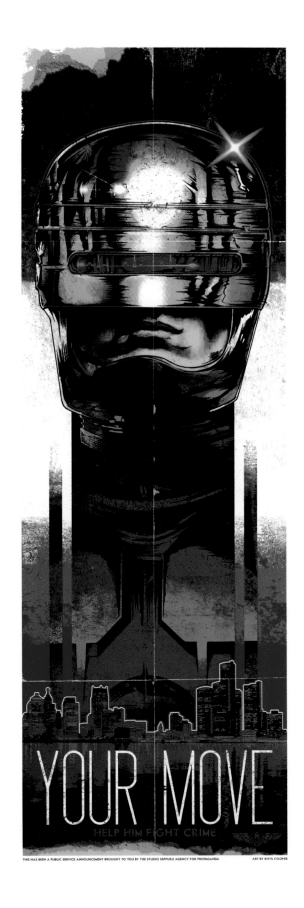

YOUR MOVE

HELP HIM FIGHT CRIME

THIS HAS BEEN A PUBLIC SERVICE ANNOUNCEMENT BROUGHT TO YOU BY THE STUDIO SEPPUKU AGENCY FOR PROPAGANDA ART BY RHYS COOPER

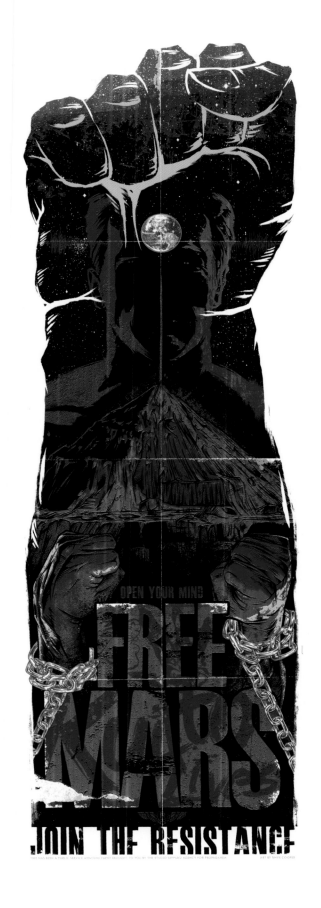

OPEN YOUR MIND

FREE MARS

JOIN THE RESISTANCE

THIS HAS BEEN A PUBLIC SERVICE ANNOUNCEMENT BROUGHT TO YOU BY THE STUDIO SEPPUKU AGENCY FOR PROPAGANDA ART BY RHYS COOPER

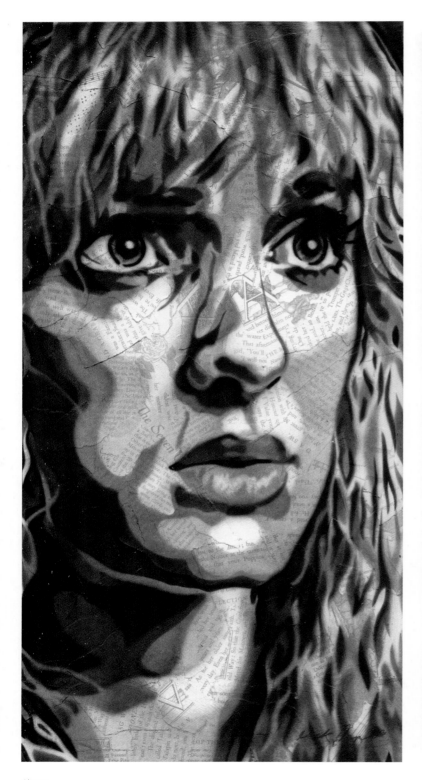
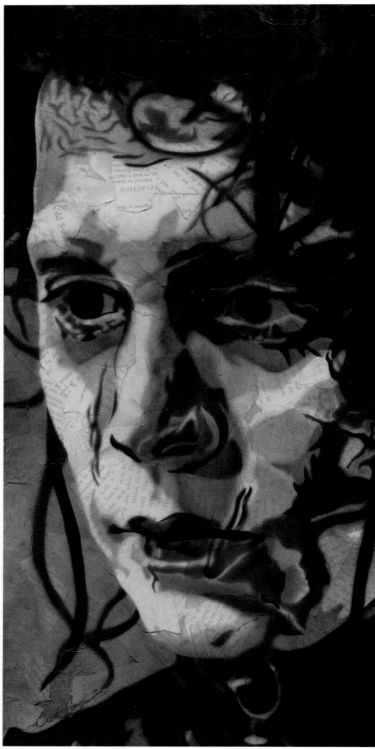

Above:
Nick Comparone
'I Can't - Diptych'
Spray Paint and Collage on Canvas Diptych
12 x 24 inches
Edward Scissorhands

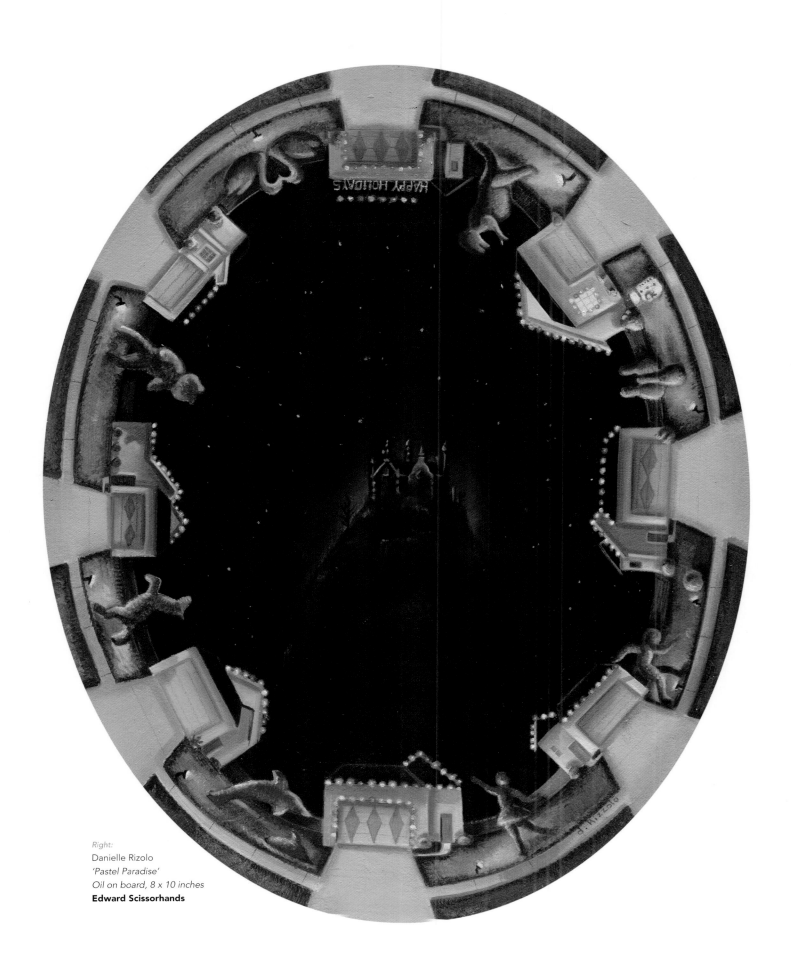

Right:
Danielle Rizolo
'Pastel Paradise'
Oil on board, 8 x 10 inches
Edward Scissorhands

Above:
Ridge
'Eddy Makes A Friend'
Digital Print
12 x 12 inches
Edward Scissorhands

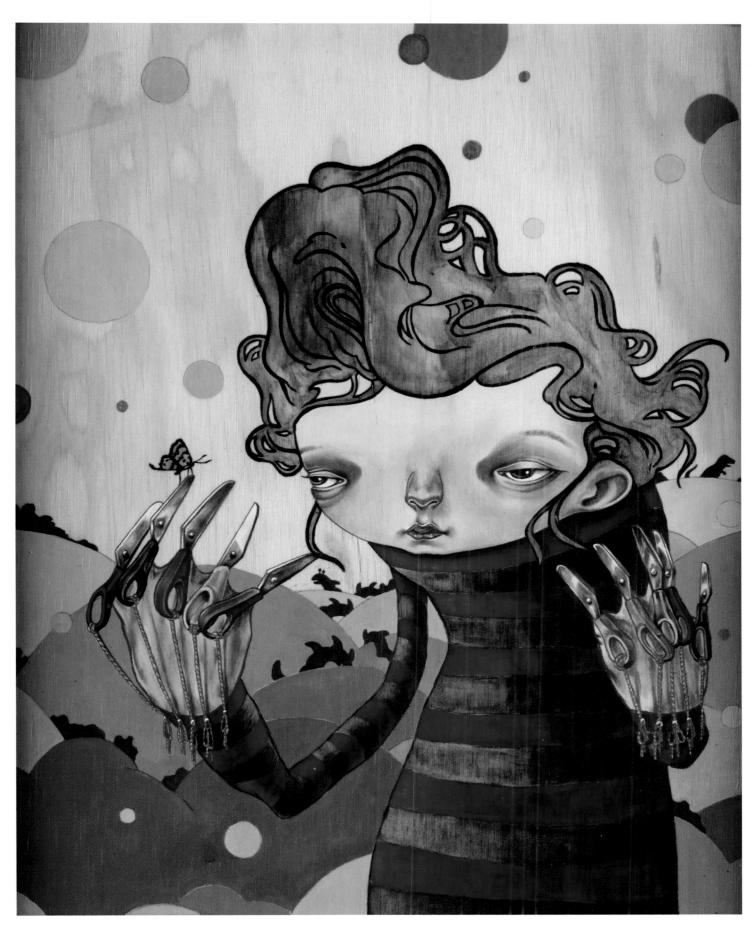

Above:
Leanne Biank
'Edward Safety Scissorhands'
Oil on wood
12 x 15 inches
Edward Scissorhands

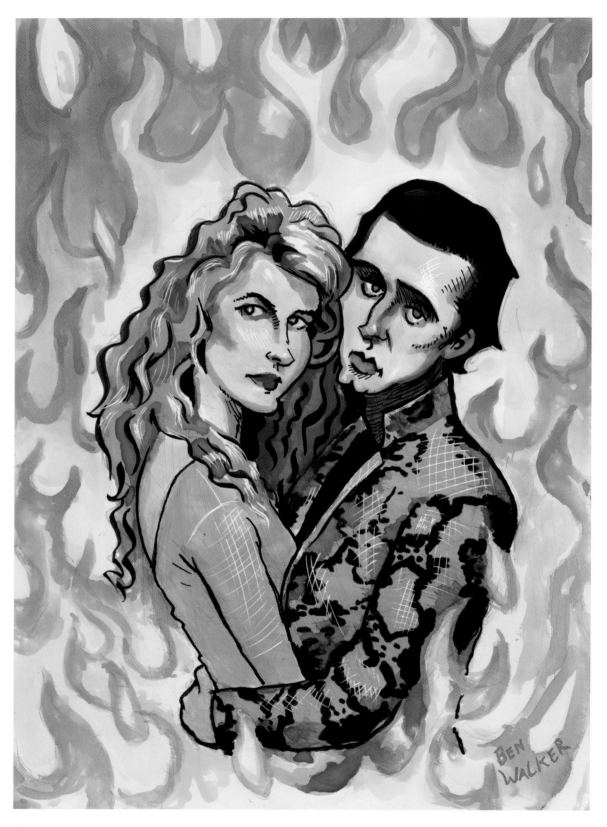

Above:
Ben Walker
'You Got Me Hotter Than Georgia Asphalt'
Watercolor and Ink on Clayboard
5 x 7 inches
Wild At Heart

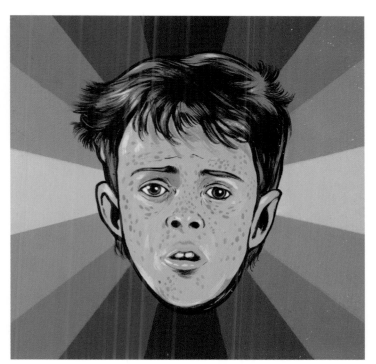

Above, clockwise from top left
Steve Seeley
'Untitled (you cant piss on hospitality)'
Acrylic and gold leaf on paper on panel, 12 x 12 inches
'Untitled (goblin 1)'
'Untitled (joshua)'
'Untitled (goblin 2)
Acrylic on paper on panel, 6 x 6 inches
Troll 2

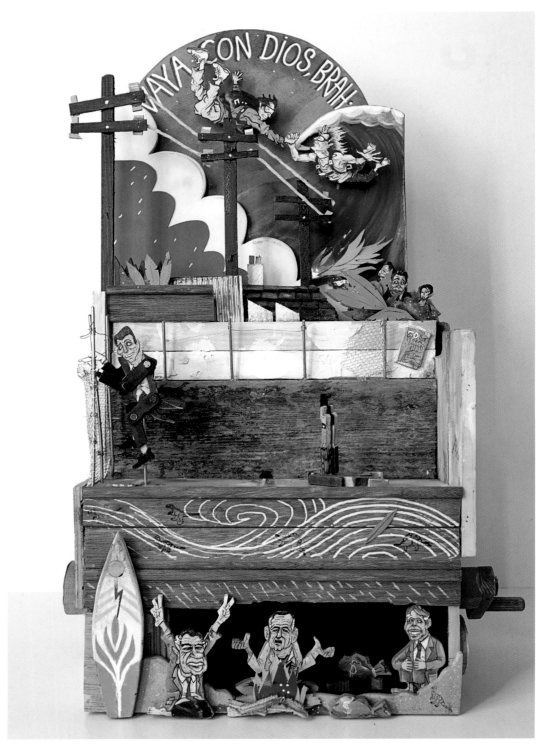

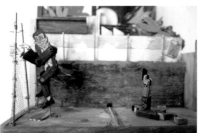

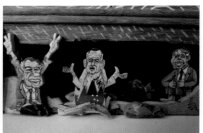

Above and left:
Mick Minogue
'100% Utah'
Mixed media
Point Break

Right:
Matt Taylor
'Nobody Rides For Free'
2 color risograph
16.5 x 11.75 inches
Point Break

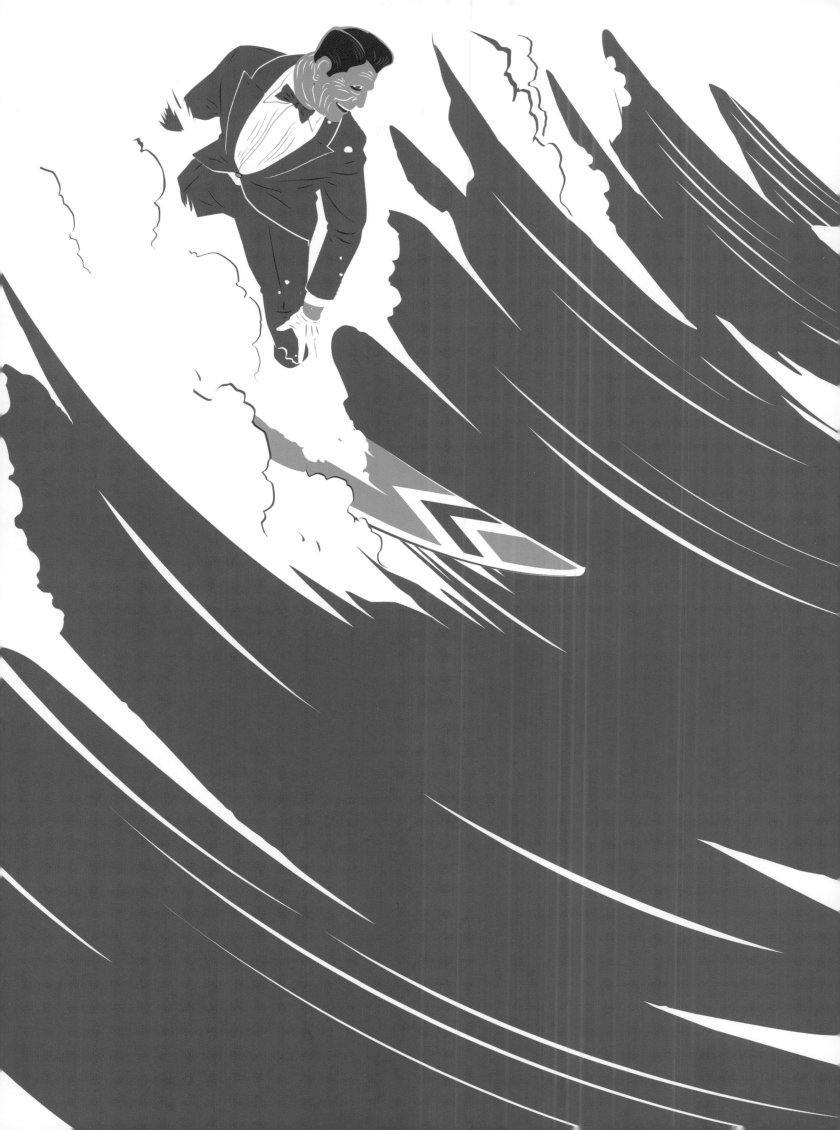

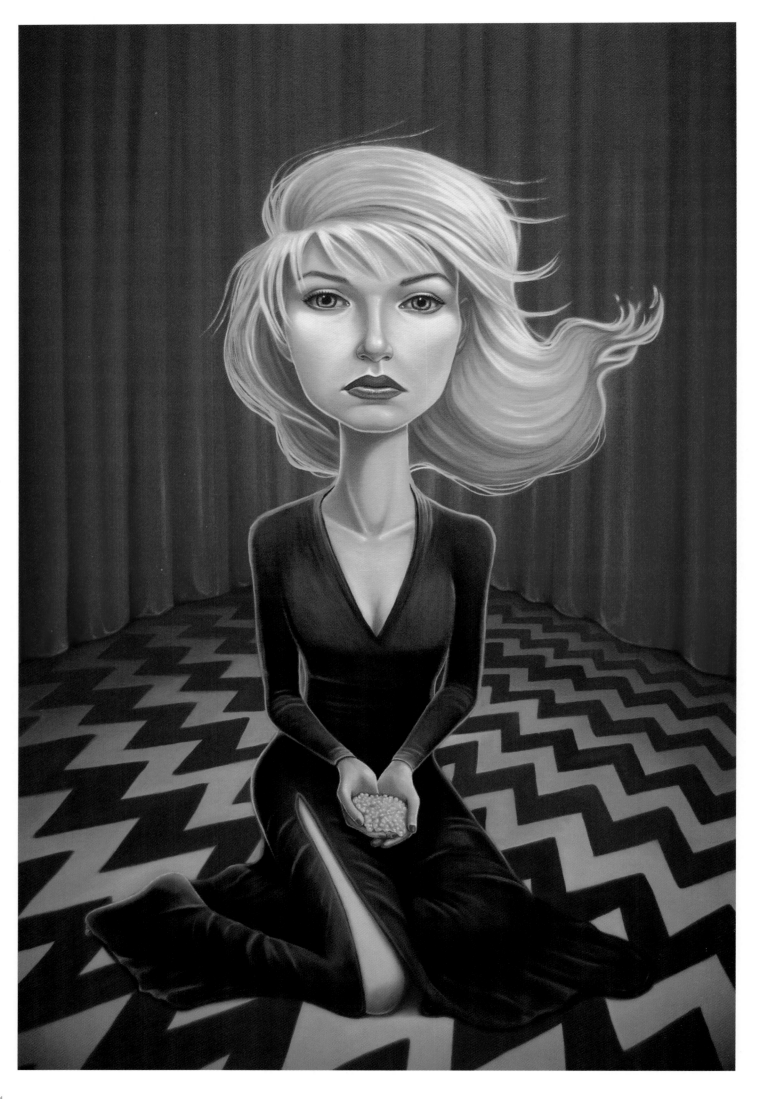

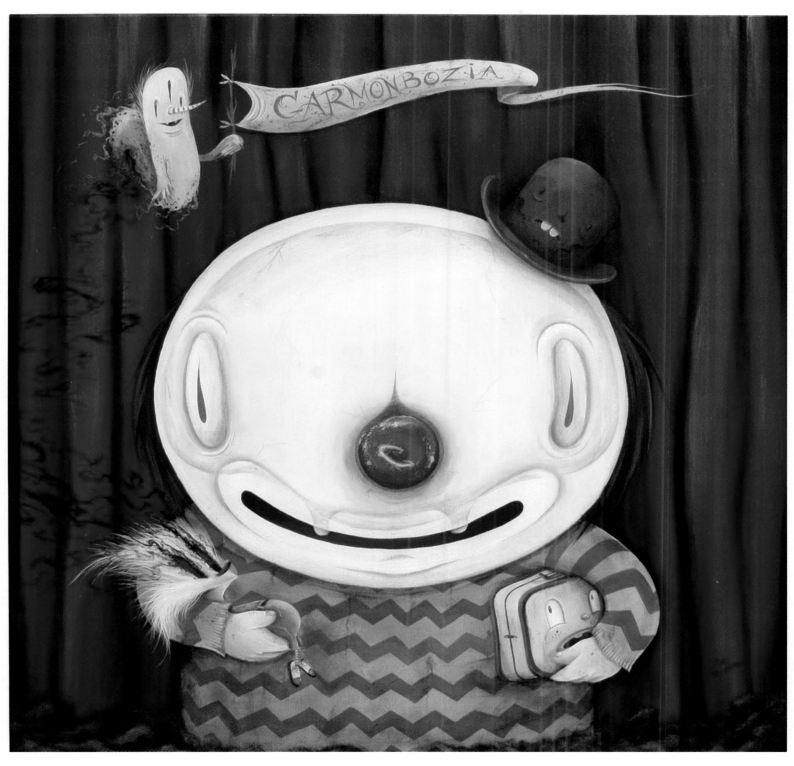

Left:

Audrey Pongracz

'When This Kind Of Fire Starts,
Its Very Hard To Put Out'

Oil on Canvas

24 x 36 inches

Twin Peaks: Fire Walk With Me

Above:

Joe Scarano

'The Little Man from Another Place'

Acrylic on wood panel

16 x 16 inches

Twin Peaks: Fire Walk With Me

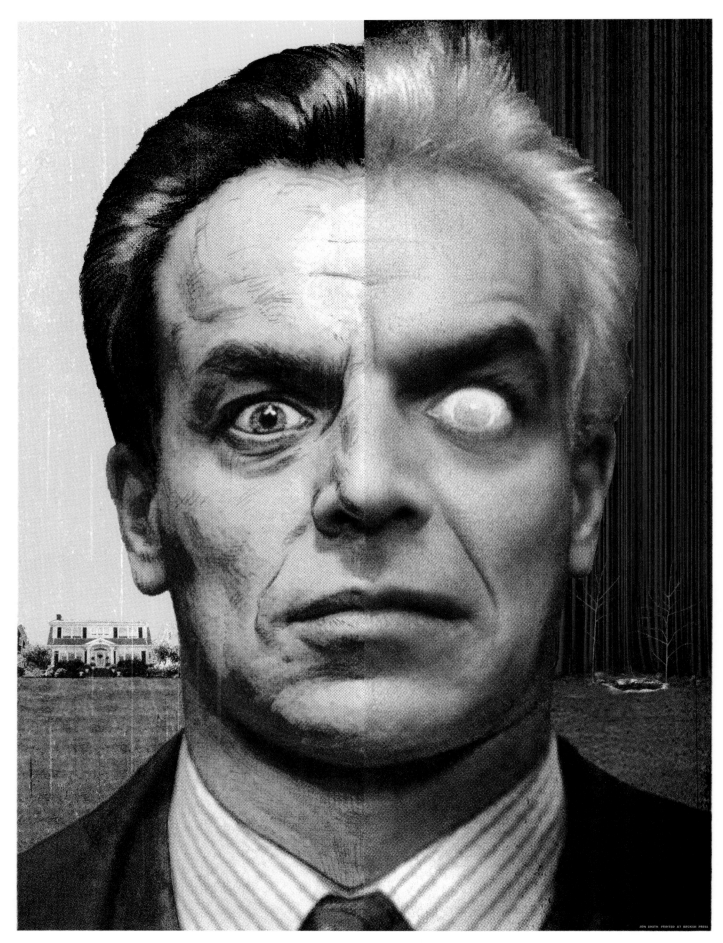

Above:
Jon Smith
'Fire Walk With Me'
4 color screenprint
18 x 24 inches
Twin Peaks: Fire Walk With Me

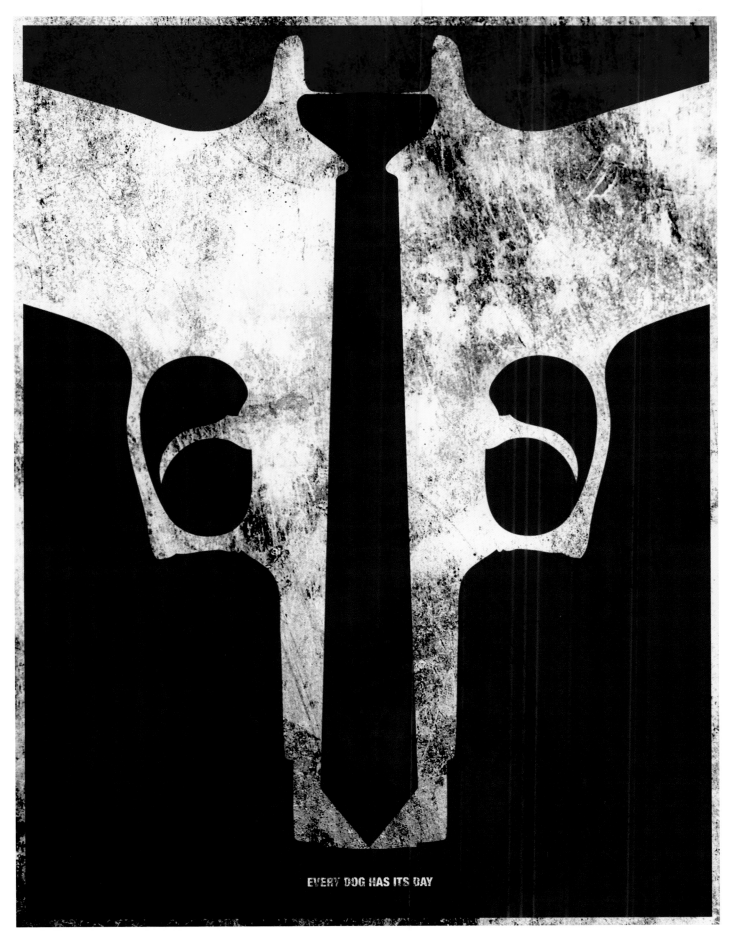

EVERY DOG HAS ITS DAY

Above:
Jason Liwag
'Every Dog Has Its Day'
Screenprint
18 x 24 inches
Reservoir Dogs

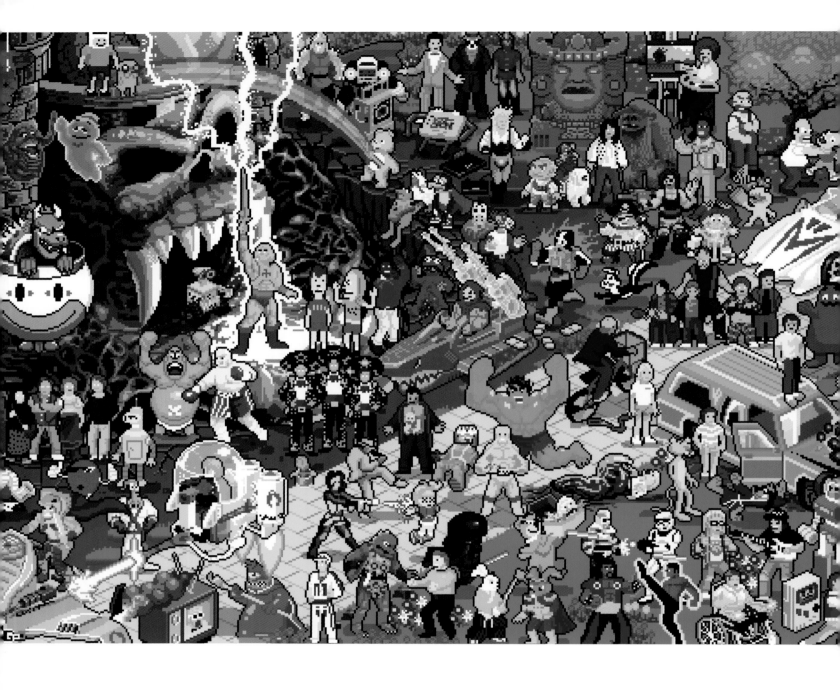

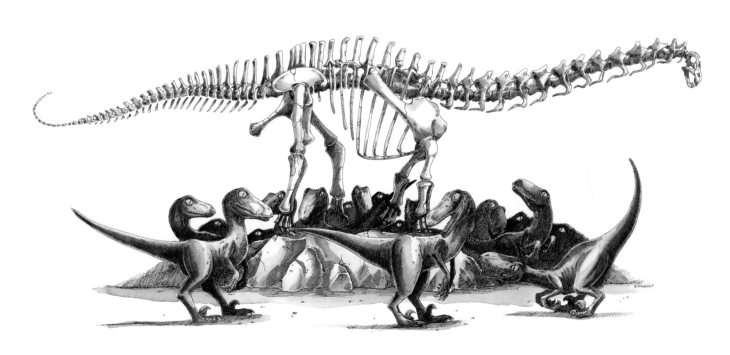

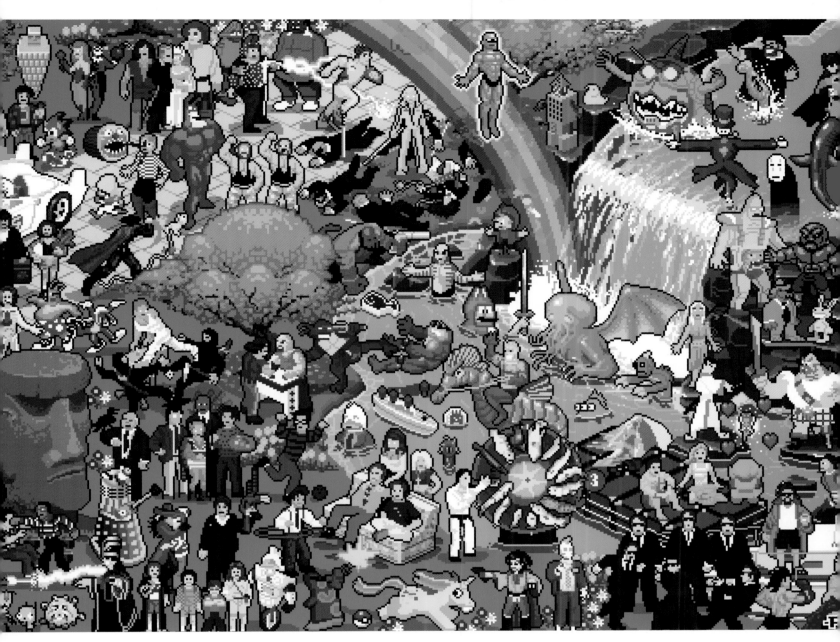

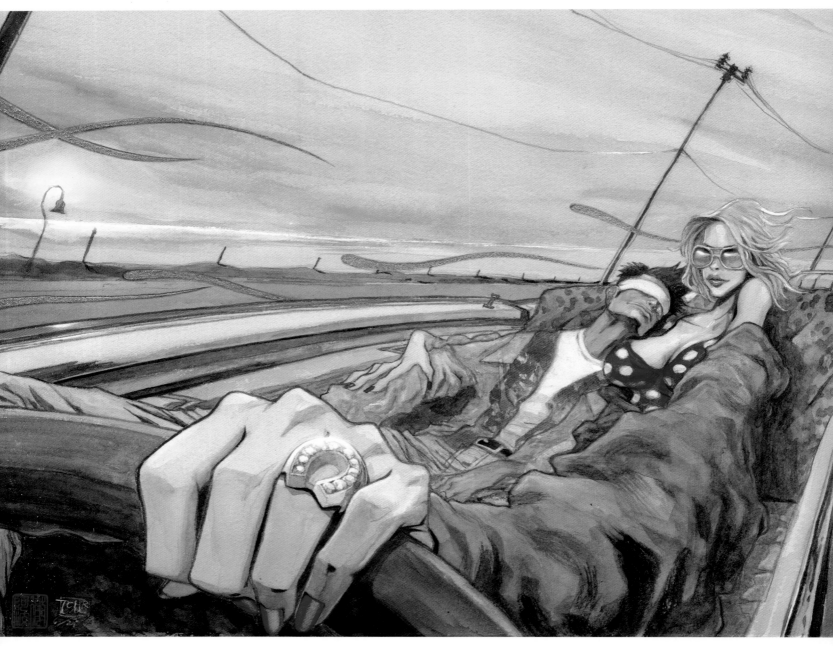

Above:
Patrick Awa
'You Are So Cool, You Are So Cool, You Are So Cool'
Watercolor and Acrylic Goauche
13 1/2 x 10 inches
True Romance

Right:
Basemint Design
'Royale With Cheese'
Screenprint
16 x 20 inches
Pulp Fiction

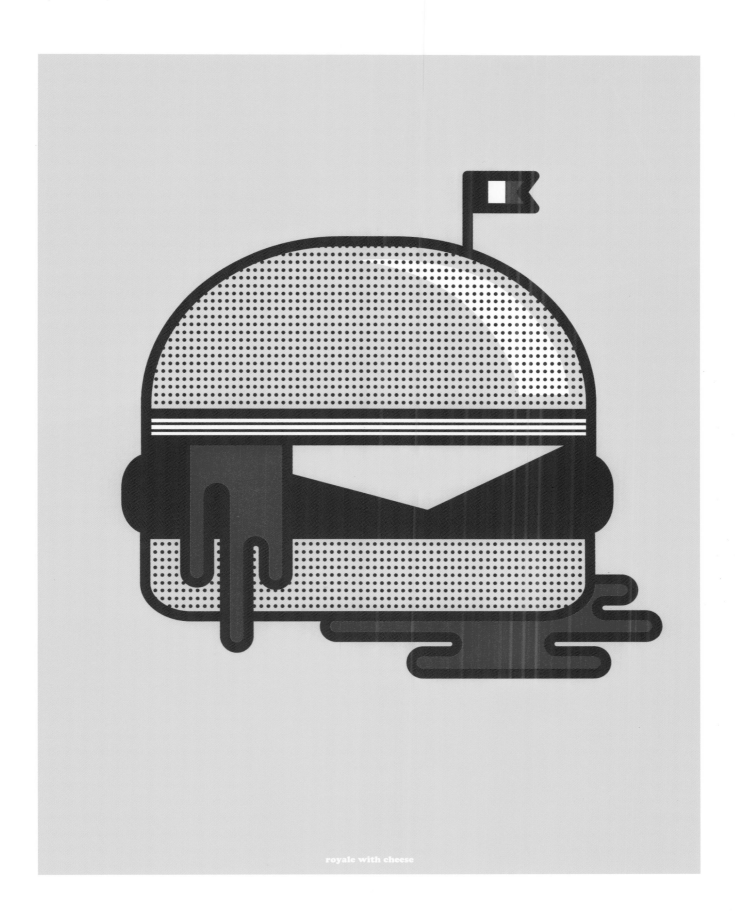

royale with cheese

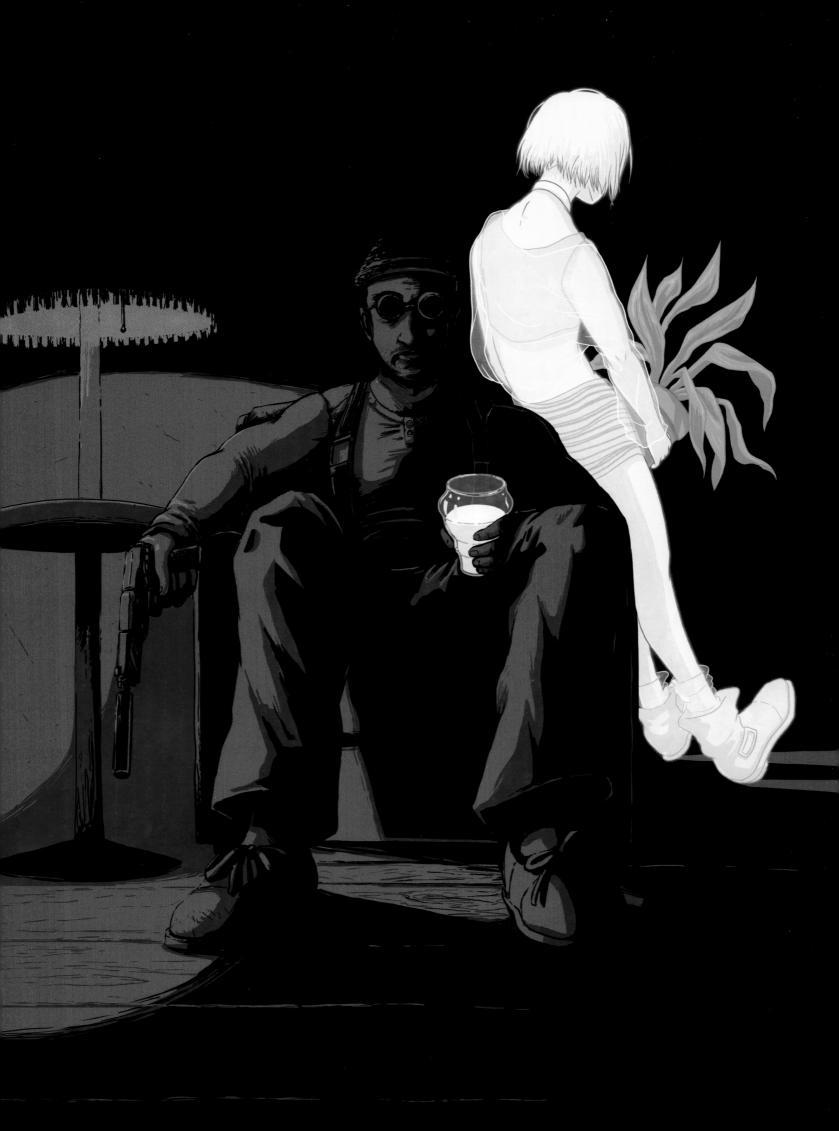

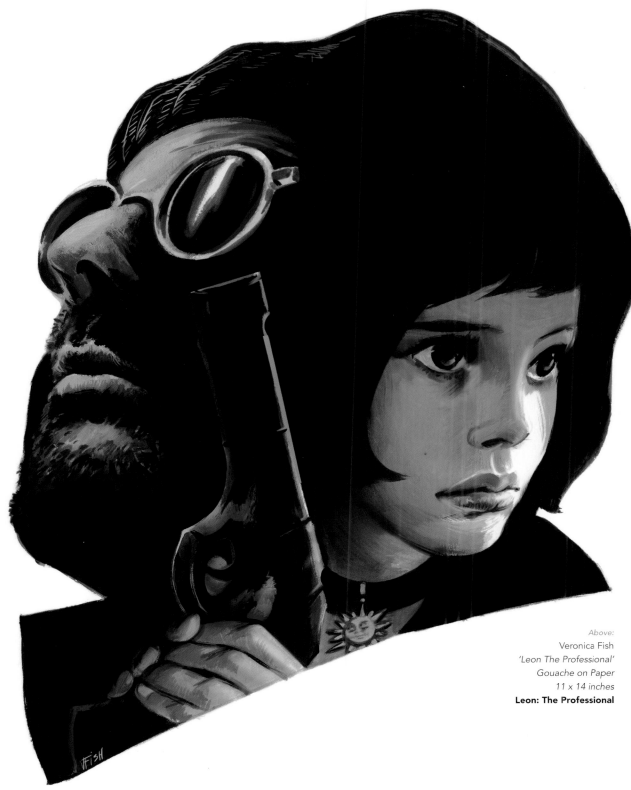

Above:
Veronica Fish
'Leon The Professional'
Gouache on Paper
11 x 14 inches
Leon: The Professional

Left:
Kim Herbst
'Leon & Mathilda'
Giclee Print
12 x 15 inches
Leon: The Professional

Following spread:
Lawrence Yang
'I Think Well Be Okay Here, Leon'
Ink, Watercolor, and Gouace on Paper
14 x 10 inches
Leon: The Professional

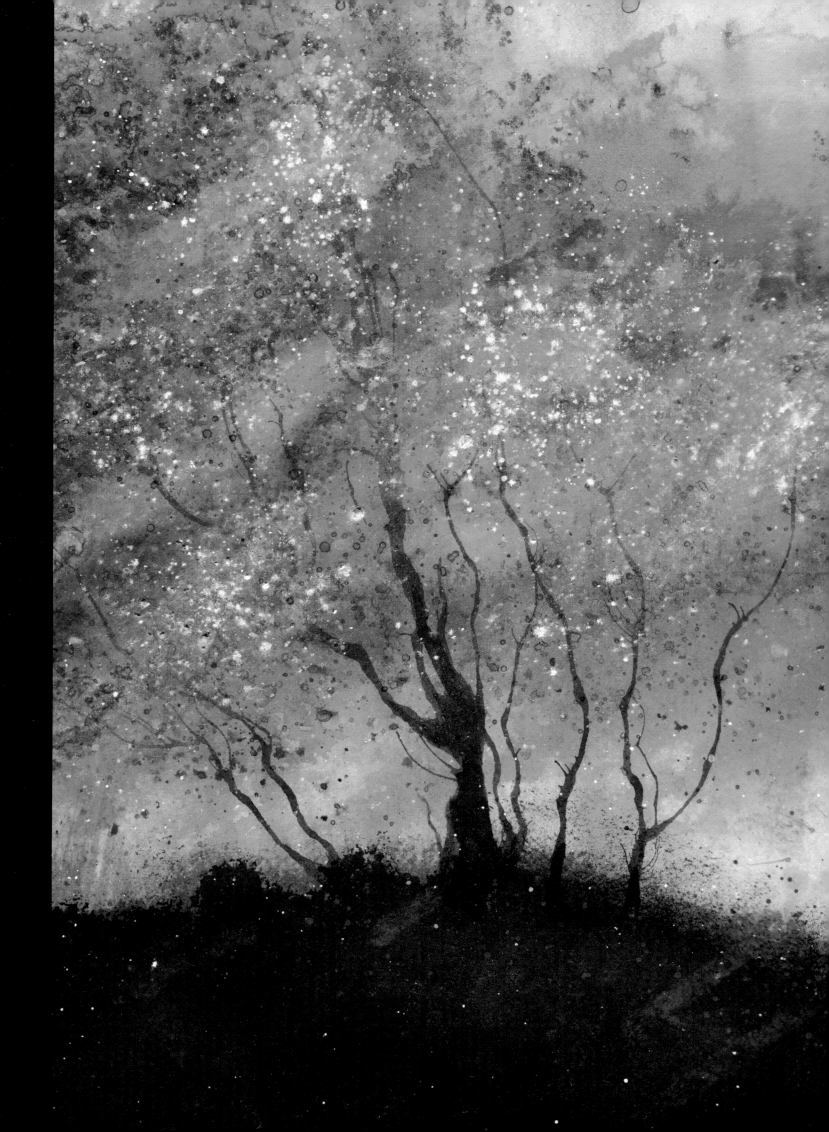

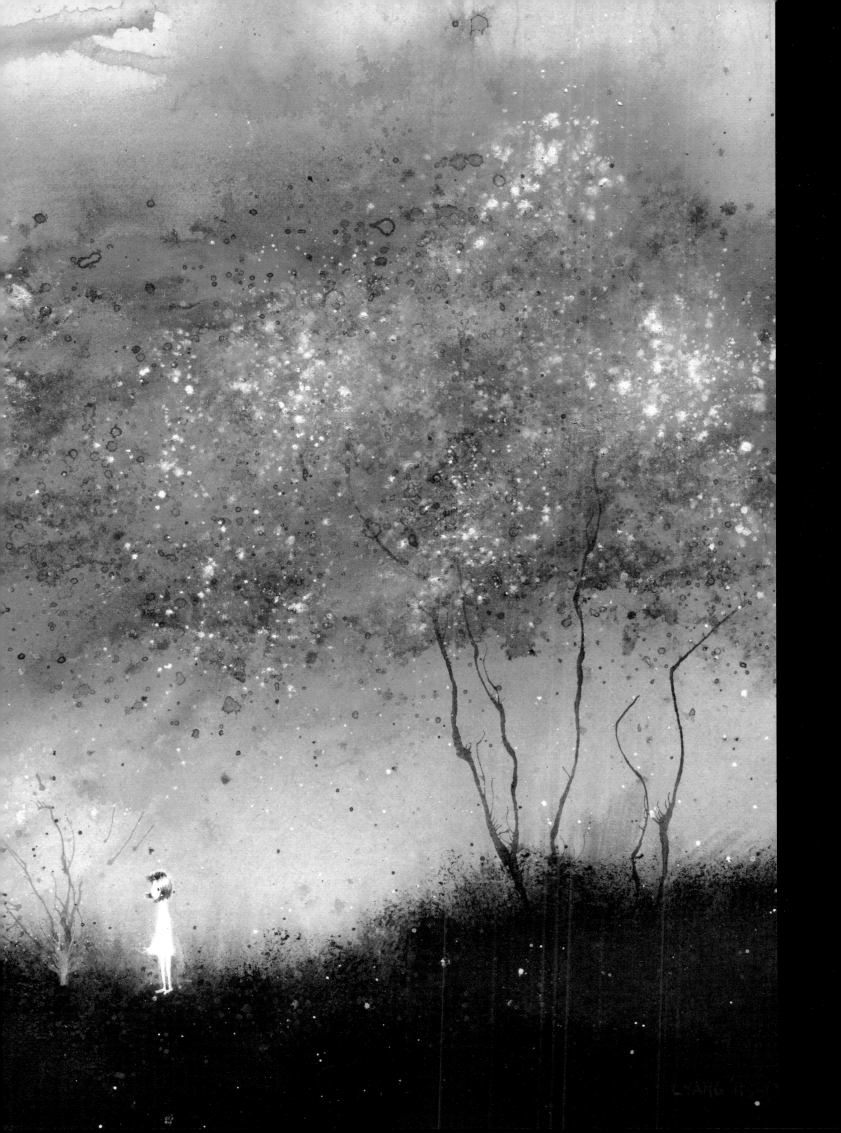

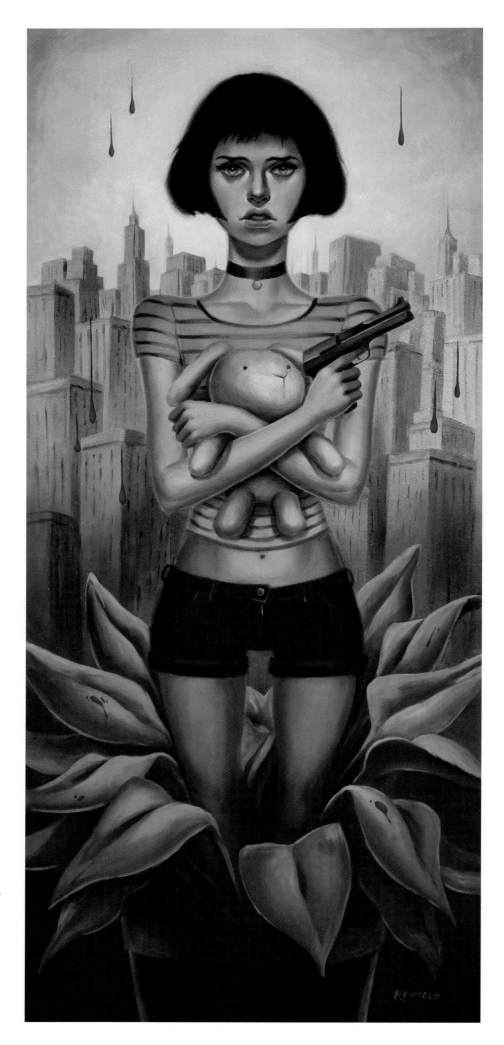

Right:
Allison Reimold
'I Think We'll Be OK Here'
Oil on paper
15 x 32 inches
Leon: The Professional

Opposite:
Erica Gibson
'RAW'
Acrylic
Leon: The Professional

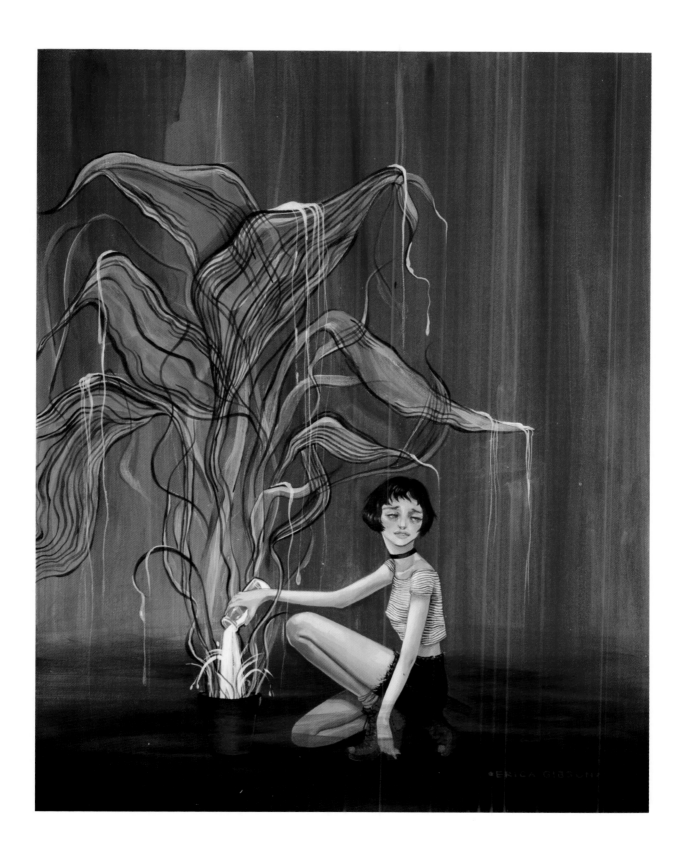

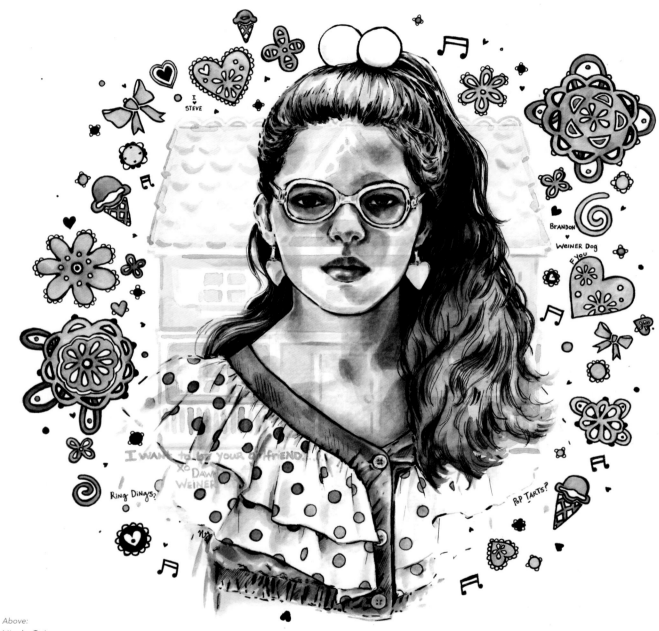

Above:
Nicole Guice
'The Prettiest Doll of Them All. Dawn
Weiner. Welcome to the Dollhouse'
Ink on Paper, 14 1/2 x 14 1/2 inches
Welcome To The Dollhouse

Right:
Stephen Andrade
'Pull The Strings'
Acrylic on Panel, 18 x 24 inches
Ed Wood

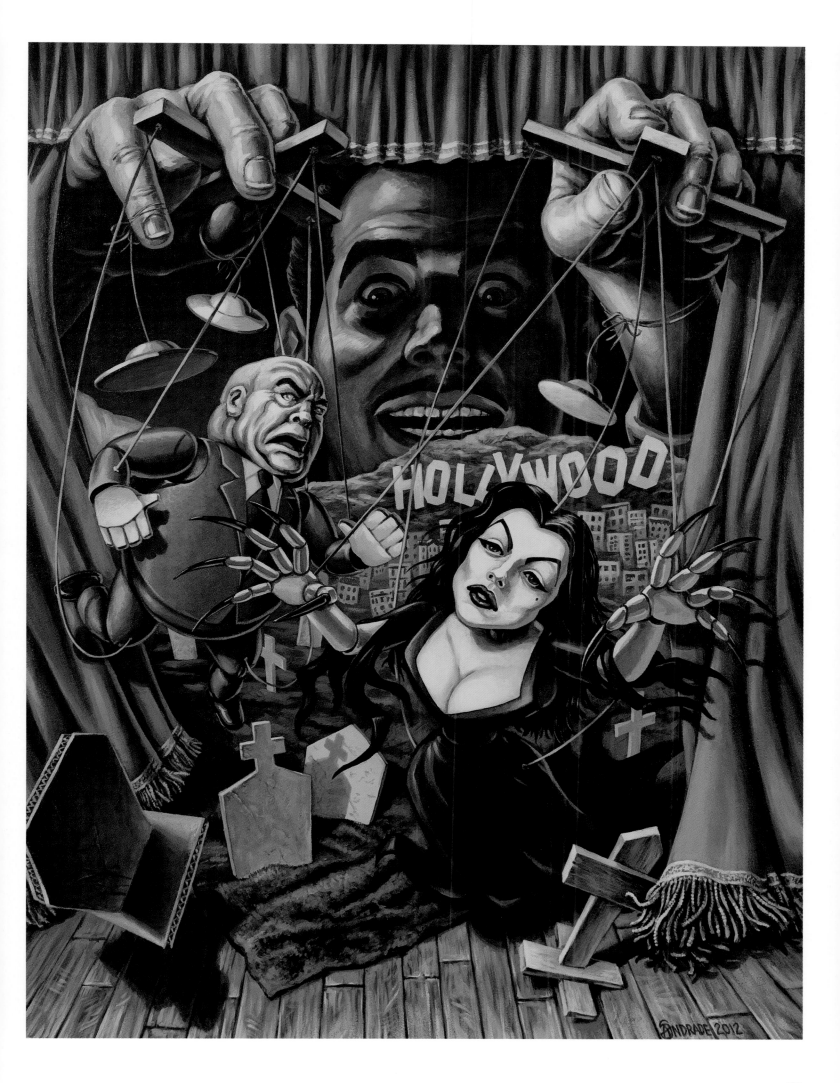

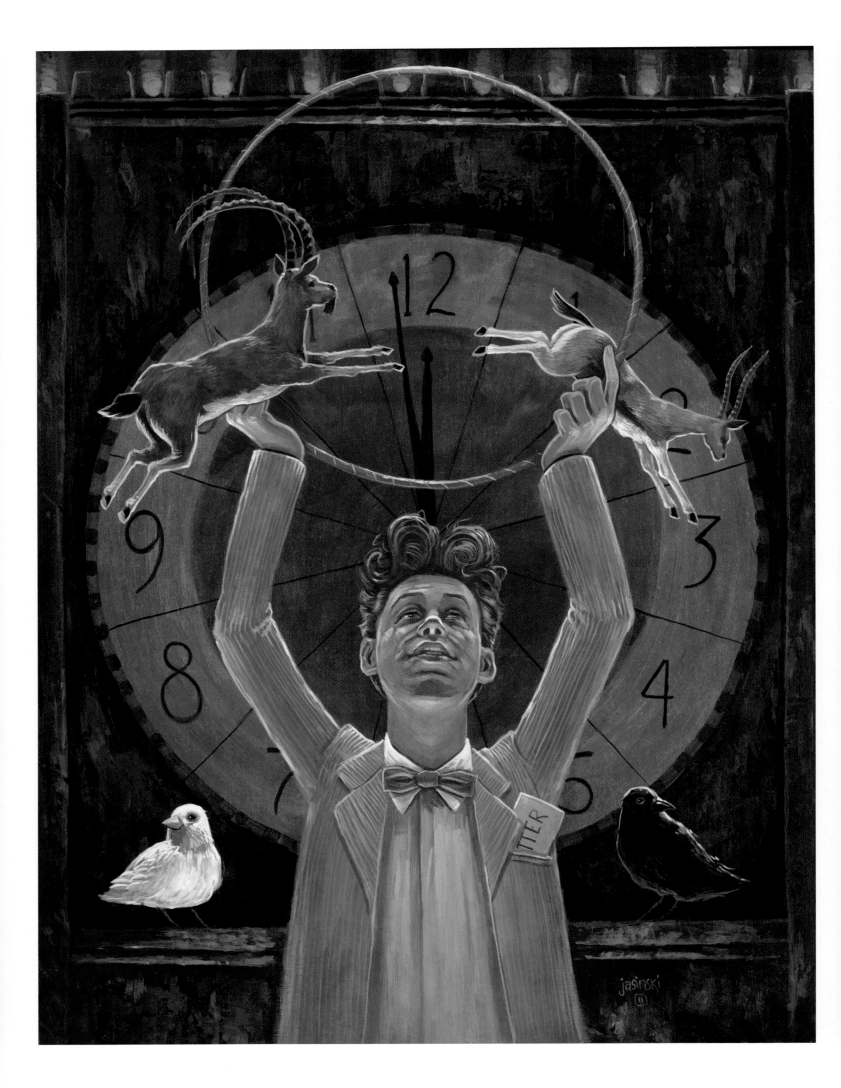

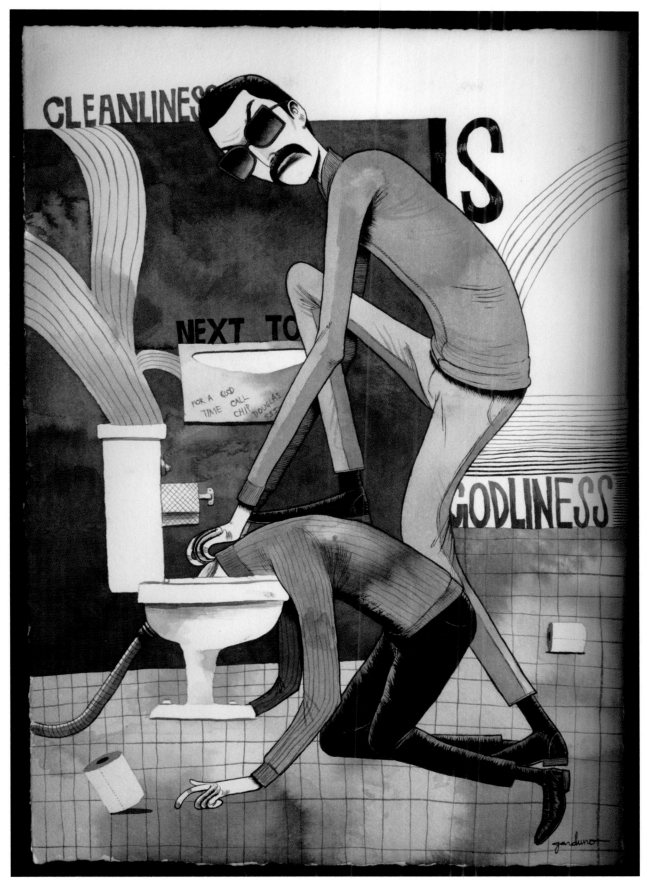

Left:
Aaron Jasinski
'Karmic Theory of Ibex and Gazelle'
Acrylic on wood panel
18 x 24 inches
The Hudsucker Proxy

Above:
Ken Garduno
'Cablo Goobla'
Acrylic, ink, and wash
13 x 17 inches
The Cable Guy

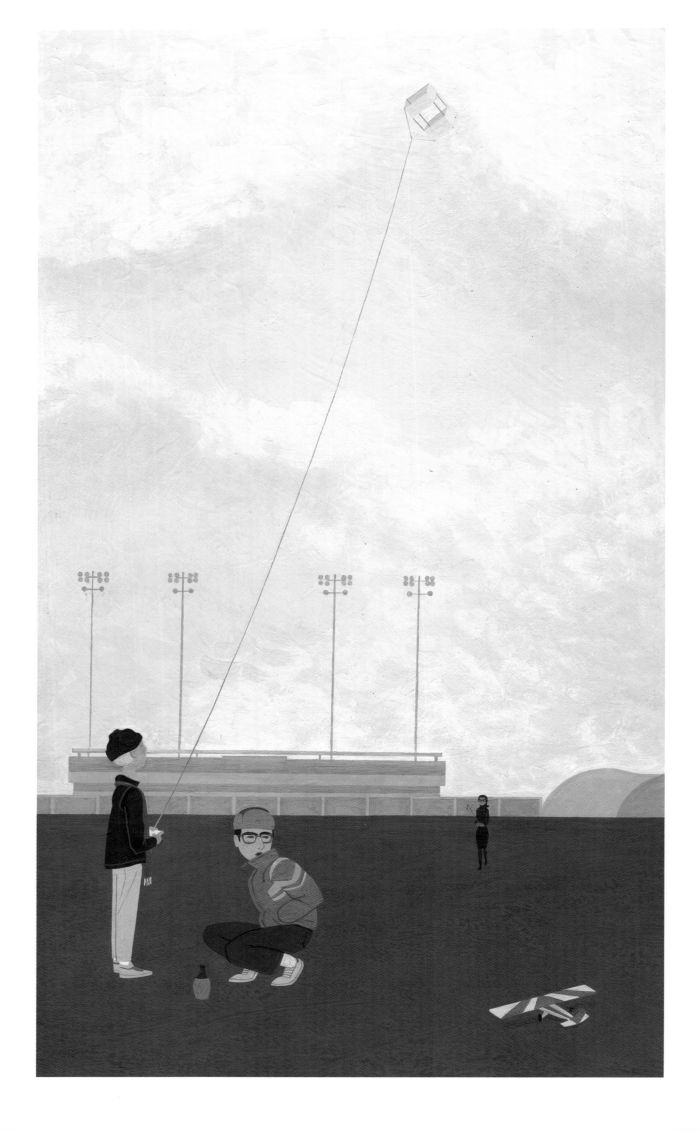

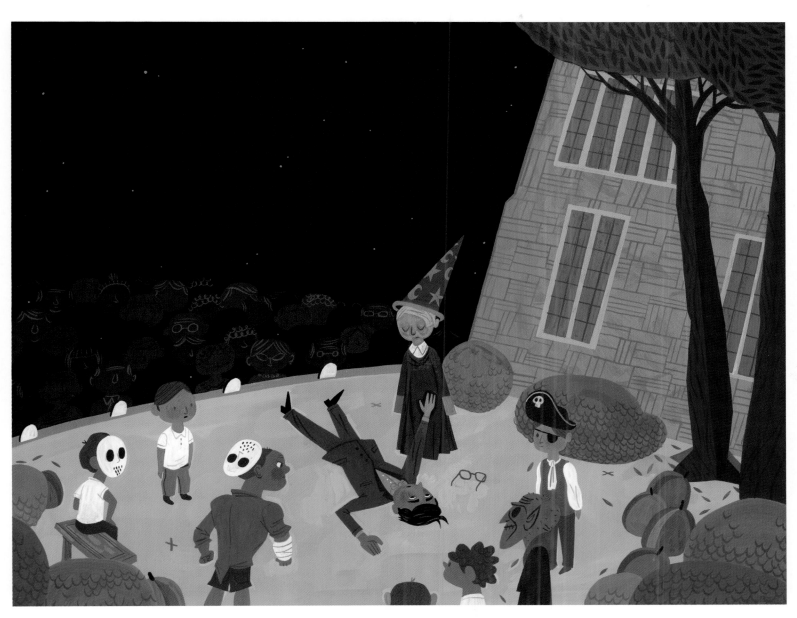

Above:
Israel Sanchez
'We Got 'Em, Dirk'
Gouache On Watercolor Paper
13 x 10 inches
Rushmore

Left:
'Rushmore Kite Flyers'
Gouache On Watercolor Paper
5 x 8 inches
Rushmore

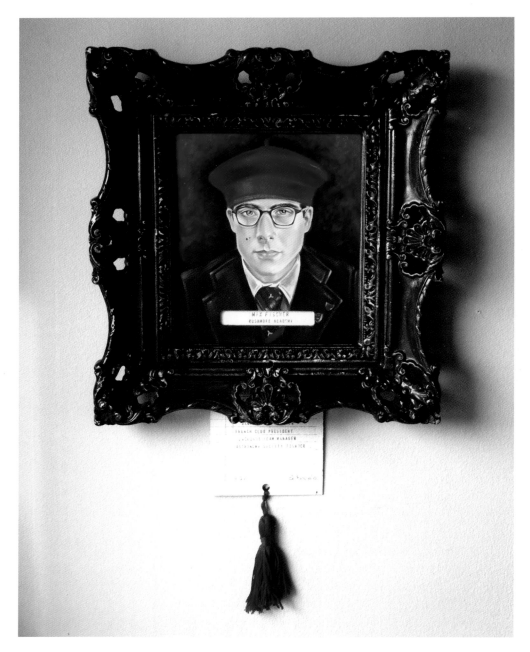

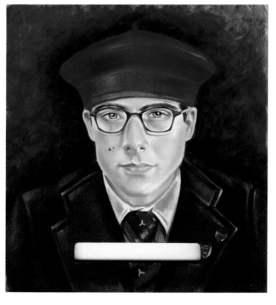

MAX FISCHER
RUSHMORE ACADEMY

BOMBARDMENT SOCIETY FOUNDER	
TRAP & SKEET CLUB FOUNDER	
STAMP & COIN CLUB VICE PRESIDENT	
RUSHMORE BEEKEEPERS PRESIDENT	
YANKEE RACERS FOUNDER	
MAX FISCHER PLAYERS DIRECTOR	
FENCING TEAM CAPTAIN	
PIPER CUB CLUB 4.5 HOURS LOGGED	
BACKGAMMON CLUB FOUNDER	
TRACK & FIELD J.V. - DECATHLON	
2ND CHORALE CHOIRMASTER	
MODEL UNITED NATIONS RUSSIA	
DEBATE TEAM CAPTAIN	
FRENCH CLUB PRESIDENT	
LACROSSE TEAM MANAGER	
ASTRONOMY SOCIETY FOUNDER	

6. 2011 D. Rizzolo

This page:
Danielle Rizzolo
'Max Fischer Rushmore Academy'
Oil on wood
6 x 7 inches
Rushmore

Right:
Chris DeLorenzo
'It Was The Handjob'
2 color screenprint on paper
18 x 24 inches
Rushmore

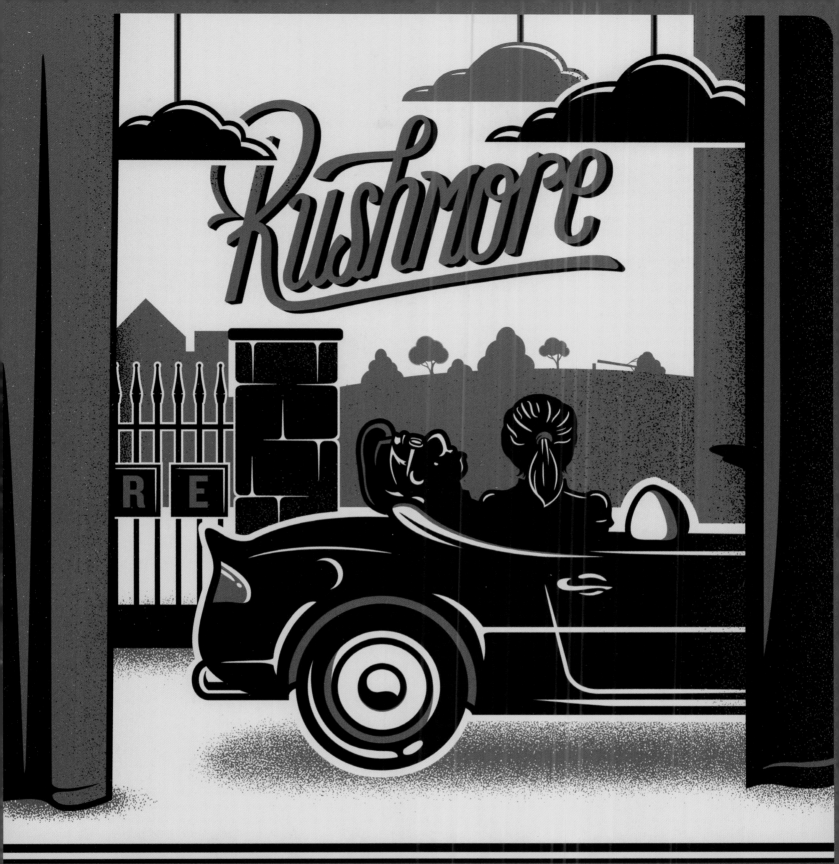

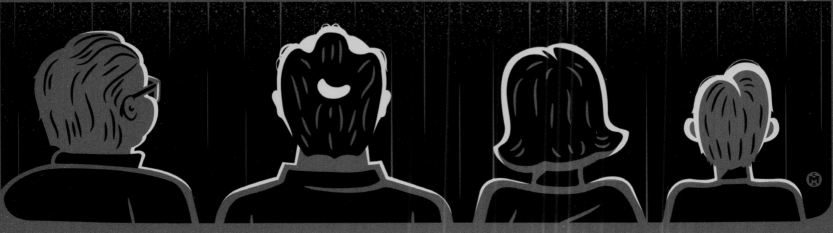

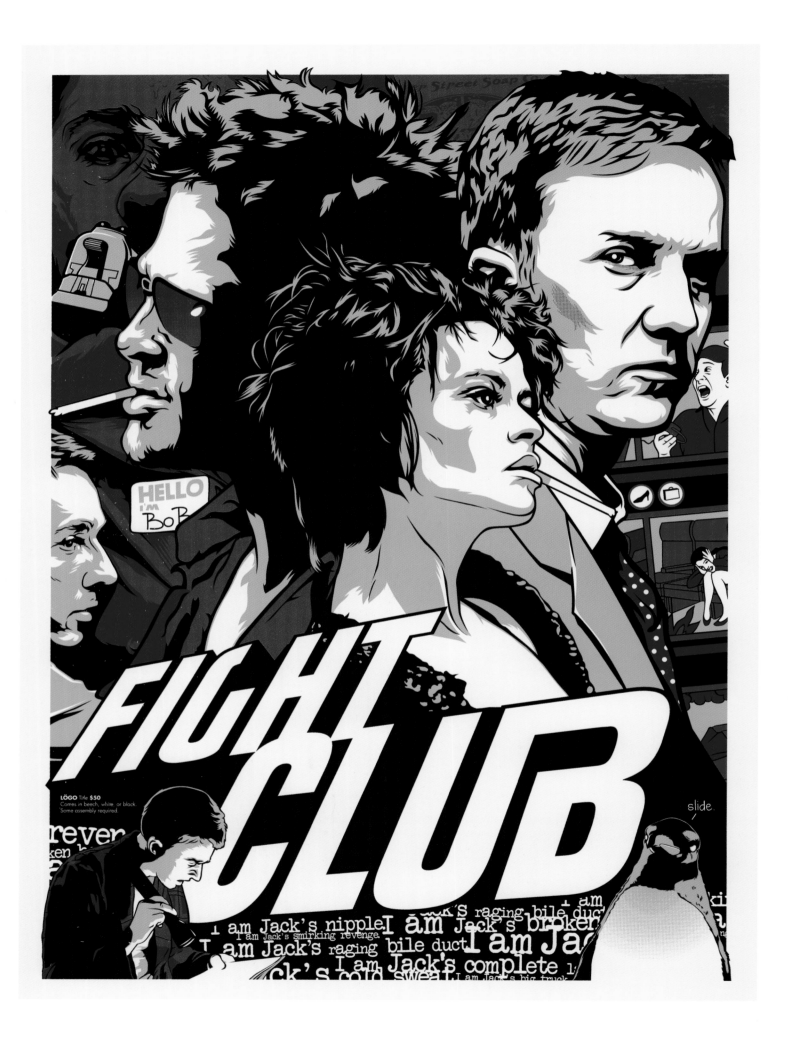

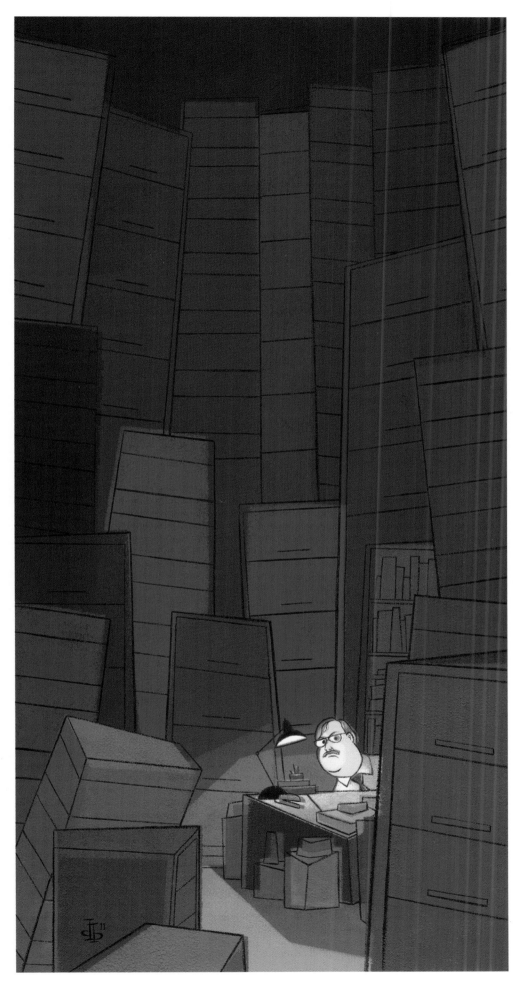

Opposite:
Joshua Budich
'Fight Club'
Screenprint
24 x 36 inches
Fight Club

Left:
Drake Brodahl
'Fortress of Solitude'
Cel-vinyl acrylic on paper
10 x 20 inches
Office Space

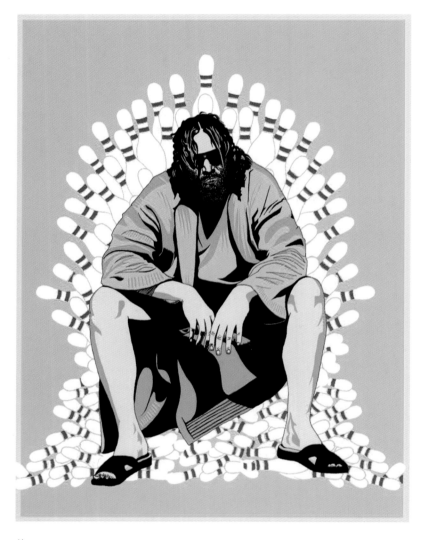

Above:
B Methe
'The Duder of Thrones'
Screenprint, 13 x 18 inches
The Big Lebowski

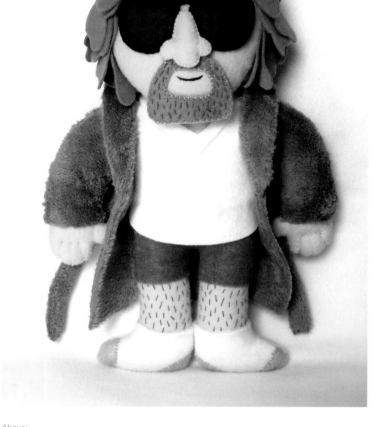

Above:
Michelle Coffee
'The Dude Abides'
Plush, 7 1/2 x 11 1/2 inches
The Big Lebowski

Right:
Tim Maclean
'The Granddaddy of all Root Beers'
Acrylic on Board
10 x 14 1/2 inches
The Big Lebowski

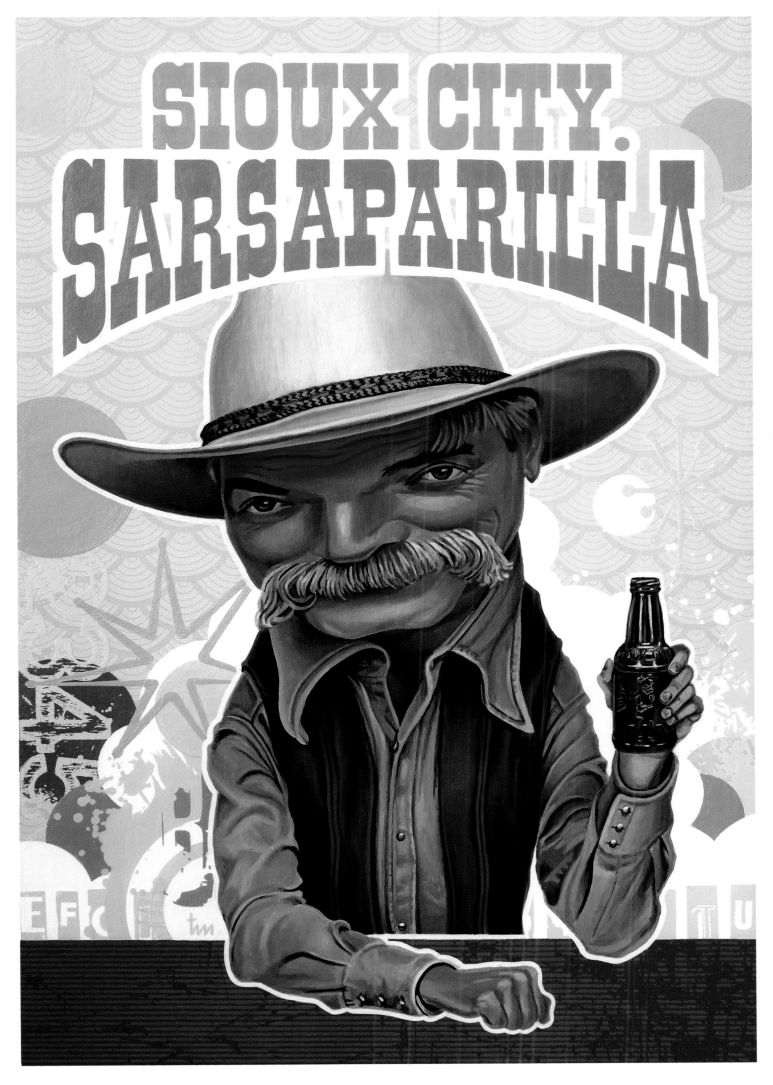

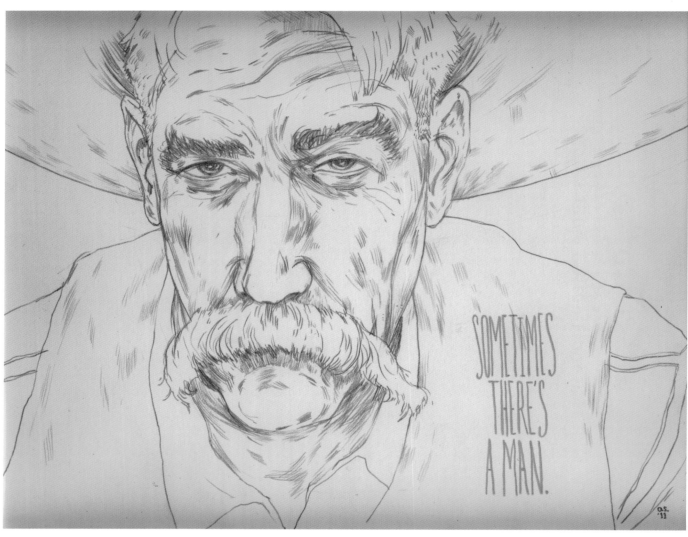

Above:
Owen Sherwood
'The Stranger'
Pencils on paper
10 x 8 inches
The Big Lebowski

Right:
Todd Slater
'Occasional Acid Flashback'
Screenprint
18 x 24 inches
The Big Lebowski

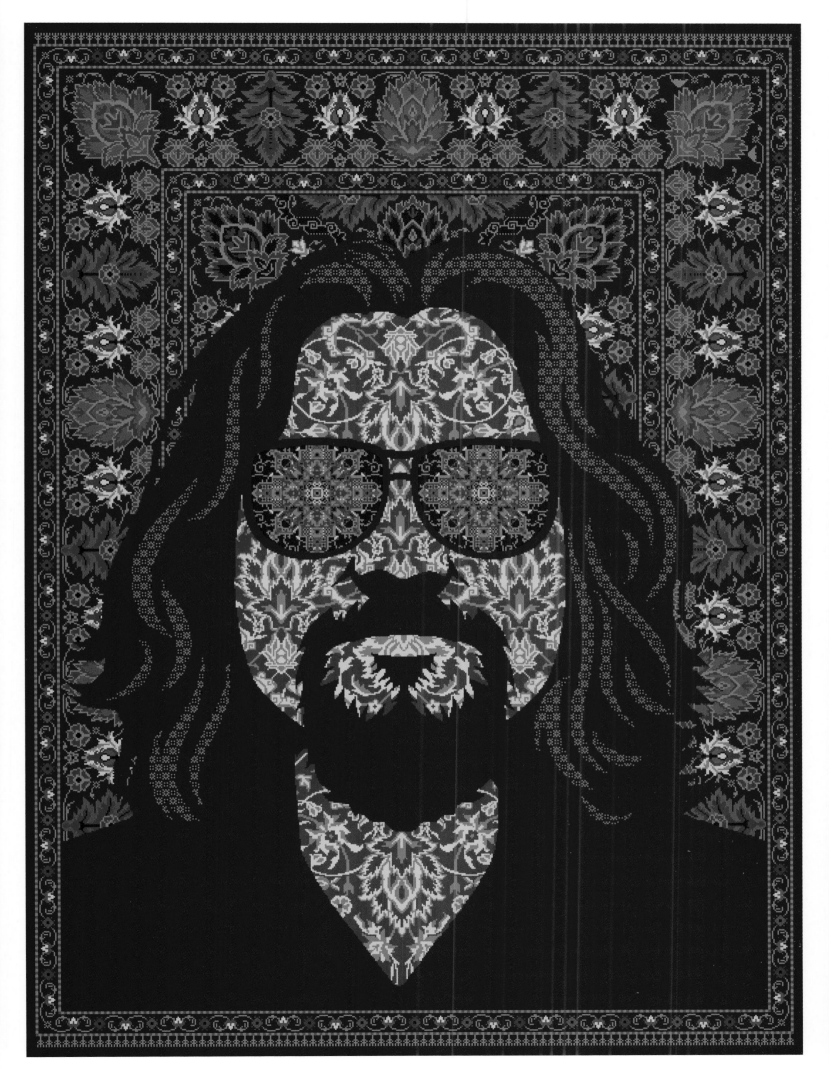

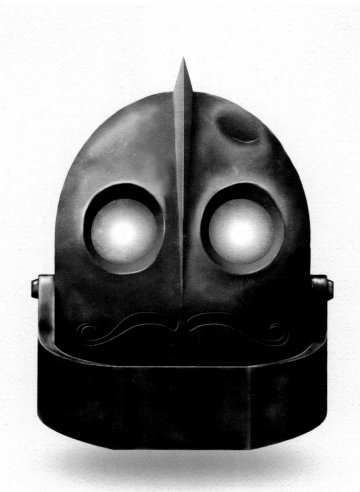

Ceci n'est pas une arme à feu.

Above:

Mike Mitchell

'Portrait of an Iron Giant as a Young Vin Diesel'

Giclee print with archival ink on cotton rag

16 x 20 inches

The Iron Giant

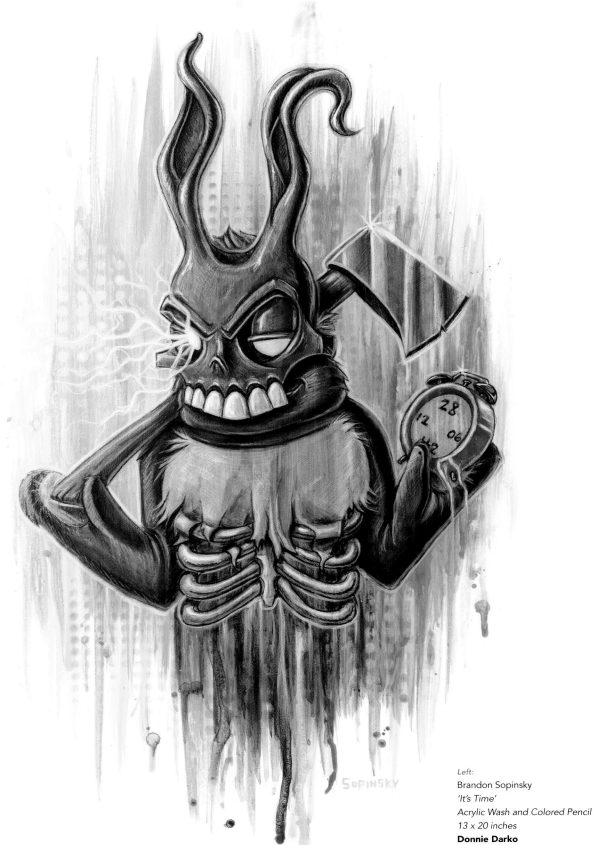

Left:
Julian Callos
'Too Cool For School'
Acrylic, Gouache, and Ink on Paper
Mounted on Cradled Panel
9 x 12 x 2 inches
Battle Royale

Left:
Brandon Sopinsky
'It's Time'
Acrylic Wash and Colored Pencil
13 x 20 inches
Donnie Darko

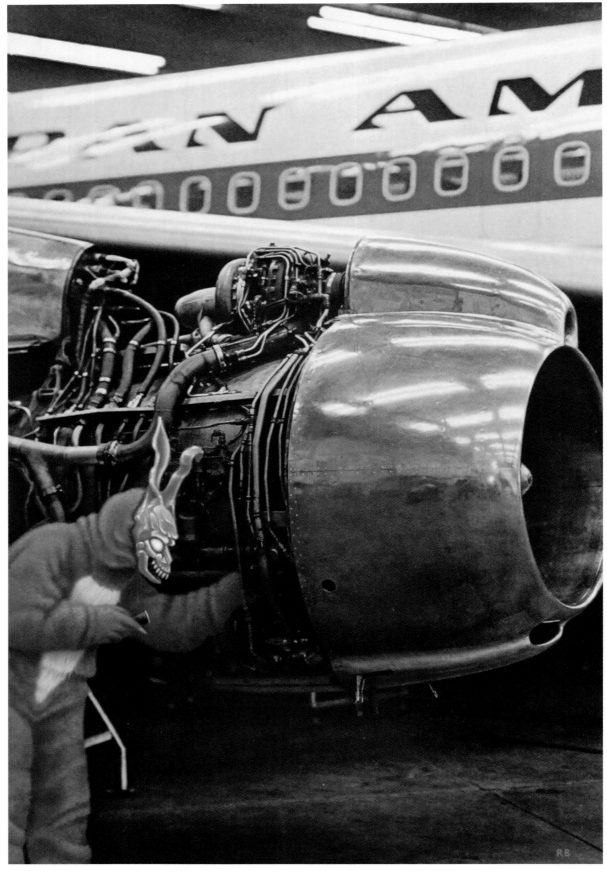

Above:
Robert Brandenburg
'Engine Maintenance, Hangar 14'
Giclee Print, 12 x 16 inches
Donnie Darko

Right:
Ruel Pascual
'Deadline'
Oil on wood, 18 x 24 inches
Donnie Darko

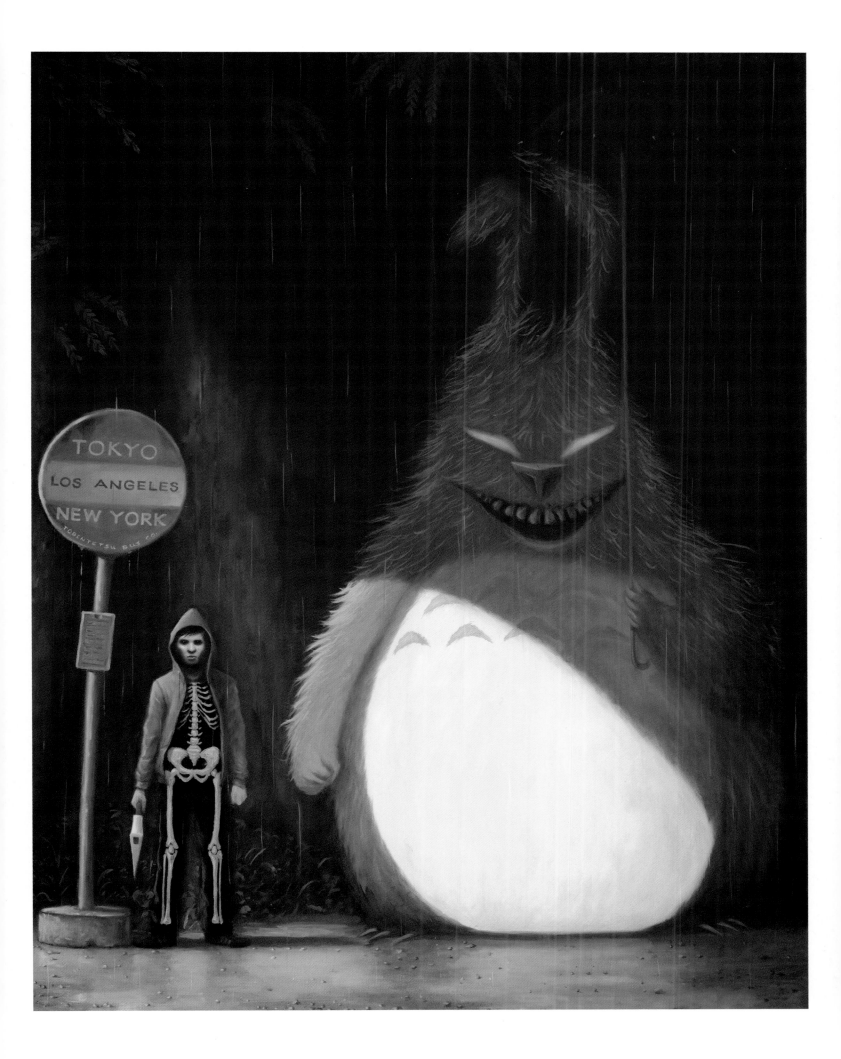

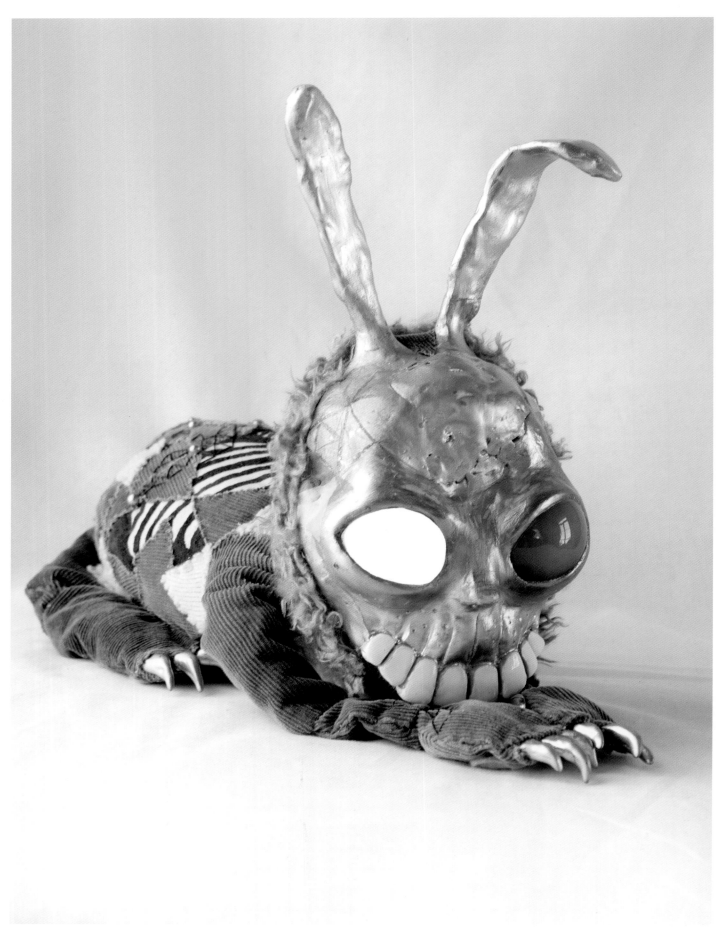

Above:
Danielle Buerli
'Bunny Darko'
Mixed media sculpture
10 x 10 x 4 inches approx
Donnie Darko

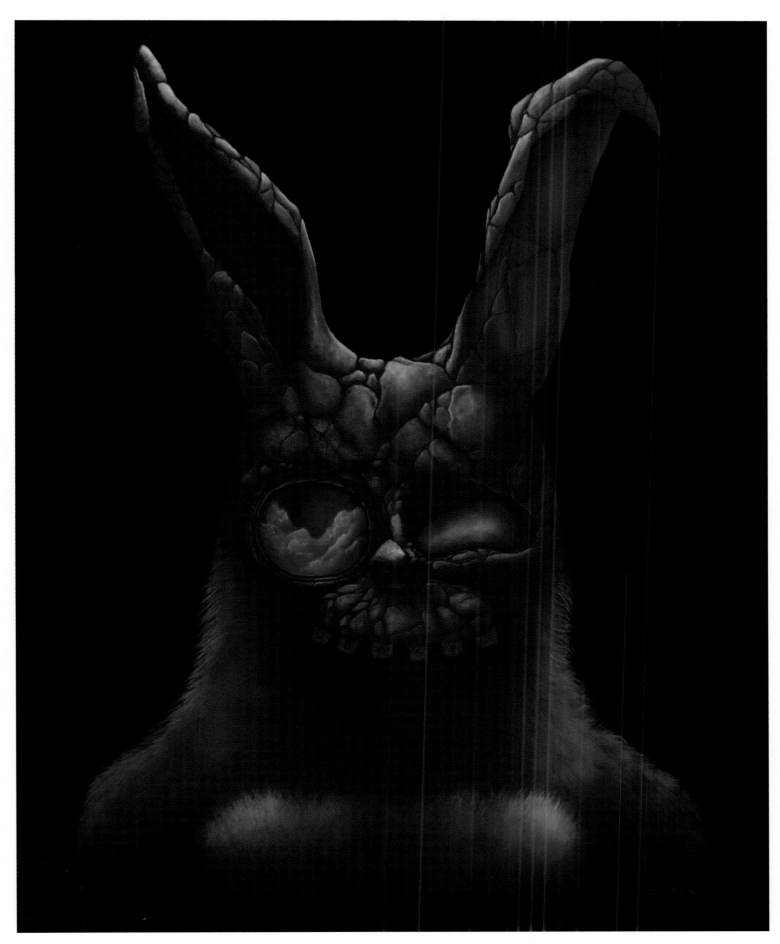

Above:
Graham Curran
'Mad World
Acrylic on Wood Panel
16 x 20 inches
Donnie Darko

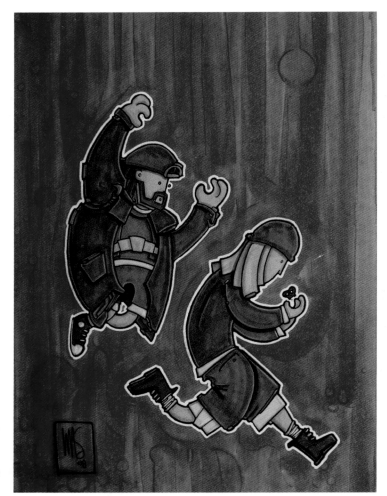

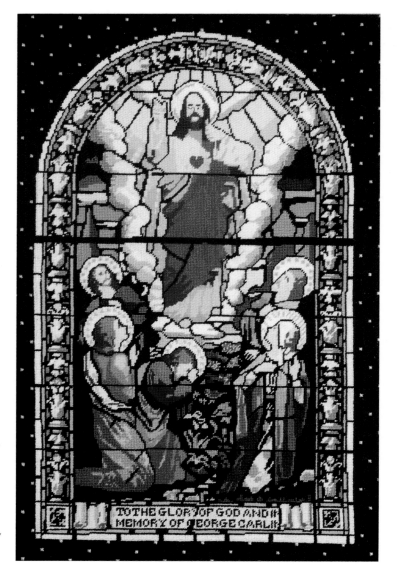

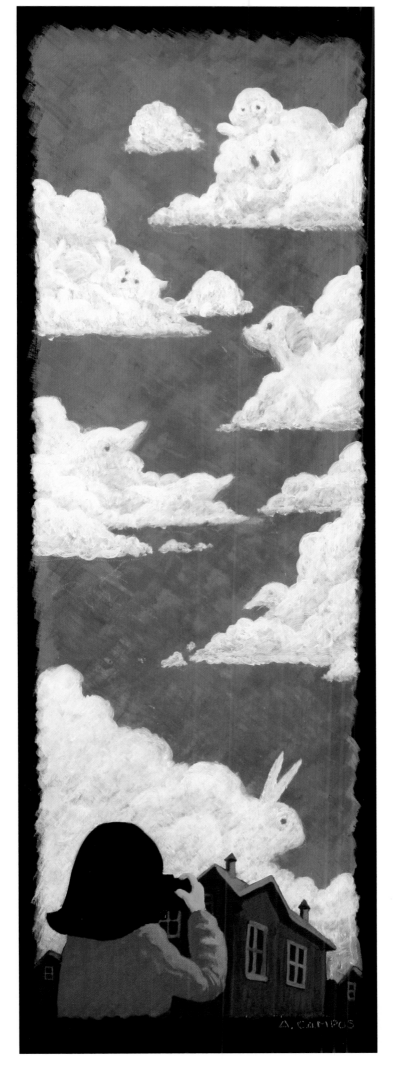

Left:
Alex Campos
'Fauna Shaped Clouds'
Gouache on wood
6 1/2 x 19 inches
Amelie

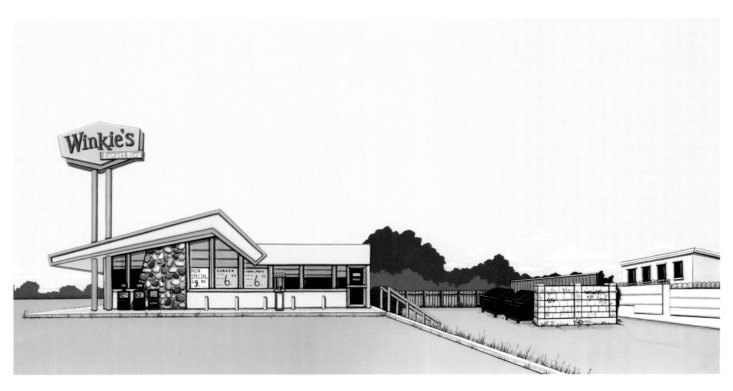

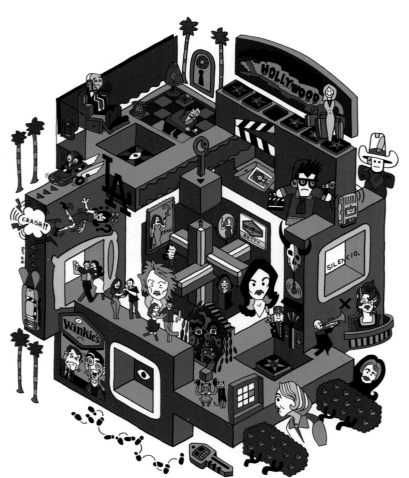

JIM HORWAT 2012

Above:
Kiersten Essenpreis
'I Had a Dream About This Place'
Flashe Paint on Wood, Sealed in Resin
22 x 12 inches
Mullholland Drive

Left:
Jim Horwat
'Homage to David Lynch's
Mulholland Drive'
Digital print, pen and ink process
16 x 20 inches
Mullholland Drive

Right:
Veronica Fish
'Mulholland Drive'
Gouache on Coldpress Paper
11 x 14 inches
Mullholland Drive

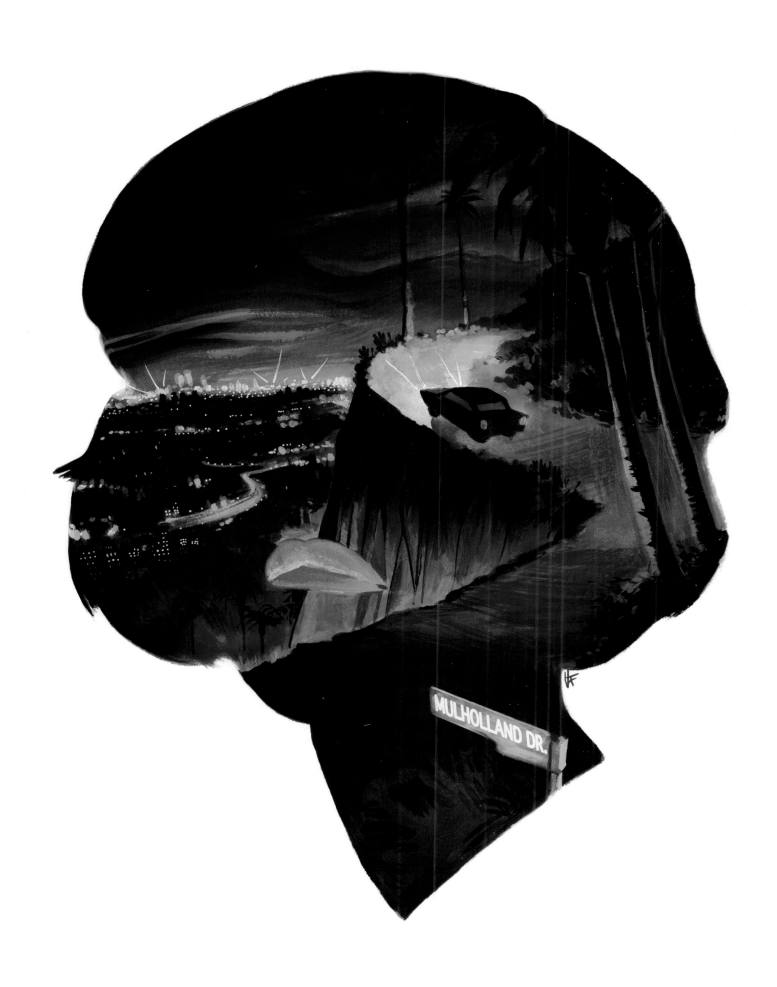

Right:
Justin Santora
'Wait For Me, Abby Bernstein'
Screenprint
18 x 24 inches
Wet Hot American Summer

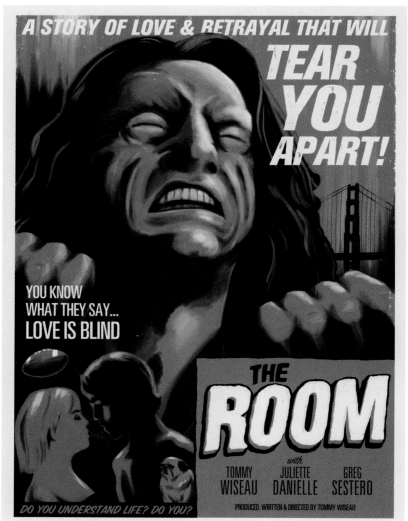

Right:
Derek Deal
'You're Tearing Me Apart, Lisa'
Screenprint
18 x 24 inches
The Room

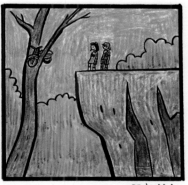

Clockwise, from top left:
Todd Webb
'Margot Tenenbaum'
'Richie Tenenbaum'
'Moonrise Kingdom'
'Max Fischer'
Ink and Crayon, 4 x 4 inches
Various Wes Anderson Films

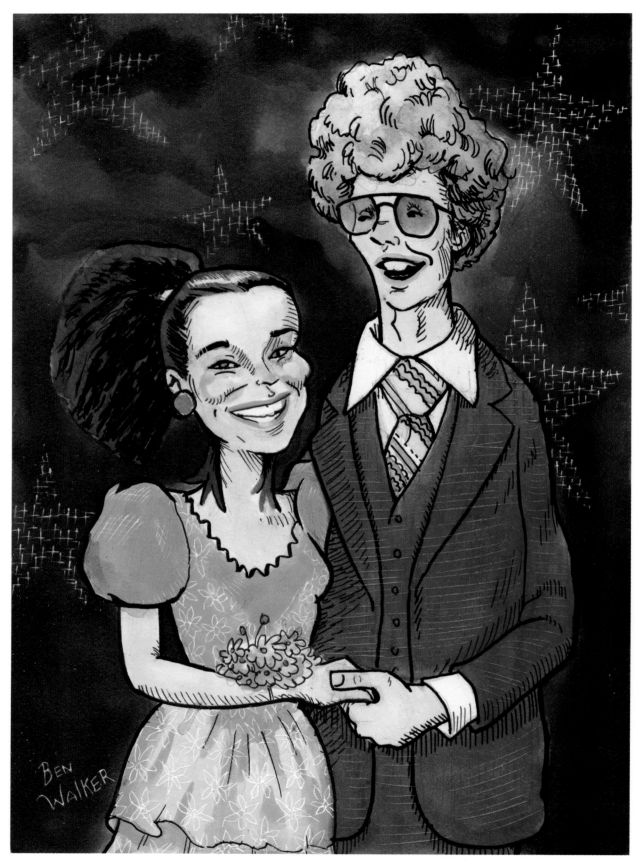

Above:
Ben Walker
'Theres Plenty More Where This Came From'
Watercolor and Ink on Clayboard
5 x 7 inches
Napoleon Dynamite

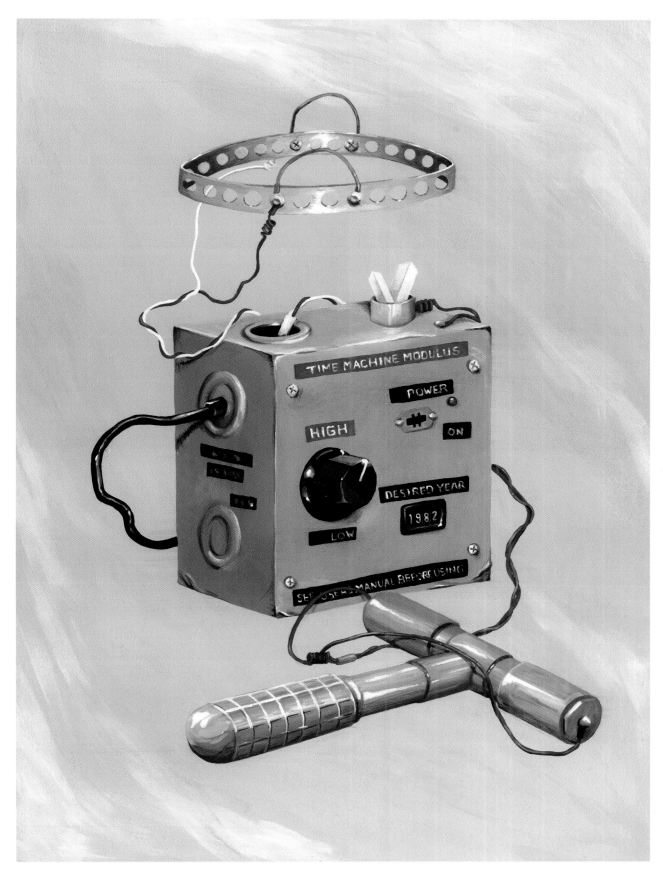

POWER

HIGH

ON

DESIRED YEAR

1982

LOW

SEE USER'S MANUAL BEFORE USING

Above:
Famous When Dead
'Uncle Rico's Time Machine'
Acrylic on Wood
11 3/4 x 17 3/4 inches
Napoleon Dynamite

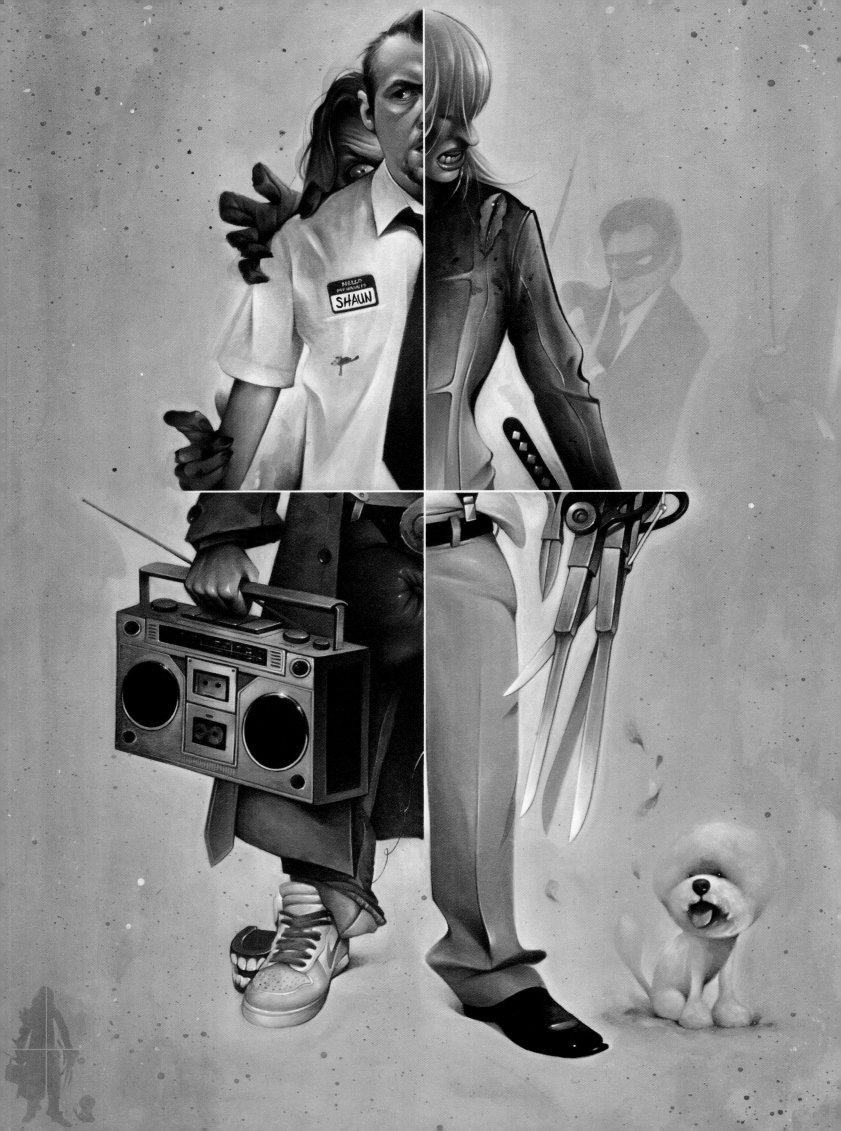

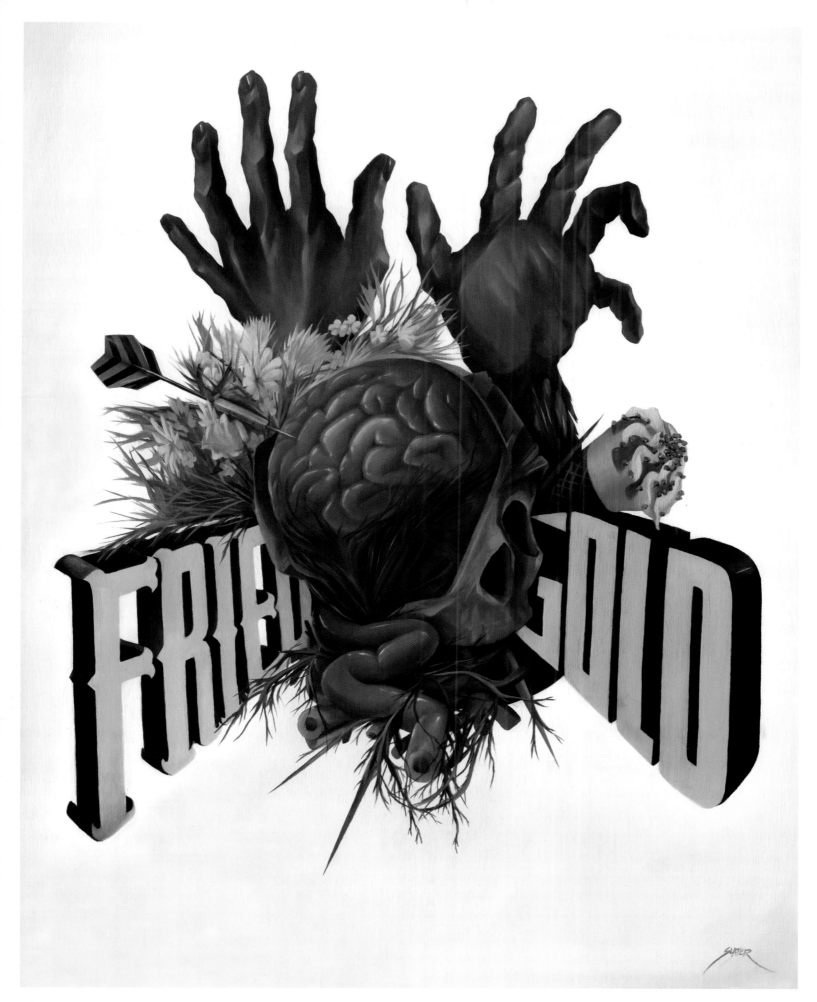

Left:
Chris B. Murray
'Mashed'
Acrylic on Panel, 11 1/4 x 16 inches
Shaun Of The Dead / Various

Above:
Bennett Slater
'Slice of Fried Gold'
Oil on Wood, 18 x 24 inches
Shaun Of The Dead

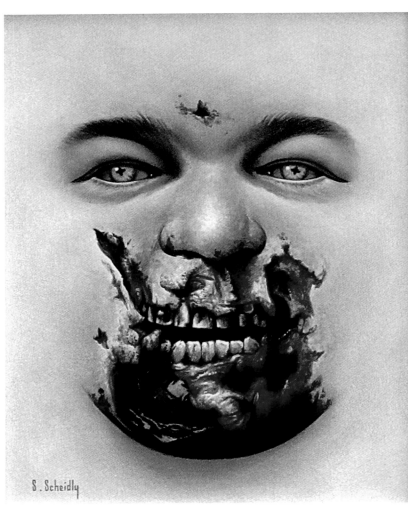

Opposite, top:
Lora Zombie
'Shaun'
Pen, Ink and Watercolor on Paper
25 x 33 inches
Shaun Of The Dead

Opposite, bottom:
Aled Lewis
'Player Two Has Entered The Game'
Giclee Print
24 x 28 inches
Shaun Of The Dead

Left:
Scott Scheidly
'Hulk'
Acrylic on wood
13 1/2 x 15 inches
Shaun Of The Dead

Below:
Munk One
'You've Got Red on You'
Glow in the dark paint and
Acrylic on Gesso Board
12 x 9 inches
Shaun Of The Dead

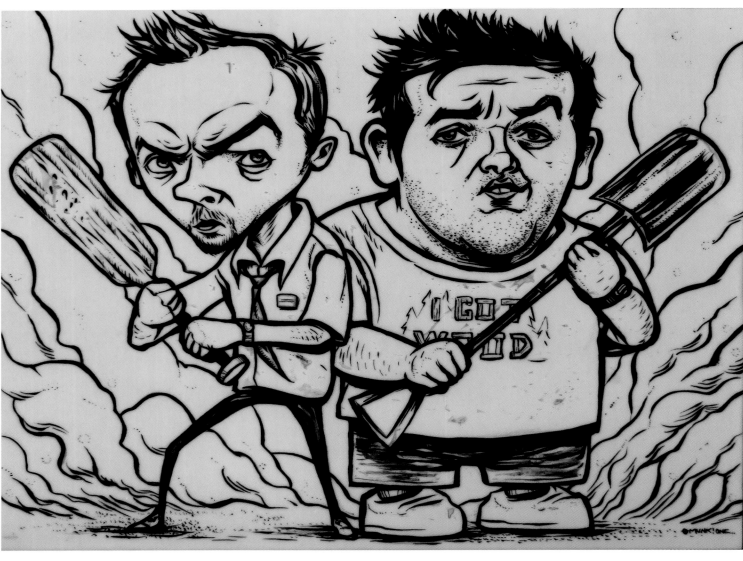

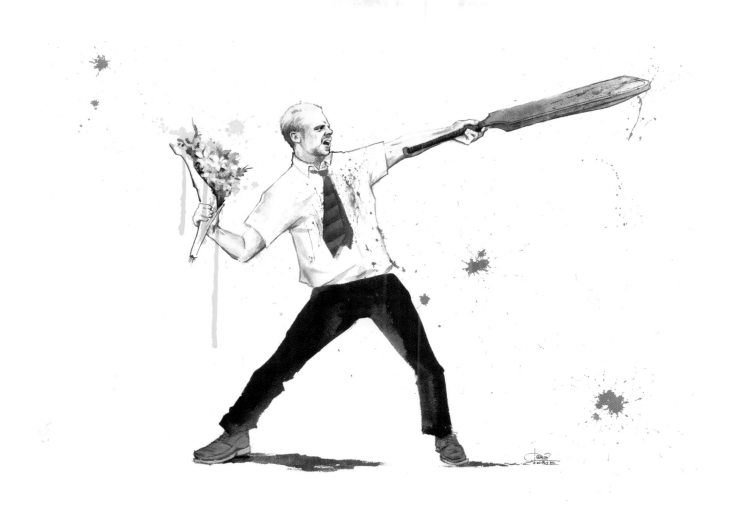

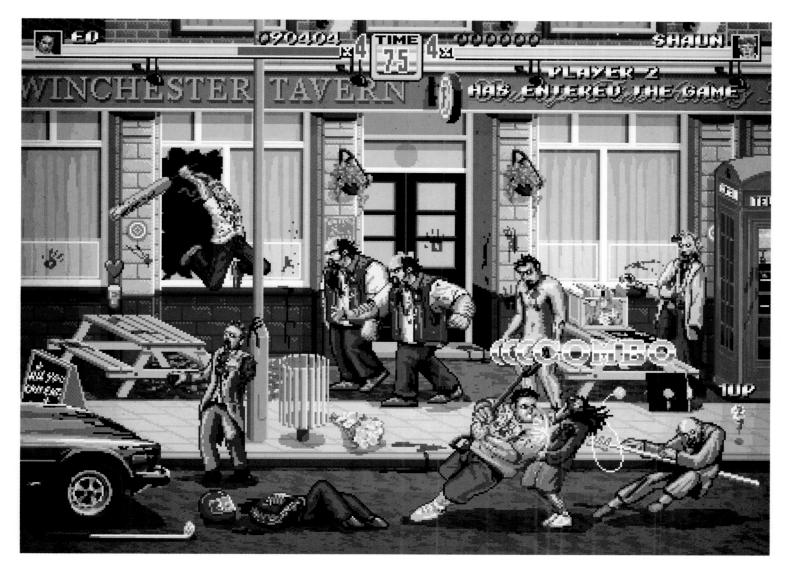

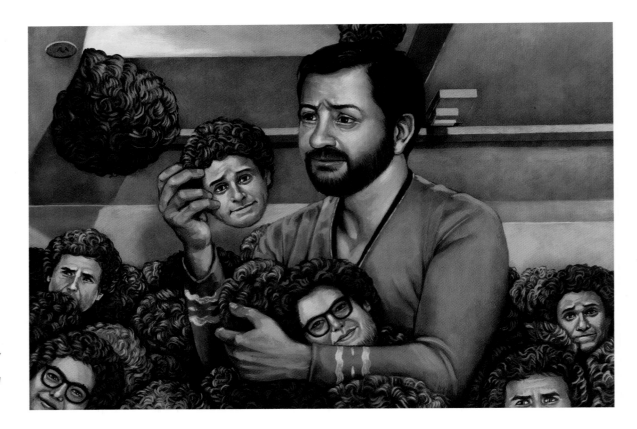

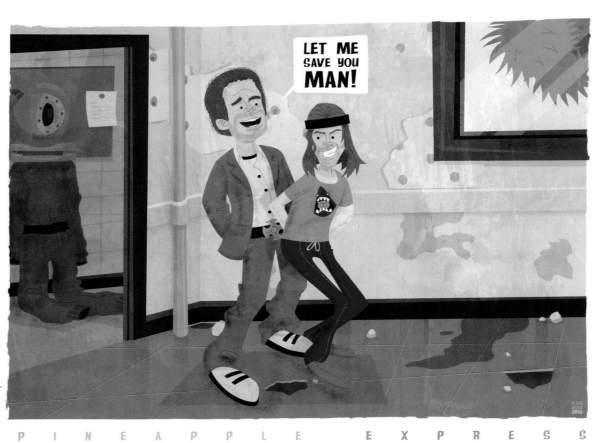

Above:
Ryan Berkley
'Everything Is Hazy'
Marker and color pencil
10 x 8 inches
Pineapple Express

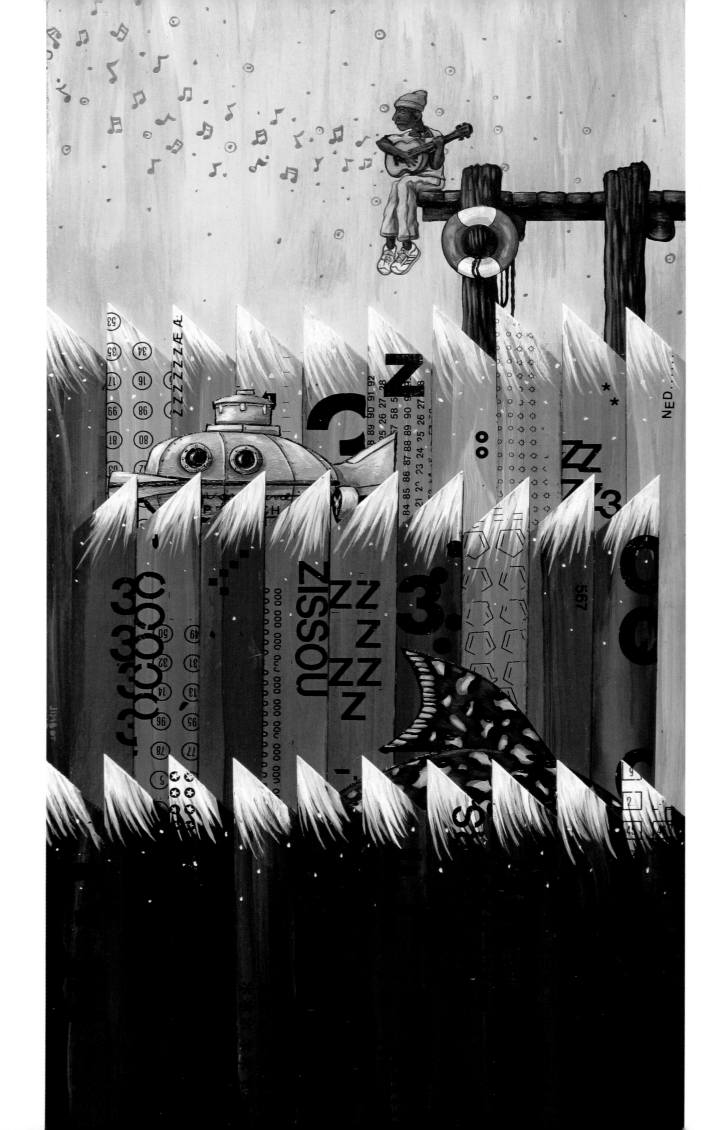

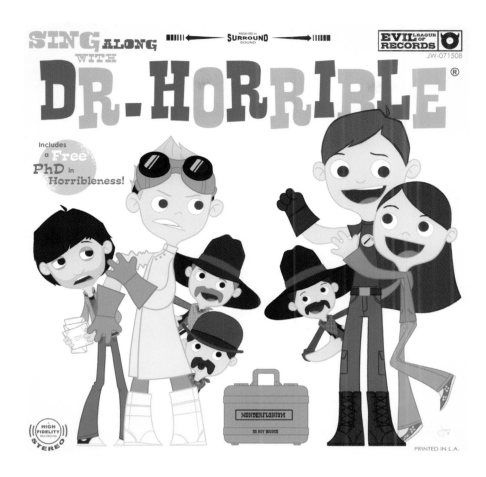

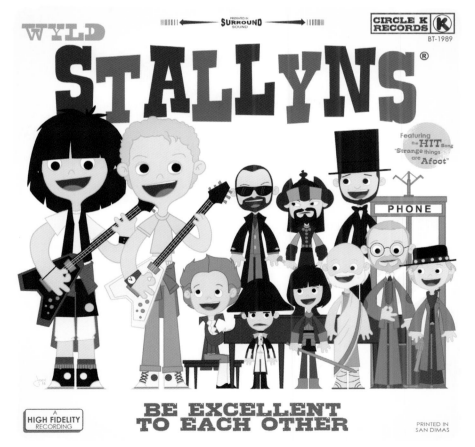

Left:
James 'Jimbot' Demski
'I Wonder If It
Remembers Me'
Wood Assemblage
and Acrylic
12 x 21 inches
**The Life Aquatic
With Steve Zissou**

Top:
Joey Spiotto
'Sing Along with Dr. Horrible'
Digital print
13 x 19 inches
**Dr. Horrible's Sing-Along
Blog**

Left:
'Wyld Stallyns - Be Excellent
To Each Other'
Digital print
19 x 13 inches
**Bill And Ted's
Excellent Adventure**

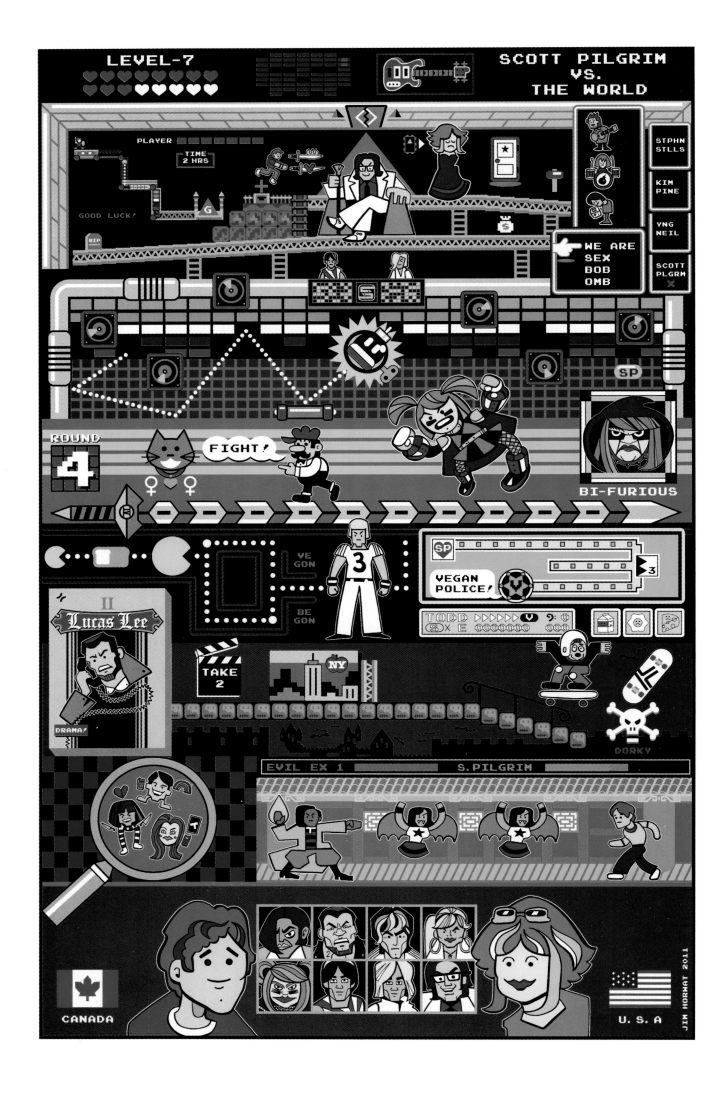

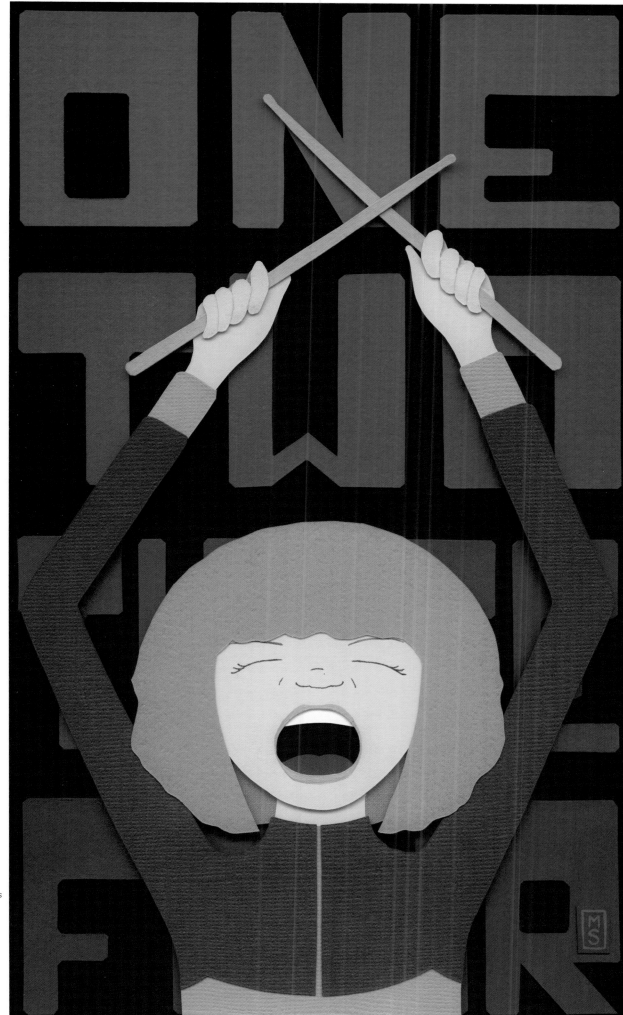

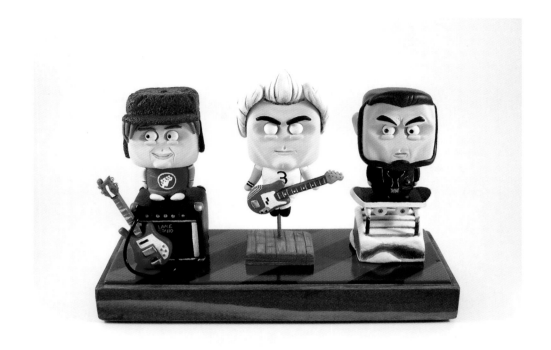

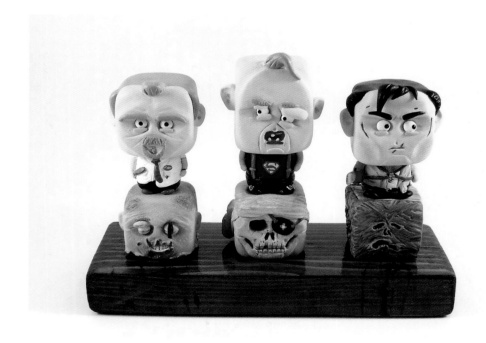

Top:
Brad Hill
'Zero, Three, Two'
Mixed Media
7 x 4 3/4 x 3 inches
Scott Pilgrim vs. The World

Above:
Brad Hill
'HailToTheKings'
Mixed Media
6 1/2 x 4 3/4 x 2 1/4
Various

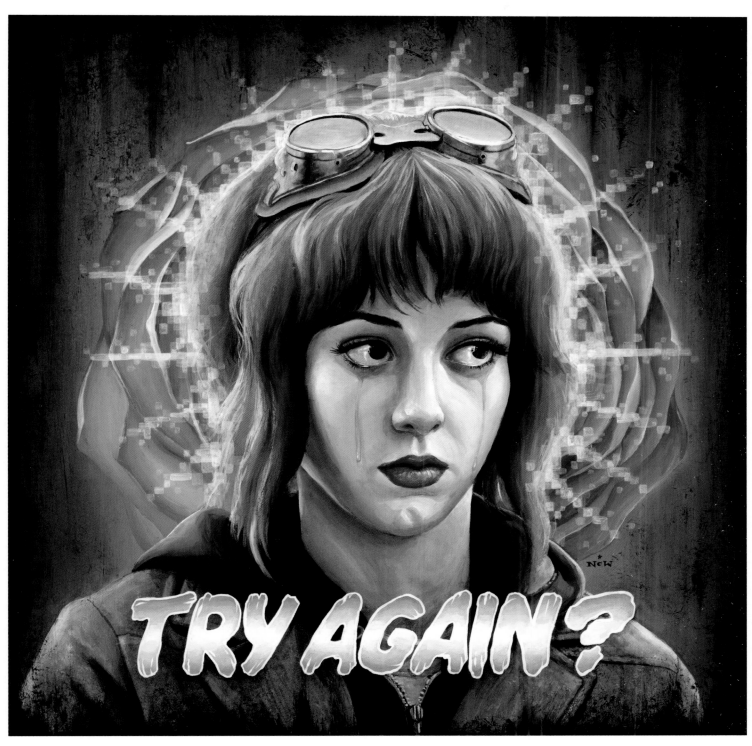

Above:
N.C. Winters
'Try Again?'
Acrylic ink on paper, mounted to wood panel, resined
14 1/2 x 14 1/2 inches
Scott Pilgrim vs. The World

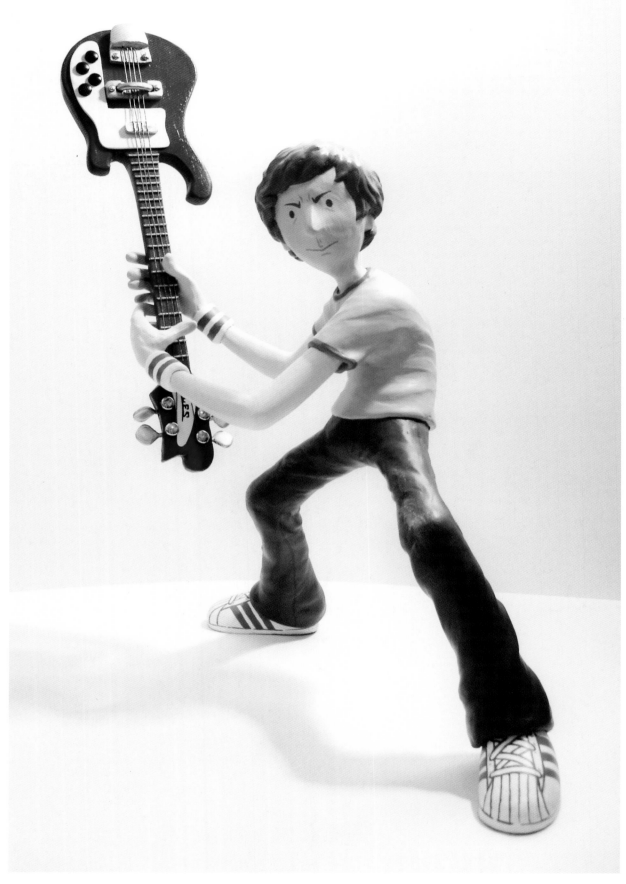

Above:
Julian Callos
'Ace Of Bass'
Mixed Media Sculpture
9 x 12 inches
Scott Pilgrim vs. The World

Right:
Glen Brogan
'Scott Pilgrim Vs. the Arcade'
11 x 17 inches
Scott Pilgrim vs. The World

Aaron Jasinski
www.aaronjasinski.com

Adam Hanson
www.adamhanson.bigcartel.com

Adam Limbert
www.adamlimbert.com

Aled Lewis
www.aledlewis.com

Alex Campos
www.8bitmemory.blogspot.com

Alex Pardee
www.eyesuckink.com

Allison Reimold
www.thereimoldeffect.blogspot.com

Allison Sommers
www.allisonsommers.com

Andrew DeGraff
www.andrewdegraff.com

Andrew Wilson
www.fourthwish.com

Anthony Petrie
www.anthonypetrie.com

Audrey Pongracz
www.audreypongracz.com

B Methe
www.bmethe.com

Basemint Design
www.basemintdesign.com

Ben Walker
www.benwalkerart.com

Bennett Slater
www.bennettslater.com

Brad Hill
www.sircreate.com

Brandon Schaefer
www.seekandspeak.com

Brandon Sopinsky
www.designbydestruction.blogspot.com

Bruce White
www.velvetgeek.com

Casey Weldon
www.caseyweldon.com

Charles Moran
www.zomic.bigcartel.com

Chogrin
www.chogrin.com

Chris B. Murray
www.chrisbmurray.com

Chris DeLorenzo
www.chrisdelorenzo.com

Chris Sanchez
www.chrissanchezart.com

Clark Orr
www.clarkorr.squarespace.com

Dan Goodsell
www.theimaginaryworld.com

Danielle Buerli
www.dbuerli.com

Danielle Rizzolo
www.danieller.com

Dave Perillo
www.montygog.blogspot.com

Dave Quiggle
www.davequiggle.com

David Soames
www.davidsoames.com

Derek Deal
www.derekdeal.com

DKNG
www.dkngstudios.com

Doug LaRocca
www.douglarocca.com

Drake Brodahl
www.drakebrodahl.com

Ellen Schinderman
www.schindermania.com

Eric Braddock
www.ericbraddock.com

Eric Price
www.ericspricelesspieces.com

Eric Tan
www.erictanart.blogspot.com

Erica Gibson
www.iamericagibson.com

Famous When Dead
www.fwdead.co.uk

Fernando Reza
www.frodesignco.com

Glen Brogan
www.albinoraven7.blogspot.com

Graham Curran
www.grahamcurran.com

Graham Erwin
www.grahamerwin.com

Ian Glaubinger
www.hasunow.com

Israel Sanchez
www.israelsanchez.com

James Flames
www.jamesflames.com

James 'Jimbot' Demski†
www.jimbot.com

Jason D'Aquino
www.jasondaquino.com

Jason Edmiston
www.jasonedmiston.com

Jason Liwag
www.jasonliwag.com

Jeff Boyes
www.visualtechnicians.com

Jesse Riggle
www.jesseriggle.com

Jim Horwat
www.jimhorwat.com

Joe Scarano
www.joescarano.com

Joe Van Wetering
www.joevw.com

Joey Spiotto
www.jo3bot.com

Joey Spiotto
www.jo3bot.com

John Bell
www.johnbellstudio.com

JoKa
www.joka444.com

Jon Smith
www.smithbellcraft.com

Jonathan Wayshak
www.scrapbookmanifesto.com

Joshua Budich
www.joshuabudich.com

Jude Buffum
www.judebuffum.com

Julian Callos
www.juliancallos.com

Justin Santora
www.justinsantora.com

Justin White
www.jublin.com

Keith Noordzy
www.quid-squid.com

Kelly Vivanco
www.kellyvivanco.com

Ken Garduno
www.kengarduno.com

Kiersten Essenpreis
www.youfail.com

Kim Herbst
www.kimherbst.com

Lauren Gregg
www.laurengregg.com

Lawrence Yang
www.suckatlife.com

Leanne Biank
www.leannebiank.com

Leontine Greenberg
www.leontinegreenberg.com

Lora Zombie
www.lorazombie.com

Mark Englert
www.markenglert.com

Martin Hsu
www.martinhsu.com

Matt Chase
www.chasematt.com

Matt Kaufenberg
www.mattkaufenberg.com

Matt Owen
www.brickhut.wordpress.com

Matt Taylor
www.matttaylor.co.uk

Meghan Stratman
www.bunnypirates.carbonmade.com

Michelle Coffee
www.michellecoffee.com

Mick Minogue
www.3buttons.wix.com/mickminogueart

Mike Mitchell
www.sirmikeofmitchell.com

Mikeatron
www.mikeatron.com

Misha
www.misha-art.com

Monkey Ink Design
www.monkeyinkdesign.bigcartel.com

Munk One
www.munkone.com

N.C. Winters
www.ncwinters.com

Nathan Stapley
www.nathanstapley.com

Nic Cowan
www.niccowan.blogspot.com

Nick Comparone
www.nickcomparone.com

Nicole Bruckman
www.nicole-bruckman.com

Nicole Guice
www.nicoleguice.com

Nicole Gustafsson
www.nimasprout.com

Owen Sherwood
www.owensherwood.com

Patrick Awa
www.patrickawa.net

Paul Hornschemeier
www.forlornfunnies.com

Rezatron
www.rezatron.com

Rhys Cooper
www.studioseppuku.bigcartel.com

Rich Pellegrino
www.richpellegrino.com

Ridge
www.ridgerooms.com

Robert Brandenburg
www.brandenburgart.com

Roger Barr & Louis Fernet-Leclair
www.i-mockery.com

Ruel Pascual
www.ruelpascual.com

Ryan Berkley
www.berkleyillustration.com

Samuel 'Sho' Ho
www.samuelho.com

Sarah Soh
www.sohillustration.blogspot.com

Scott C.
www.pyramidcar.com

Scott Derby
www.scottderby.blogspot.com

Scott Listfield
www.astronautdinosaur.com

Scott Scheidly
www.flounderart.com

Sean Clarity
www.fnaok.com

Shana Bilbrey
www.doowackadoodles.blogspot.com

Shannon Bonatakis
www.shannonbonatakis.com

Shannon Finch
www.shannanigan.com

Stanley Chow
www.stanleychowillustration.com

Steff Bomb
www.steffbomb.com

Stephen Andrade
www.sandradeillustration.com

Steve Seeley
www.thedelicatematter.com

Tim Maclean
www.timmacleanart.co.uk

Todd Slater
www.toddslater.net

Todd Webb
www.toddbot.com

Tom Whalen
www.strongstuff.net

Travis Louie
www.travislouie.com

Veronica Fish
www.hebsandfish.com/Veronica.htm

Wade Schin
www.atibia.com

ACKNOWLEDGMENTS

Gallery1988 would like to give very special thanks to Seth Rogen, Damon Lindelof, Nick Kroll, Jason Reitman, and Scott C for contributing to this book, and society as a whole. We also want to thank Aristides & Heather Pinedo-Burns for helping us take Crazy 4 Cult to NYC. And without the help and early support from Scott Mosier & Kevin Smith, we could never have achieved the success from this show that we've experienced. Our families are also super supportive, which is nice and deserves a mention here. And lastly, we want to give a HUGE thank you to Amber Deane Bell and John Wilmes for working their asses off. We are forever grateful for your hard work on these amazing projects.

GALLERY 1988'S
CRAZY 4 CULT: CULT MOVIE ART 2

ISBN: 9781781167519

Published by
Titan Books
A division of Titan Publishing Group Ltd.
144 Southwark St.
London
SE1 0UP

First edition: October 2013
10 9 8 7 6 5 4 3 2 1

Did you enjoy this book? We love to hear from our readers. Please e-mail us at: **readerfeedback@titanemail.com** or write to Reader Feedback at the above address.

To receive advance information, news, competitions, and exclusive offers online, please sign up for the Titan newsletter on our website: **www.titanbooks.com**

Printed in China by C&C Offset Printing Co., Ltd.

Front cover:
N.C. Winters
'Descent Into Madness'
acrylic ink on paper, mounted to wood panel, resined
13 1/4 x 14 1/4 inches
The Shining

Back flap:
Jason Edmiston
'Robocabbie'
Acrylic on wood panel,
18 x 24 inches
Various

Case front:
Rhys Cooper
'Your Move'
Screenprint, 12 x 36 inches
Robocop

Case back:
Rhys Cooper
'Vivir Libre New York!'
Screenprint, 12 x 36 inches
Escape From New York